Capture
the Moment

Capture the Moment

A practical guide to sports photography – London 2012 and beyond

Andy Hooper

WILEY

Conten

Introduction 9

1 Photographing Key Events 24

2 Outdoor Sports 46
Athletics 50
Cycling 63
Equestrian 81
Tennis and Golf 87
Target Sports 96
Outdoor Team Sports 101
Outdoor Water Sports 119

3 Indoor Sports 138
Combat Sports 143
Cycling – Track 149
Gymnastics 159
Power Sports 164
Racket Sports 167
Target Sports 172
Indoor Team Sports 176
Indoor Water Sports 184

4 Taking Pictures in and around London 204

5 Techniques and Equipment 232

6 Legal Issues 270

Glossary 282
Index 284
Picture Credits 288

Author's Acknowledgements

First and foremost I want to thank my wife Lucy for her help, patience and enthusiasm in writing this book. My four lovely children, Calvin, Henry, Mary and Tommy who I love dearly.

I firmly believe you should always grasp the opportunities that come along, I hope this book is an inspiration to all aspiring photographers.

A special thanks goes to Lee Clayton, Sports Editor, *The Daily Mail*, Paul Silva, Picture Editor, *The Daily Mail,* Brendan Monks, Sports Picture Editor, *The Daily Mail* and Paulo Silva, Syndication, *The Daily Mail*. My book editor Catherine Bradley for her patience and guidance. Briony Hartley for her great design and Darren Crush, my technical editor, for his enthusiasm. I would also like to thank Marc Aspland and Richard Pelham for contributing the photographs on pp.136–7 (Marc) and p.144 and p.146 (Richard) respectively.

Captions for chapter openers:
pp.24–5 Michael Vaughan holds the urn aloft after England's victory in the home Ashes series in 2005. This picture was taken using a 70–200mm zoom lens and a shutter speed of 1/250th second at F5, ISO 400.
pp.46–7 Ante Kusurin's gritted teeth show the strain during trials for the Oxford v Cambridge University Boat Race on the River Thames in 2009. I used a 500mm lens from a press launch to capture this close-up image.
pp.138–9 Michael Phelps breaks the surface during the Butterfly competition at the 2008 Olympic Games. Filling the frame when shooting action shots like this gives maximum impact. I used a 400mm lens and a shutter speed of 1/1000th of a second at F2.8.
pp.204–5 A horse and rider jump in Greenwich Park during a test event for the 2012 Olympic Games. Unusually I positioned myself slightly behind the jump to capture the London skyline, using a wide angle lens (24mm).
pp.232–3 Footballer Wayne Rooney battles between two USA players at the Royal Bafokeng Stadium, Rustenburg during the 2010 World Cup in South Africa. I used a 400mm lens for this action shot.
pp.270–1 While waiting at the final fence for the main race of the day at the Cheltenham Festival I trained my lens on the race before. This remarkable fall happened right in front of me – a reminder always to expect the unexpected. I used a 70–200mm lens and a shutter speed of 1/1000 to freeze the action.

About the Author

Andy Hooper is Chief Sports Photographer at the *Daily Mail*, and one of the UK's most celebrated sports photographers. He has won Sports Photographer of the Year four times, most recently in 2010, as well as Royal Photographer of the Year and other awards. He has photographed the Olympic Games in Beijing, Sydney and Athens as well as Football and Rugby World Cups, the World Athletics Championships, Wimbledon, the Grand National and Cheltenham Festival and even Dragon Boat Racing in Hong Kong.

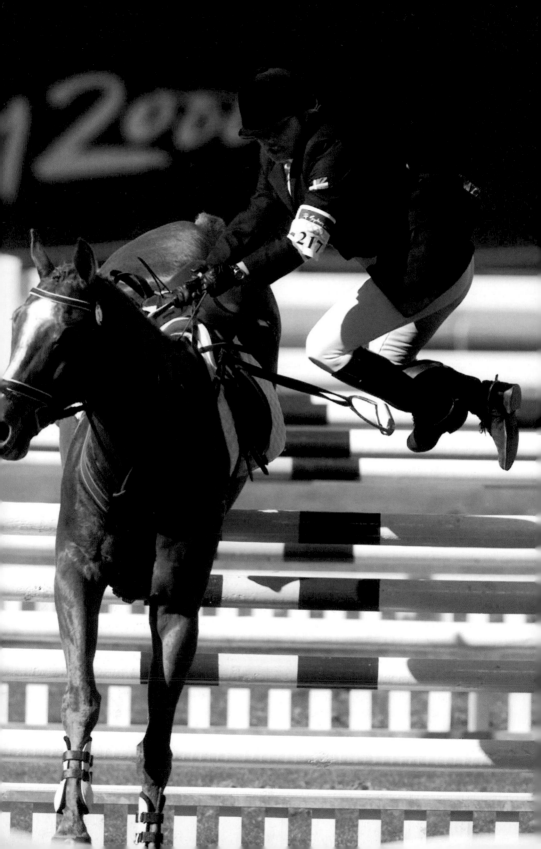

Introduction

As Chief Sports Photographer for a national daily, I'm often told that I have the best job in the world. It's difficult to disagree when I have the chance to be so near to the action – to be there when the records are broken, able to witness the drama unfold. At the Wimbledon tennis championships, for example, we are so close that you can literally touch the grass: a very special and privileged place to be. Creating a picture that sums up what you've seen in front of you to share with millions of people the next morning really tops it off.

People often ask me what my favourite image is; or which sport is best to photograph and which event was the most exciting to photograph. For me the highlight was capturing Jonny Wilkinson's drop goal against Australia to win the Rugby World Cup. It was a truly momentous occasion with huge pressure on the players – and also on us photographers to deliver the image. The clock ticked down and all the photographers were primed for a drop goal. In the back of your head you're going through your list of things to get right and remembering what mistakes not to make. Get the picture sharp, fill the

◀ Expect the unexpected. This image of the show jumping discipline in the Sydney 2000 Modern Pentathlon was taken with one of the first commercially available DSLRs.

frame, choose the right lens, get the right camera setting... this is all racing through your mind on the build-up as the England team pushes towards the Australian line. A drop goal could come at any time: do you shoot it tight or loose? Is Jonny going to use his left or right foot? Do you get up and run 20 feet further forward to get a better angle? Sometimes it just happens – he kicks, you press the shutter. How long do you wait before you look at the image on the back of the camera? You think you've nailed it, but there is always doubt. Will the image be there on the back of the camera? It's a very tense moment.

Sport is possibly one of the most challenging and rewarding areas to photograph. It can produce instants of pure drama, and things can change every second as a winning goal is scored or a world record broken. Yet sports photography is also one of the hardest disciplines of photography, varied and full of challenges. The unpredictability combines with a short – sometimes extremely short – timescale of an event. Contrast, for example, the flight of an archer's arrow with the two hours spent running a marathon. Sport often takes place in the dark under floodlights, in bad weather or in the direct sunlight of an English summer. At the 2012 Games, sometimes you will be very near to the action, such as at the Road

Cycling, while Sailing off Weymouth and Portland will be a long way offshore and so a challenge to photograph in itself. I enjoy finding solutions and overcoming these challenges to produce something to excite people – it's what the sports photographer thrives on.

Opportunities at the London 2012 Olympic and Paralympic Games

Now really is the moment to brush up your skills for the event of a lifetime, whether to photograph sporting action or to capture London and its buildings in their 2012 Games glory. Who knows who might appear in your picture? For those lucky enough to get a ticket into the 2012 Olympic or Paralympic Games, preparation is all. This applies to amateurs as well as professionals, as the pressure will be on. Imagine the scene as the starting gun fires and athletes race off their blocks. These are the most anticipated races in the athletics world. They are at the core of the London 2012 Games, over in seconds – you don't want to miss that shot.

The most dramatic moment – when the ball is caught, the jump reaches its height, the goal is scored, the man crosses the line – is called the peak of the action. This fraction of a second, this instant in time creates the ultimate image, providing the basis for all sports photography. This is the moment that all photographers strive to capture, whether at an elite sport level such as London 2012 or at a school sports day. Whatever equipment you have, from a top-of-the-range DSLR all the way down to a basic point-and-shoot

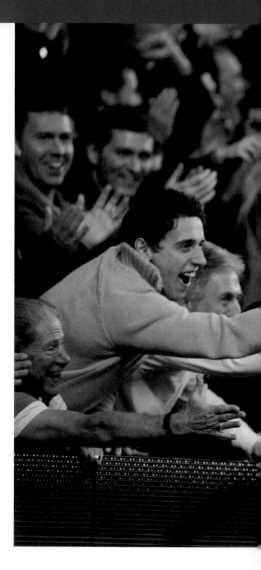

camera or a camera phone, you'll still be able to capture the action.

Taking Better Pictures

For over 20 years I have photographed major sports events, including the last three Olympic Games, Football and Rugby World Cups, Wimbledon, the London Marathon, Open Golf Championships and the World Athletic Championships. All this experience now helps me to produce technically great pictures every time – the consistency that

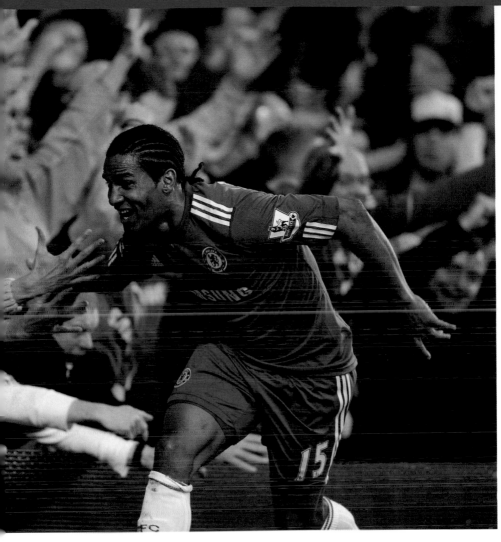

every photographer strives for. I have made all the mistakes and learned from them, enabling me to anticipate problematic areas and overcome them with relative ease. The view through my viewfinder is my primary way of seeing the world.

Photography has advanced incredibly quickly in the in the last 10 years; rarely a month goes by without a new piece of hardware or a new technique coming out. With this in mind I am going to help you use the latest techniques to get the best from your equipment. Whatever level

▲ Chelsea's Florent Malouda celebrates after scoring in front of a home crowd. The key here is to not shoot too close up and leave room for the crowd's expressions.

it may be, and whether you are shooting the London 2012 Games or your child's first football match, there is always scope to improve your pictures. Take my experience behind a camera and put it behind yours.

No matter what your sport or level of expertise, this book will make you

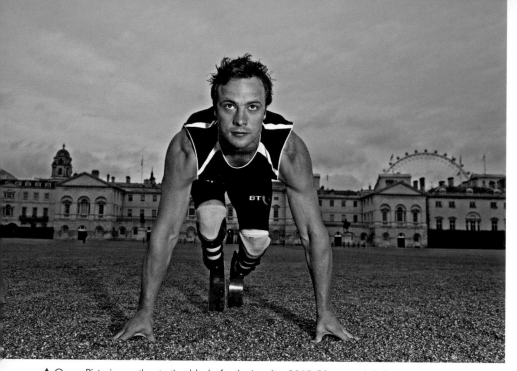

▲ Oscar Pistorius on the starting blocks for the London 2012 Olympics, with the Horse Guards Parade in the background. Off-camera flash is used to remove any dark areas.

a better digital sports photographer. Dozens of full-colour examples illustrate professional hands-on advice, covering past Olympic and Paralympic Games and a range of other events. The last three Olympic Games have been the best photographic experiences I have ever had. I want to share these amazing images with you, explaining the story behind the photographs and showing how they were taken.

Getting Expert Advice

We will look at camera equipment choices, explaining range and variety to discover what is right for you and your budget. The market can be bewildering and every sport is different – some need long lenses, others don't. You may be very happy with the equipment you have, but if you are thinking of upgrading then now is the time for some research. Think about the sports you want to photograph, whether at the London 2012 Games or elsewhere, and learn in more detail what they require in terms of camera equipment. Do you really need a fast motor drive? It certainly helps, but there are ways round it if it's beyond your budget.

Digital cameras have changed hugely even in the last five years. It's now possible to take sports pictures indoors with basic equipment, something that was simply not possible before. Adapting from indoor to outdoor photography and vice versa has become far easier. I'll explain the importance of high and low light sensitivity settings (ISOs), and the ways in which this has revolutionised indoor sports photography.

To get the best out of photographing the London 2012 Olympic and Paralympic Games, or the city dressed for celebration, you need to be prepared. *Capture the Moment* shows you how to photograph lots of different sports as well as the challenges of one-off events: processions and parades, award ceremonies, school sports days, London as a backdrop to the Games, with amazing new venues transforming some familiar landmarks. I will guide you to the best possible locations, from the Opening Ceremony to the Olympic Games and Paralympic Games (among the most photographed and anticipated sporting occasions on Earth), to the Equestrian events at Greenwich Park and the Rowing at Eton Dorney – one of England's most historic venues. This book will help you set up your camera, use your equipment effectively and give you tips on anticipating the action.

Honing your photographic techniques is the key to improving images. You will learn how to predict action and reaction, and how to freeze the action at the critical moment. You'll learn the importance of anticipation, whether you are photographing Athletics at the Olympic Stadium, Mountain Biking at Hadleigh Farm or sports days at your children's school. These are times of high drama. After four years of training Olympic and Paralympic athletes are at their peak, and whether they win or lose they will react with intense emotion. Emotion and energy in a shot tell the story and bring the photo to life. Some of the best pictures can be of the crowd reacting to this. The story is not always on the track: it can be

taking place all around you, so be alert.

Chapter 1 covers the unique practical challenges of photographing live events. At London 2012 these will include the Olympic Torch Relay, Opening and Closing Ceremonies and Victory Ceremonies, but many of the techniques apply to processions, victory parades and trophy presentations of any victorious individual or team. This includes the highlights and pitfalls of photographing your family and friends at their local sports matches or swimming galas. Children now have so many more opportunities to play sport of all different kinds, and you'll be able to follow the techniques that I show you and apply them at every level. Capturing your child receiving his or her first award will be one of the most important and treasured photographs you'll ever take.

We then move on to the techniques of photographing individual sports, focusing on Olympic and Paralympic disciplines together with other major sports such as golf, cricket and motor sport. Chapters 2 and 3 are split into outdoor and indoor sports, reflecting their unique characteristics. Photographing volleyball indoors, for example, is obviously very different to photographing sailing on the water. I then guide you through all the techniques you can use to get the best out of your equipment when you photograph these sports. You'll learn tips on camera set up, composition, the rule of thirds,

▶ Paralympian Rachael Latham backstrokes across the Union Jack. This was shot from the 10m diving board using a 70-200mm lens and two off-camera flash guns to light the scene.

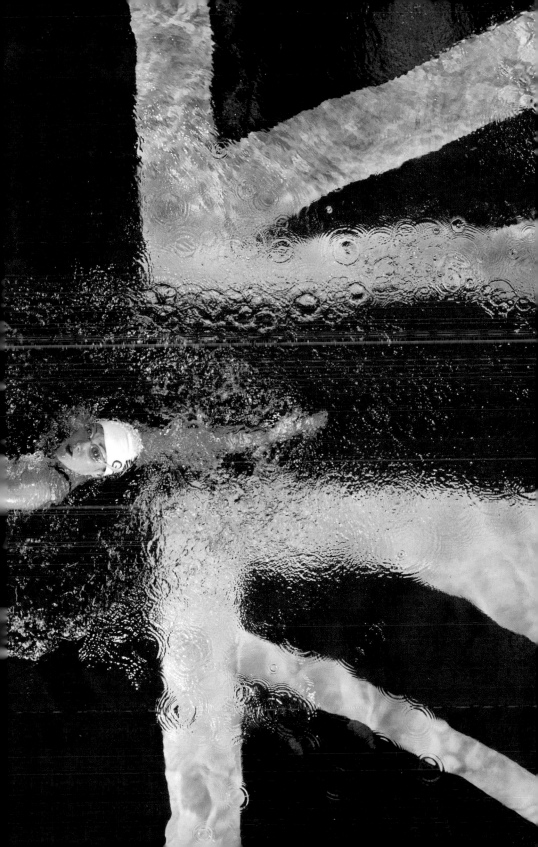

symmetry and balance, foregrounds and backgrounds and leading lines. Boxes provide a quick reference guide for each sport providing handy tips and ideas for that individual sport. A sidebar considers a 'winning shot', sometimes in the mind's eye, sometimes from my professional collection. How was it taken and how can you emulate it?

A second sidebar explores the challenges of the spectator's angle: how to get the best image possible from your seat, wherever that might be. Some events, for example the Cycling Road Race, obviously have spectator vantage points all along the route, with hundreds of different choices for creative shooting. Other events in seated stadiums have less choice, so *Capture the Moment* considers the options to get that once-in-a-lifetime shot. (Do not forget that some of the best pictures are taken of the crowd, family and friends sat next to you.)

We know that not everyone will be lucky enough to be beside the action, but that doesn't stop you getting fantastic pictures throughout the London 2012 Olympic and Paralympic Games. Everyone can photograph their family or friends at the best locations to show the next generation that they were there in 2012. So Chapter 4 considers the opportunities for photographing in and around London itself, and finding the best locations at the venues and around the Host City. The London 2012 venues are unique – some of the city's most familiar landmarks, such as Horse Guards Parade, Buckingham Palace and The Mall, will be transformed for the occasion. Whether you are interested in

historic buildings, iconic landmarks or urban modernity, you really are spoilt for choice. London is one the most photogenic cities in the world, and this is a chance to capture it in an extraordinary holiday mood.

Part of Chapter 4 explores the iconic moments that will inevitably occur at the London 2012 Olympic and Paralympic Games, and indeed at other sporting events. At Sydney 2000 it was Sir Steve Redgrave, overcome with emotion after winning his fifth gold medal as he embraced Matthew Pinsent who had crawled down the boat to congratulate him. In the 2004 Games in Athens it was the image of a wide-eyed Kelly Holmes, incredulous at winning a gold medal after a comeback at the age of 34. In Beijing 2008 it was perhaps the jubilation of Ellie Simmonds or the Olympic Flame being lit in the Bird's Nest Stadium. Capturing such moments on camera requires its own special skills, and this section discusses how to harness them.

Chapter 5 explains the technical aspects of digital sports photography. Having spent the past 20 years of my life carrying mountains of equipment around the world I have learned to keep it simple – just take what you need. Yet it's still a really big dilemma – which pieces of kit should you leave at home? Which are worth taking in the boot of the car and which bits (the essentials) do you have to carry on the shoot with you? This chapter explores in detail the techniques of camera set up, automatic versus manual settings, shutter speeds and apertures, all the functions of DSLR, compact and camera phones. It traces the life of a digital

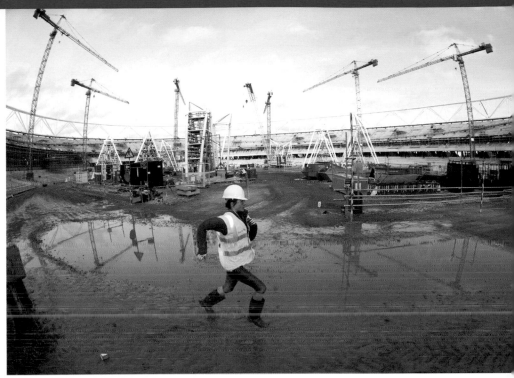

▲ Emily Pidgeon, the first athlete to run around the 400m track during the construction of the Olympic Stadium, was shot here on a 14mm-24mm lens 1/640th of a second at f/4.

photograph – everything that happens to the image from the moment of capture through editing, archiving, printing, sharing to uploading on to the web.

The choice of cameras can be overwhelming, so this chapter also assesses various equipment options, from telephoto lenses to wide angle. I will talk about the pros and cons of different megapixels, lenses, motor drives; higher ISOs, optical zooms versus electronic etc, in what is a rapidly changing market. This chapter considers what the difference is, and what different levels of skill are needed for each; when (and why) it might be worth trading up to a more advanced camera, and how to get the most out of what you already possess.

One of the most exciting parts of photography is sharing the images with your friends, whether by printing them, uploading the images to Facebook or displaying them in an album. There are so many ways of sharing on the web, including social networking sites, photographic libraries and photography printing sites. The choice has never been greater, but it is also complex. This chapter discusses the quality and various ways of uploading the images. Editing is a key stage as sports photographers tend to overshoot, leaving you with hundreds of images to store.

Chapter 6 covers many of the legal issues arising from the techniques discussed in Chapter 5. It explores the responsibilities of copyright (in print and online) and security concerns, emphasising the need to know your rights and follow the rules. I will explain

how to protect and take responsibility for your copyright, with special attention to the London 2012 requirements. For example, personal still images taken at London 2012 events published on social media websites must be correctly credited with the owners' rights; they must not be made available for commercial use. This chapter also examines the etiquette surrounding photography at amateur/junior sporting events, including child protection issues regarding images of youth sports teams and naming players in youth-team pictures. It includes tips on how to register as a photographer at public sports events, plus examples of best practice and guidelines.

Chapter 6 also considers issues of accreditation, exploring the challenge of getting accredited at professional sports events (especially football matches). Remember, even if the best positions are inaccessible to amateur photographers, knowing the right technique can still allow you to take unique and interesting pictures.

Creative Vision

Location, location, location applies as much to sports photography as it does to house buying – but there are times when you just have to sit where your ticket tells you. When you can't get close, you need to get creative. To conceive an inspirational image you need to free your mind and think laterally. Surprisingly few pictures make such an impact that we can remember them later and see them clearly in our mind's eye. When looking at a scene you won't see the same as the person standing next to you. How you perceive things, your experiences, interests, dislikes and likes, will all influence and shape what you see. Putting this in practical terms, once you've decided on your location take a few minutes to stand and think about how you can improve the image in your mind. Can you lie on the ground and shoot up? Can you add a foreground of flowers or trees to your picture? Can you use a special effects lens? Can you apply some of your creative research? It's this drive to improve the picture that will make your

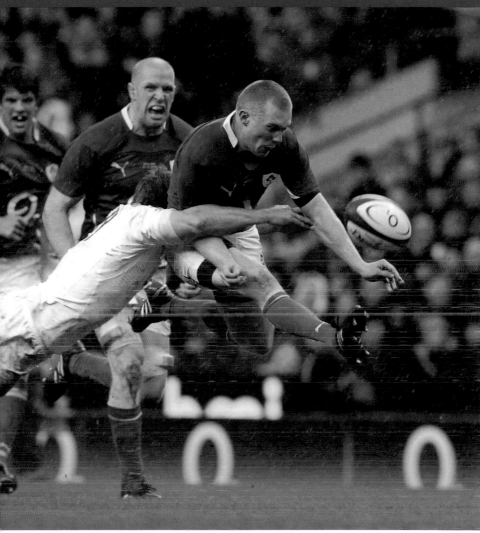

images really stand out from the rest.

It may sound as though I'm stating the obvious, but use both eyes. You only need one to look through the camera, so use the peripheral vision in your other eye: it's not always the obvious that makes the best picture. While the main action is taking place you might catch sight of something happening off the ball or on the sidelines that can make a fantastic photograph. Even though sport usually happens right in front of you at a certain time, always be on the lookout

▲ England's Jonny Wilkinson tackles Ireland's Keith Earls mid-kick at Twickenham. This shot is enhanced by the faces of the chasing pack. It was taken using a 500mm lens shooting at 1/640th of a second f/4 2000 ISO.

for something different and creative that possibly isn't the peak of the action.

Inspiration for creative thinking can come from design elements such as lines, shapes, forms, textures and patterns. What direction do the lines take – horizontal or vertical? Implied lines or eye-lines can be powerful as they are

perceived rather than seen. The overall lighting also plays an important part. Is it harsh or soft, are there interesting shadows? Look for contrasts – often found in sport in contrasting reactions between the winning athlete and the rest. Get close, zoom right into the scene to find a whole new angle, such as a hand gripping a tennis racket with sinews tensed and skin bathed in sweat. Try moving the angle of your camera so that you're looking either up at or down on your subject – it changes everything. You will learn a variety of photographic techniques to add to the individuality of your images. Pan and blur can be very effective, for example, and well worth getting to grips with. I'll help you with tips on 'seeing' pictures as the professionals do.

Know Your Sport

There are so many different sports, from the fast-moving diver leaping off the 10m board to the slow movement of a boat across the ocean. All have their own individual stars, tricks and unique difficulties. Just as sport is about practice and performance, the keen sports photographer can't expect to just turn up, point his or her camera and hope for the best. You've got to know your sport inside out. Be aware of who the favourite is, who's likely to win and who's not, where the favourites line up, where the best side of the track is and where not to go. Work out in advance which is the best angle, which fence is higher than the rest and can cause a crash, where the sun's going to be at what time, where you can go and

where you can't work. It's important to involve yourself in the rhythm of the game rather than just turn your attention on and off; only by doing this will you see the opportunities. The moment is out there – be ready to capture it.

Personalities are also important. Learn which players react, and which don't; who is fired up and looking for glory, and who is likely to be controversial; who's at the very peak of their fitness, and who is about to break a record. If you are lucky enough to be photographing athletes at the peak of their career you'll always get something of interest, whether your subject is Rafael Nadal, Jessica Ennis, David Beckham, Lee Pearson, Chris Hoy, Rebecca Adlington or Tom Daley. Doing some homework about your sport will help you make the right decisions when you are photographing, which might lead to a great image instead of an average one.

The Road to London 2012

For competitors the London 2012 Olympic and Paralympic Games will be the culmination of several years of training. In my work I have been lucky enough to record the progress of some very talented British athletes on their journey to the Games. I have captured the highs and lows of Tom Daley (Diving), Shanaze Reade (BMX), Louis Smith (Gymnastics), Giles Scott (Sailing),

▶ This is just one of the many frames I took of Usain Bolt after he won his second gold in Beijing 2008. Usain's arms create leading lines to make this a strong vertical image.

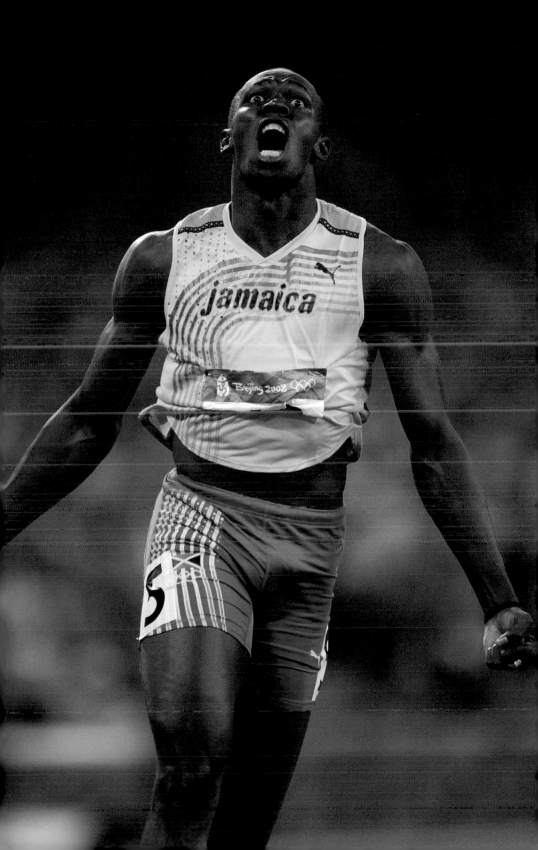

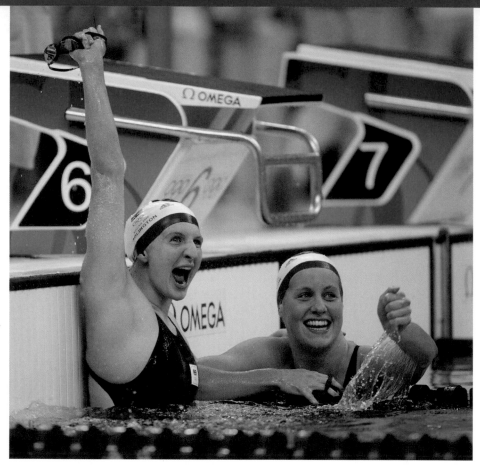

▲ Rebecca Adlington wins gold and Jo Jackson bronze in the 400m Freestyle at Beijing 2008. This low down angle from the scoreboard side of the pool captures the moment perfectly.

J R Badrick (Judo), Rachael Latham (Paralympic Swimming) and Emily Pidgeon (Athletics: middle-distance running).

There have been mixed fortunes along the way. Lewis Smith, for example, has already won an Olympic medal at Beijing 2008, while Shanaze Reade and Tom Daley have become World Champions. Sadly there are always those who do not complete their journey, and both Rachel Latham and J R Badrick have had to pull out due to injury. This is why the Olympic and Paralympic Games are so special to me, and why I so enjoy photographing there. When the winner

crosses the line, breaks the record and receives his or her medal, overwhelmed by the sheer joy and elation at achieving a dream, I like to think that they have pushed their limits not just for themselves, but for all those excellent athletes that tried and did not ultimately succeed.

As a sports photographer you should be prepared for anything. I ended up standing in a muddy field early one spring morning waiting for Louis Smith to perform his routine on the back of the country's largest Shire horse! The idea was to showcase Louis's talent by performing in a unique, visually stunning

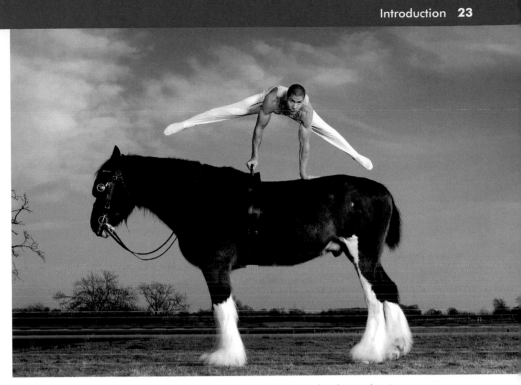

▲ Louis Smith performs a flare manoeuvre on the country's largest shire horse, showing his skills outside the gymnastics arena. The image was lit by four off-camera flashes.

setting. Louis was incredibly brave to do this: not only was it a long way from the ground, but the horse also shifted from hoof to hoof every so often – an unnerving experience. A few months later I was trying to sink a very large Union Jack flag to the bottom of a swimming pool so that Rachael Latham could swim over the top for this colourful image (pp.14–15). The flag kept floating to the surface, but in the end we were able to raise the floor of the pool hydraulically, place the flag on it and then lower it back to the bottom. All in a day's work for a sports photographer.

Whatever your equipment you can now take better digital images. The advance of technology means that everyone has the opportunity to take great sports images, something unimaginable 10 years ago. The field of photography has opened up, and is not just for the professional to capture sports pictures. It's all there for you to create the pictures you want.

There are two main challenges to master in photography – the practical techniques of equipment set-up and the creative visualisation of the finished image. *Capture the Moment* shows you how to improve your skills in both.

Take the time to read this book and to get to know your camera and its capabilities. You will need to put some effort in and practice, developing and building techniques and gaining the confidence to experiment. You can start by using these techniques at amateur levels of sport, building up to the excitement of London 2012 and beyond. Enjoy the chance to capture some unique memories – you'll be amazed at the results.

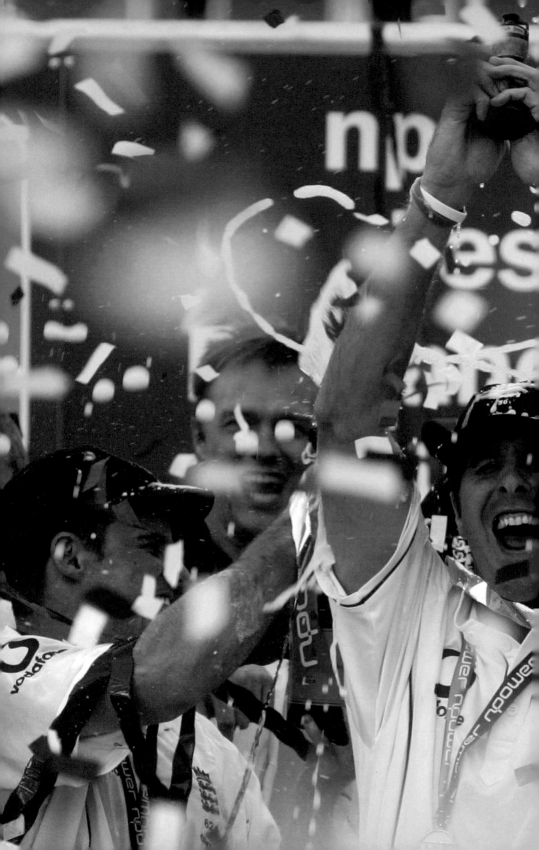

1

Photographing Key Events

I n this chapter we'll be looking at two different types of event, which are photographed in much the same way. Like many of the techniques in this book, the skills described here are flexible and transferable. You can develop and practise them, then adapt them to a wide range of occasions, keeping your eye in and your photographic instincts fresh. The first type includes perhaps the biggest events you'll ever witness – the Opening Ceremonies of the London 2012 Olympic and Paralympic Games. If you are lucky enough to be one of the spectators in the Olympic Stadium, you will want to record these extraordinary global events, watched by one billion people worldwide, in the best possible way you can. The Olympic and Paralympic Torch Relays, although not strictly sporting events, will bring the drama of the Games closer to people across the UK. Those who don't have a ticket to see the sports can still feel part of the London 2012 experience by seizing the chance to photograph the Torch Relay as it passes near you and your family.

The second kind of event is more modest, yet often even more important to those directly involved. Your son or daughter's first swimming gala or running race will remain in your memory longer than elite athletes in their 100m final. So this chapter shows how to apply the sports photography techniques that we discuss in Chapters 2 and 3 at your local leisure centre or school sports day.

Whether you are looking to capture your child's first goal, baby's first steps or teenage success in a gymnastics competition, rowing race, judo, rugby or cricket match, the same skills will be needed. Junior events and competitions pose their own particular challenges, and many are similar to those in elite sport.

Compact Cameras

Compact cameras are ideal for shooting key events. The portability of these great little cameras means that you can capture images while on the go at the Torch Relay, Opening and Closing Ceremonies, Victory Ceremonies and other large sports events.

If you are just starting out or an intermediate photographer keep your camera in your pocket. Set it to sports mode where the high shutter speed will freeze the action and you will be able to take pictures quicker than anyone else. The built-in flash that comes with these cameras is a great advantage when shooting in difficult light. Remember that timing, anticipation and panning are the most important techniques. Most professional photographers carry a compact camera somewhere in their kit bag and the quality of the image sensors in some compacts is first rate. The automatic nature of compacts means they are also ideal for passing around the family to let the children have a try.

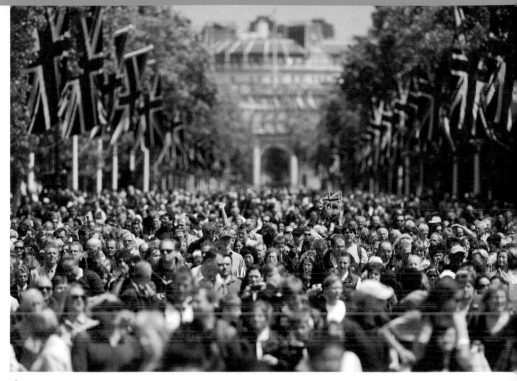

▲ A long telephoto lens has been used here to compress the crowd and shorten the perspective of The Mall in London. A high vantage point is recommended when photographing crowds.

Torch Relays

The Olympic Flame will arrive in the UK from Olympia in Greece on 18 May 2012. It then embarks on a 70-day journey around the UK, coming within an hour's travel of 95 per cent of the population. As many as 8,000 Torchbearers will carry the Flame over the nation's varied landscapes and settings – rural and urban – offering some great opportunities for photography. The Paralympic Torch Relay will also travel around the UK, taking place slightly later in the summer. Both Relays will end in the Olympic Stadium as part of their respective Opening Ceremonies on 27 July and 29 August 2012. With some forward planning and practice of key skills you can confidently take your camera to the Relays and get that once-in-a-lifetime shot.

This chapter covers the use of wide-angle lenses and flash (useful if people can get close to the Torchbearer) as well as alternative strategies and

SPECTATORS' ANGLE

The opportunity for spectators to get great shots is all part of the Torch Relay experience, and professional photographers will have no advantage. Their 'angle' is the same as yours and they will be making the same decisions about positioning as you are. The challenge is to find yourself the best location and stick to it. Remember to consider how light and shadows may change in the time that you are waiting.

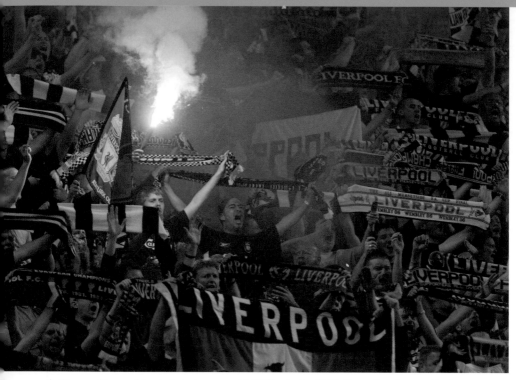

▲ Liverpool fans celebrate their victory over AC Milan in the 2005 Champions League Final. Shot on a 400mm lens from the pitch side.

photo opportunities for those further away. It is intended that the Torch will be carried for 12 hours a day, ending with an evening celebration whatever the weather. This chapter thus includes advice on photographing at night and in poor weather conditions.

Challenges

The main photographic challenge is how to capture the Torchbearer as he or she runs past you at speed. The roads will be lined with people, so you should get there early to choose a good spot. A convoy of vehicles will probably accompany the Torchbearer – it won't just be one person running alone. As when you photograph Road Cycling (p.70), choose your moment when the Torchbearer is visible to you to take your picture.

If the Torch passes you during the evening or you are capturing the evening celebration, then you will have to use your flash. Get as close to the Relay as you can, as your flash will only travel a certain distance – usually 20 or 30 feet. The further away the subject, the stronger the flash burst has to be – the recycling time becomes longer, leading to fewer shots. Don't waste early shots when the Flame is too far away; be patient and wait until it gets up close.

You might have to wait several hours once you've selected your position, so use the time and be prepared. Take time to set your camera up. I recommend using shutter-speed priority or manual exposures, as when the Relay does pass everything happens very quickly.

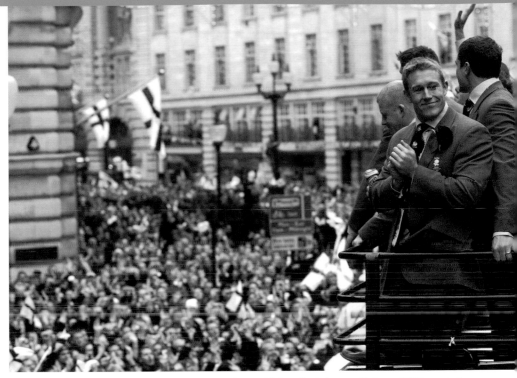

▲ This image was taken after England's 2003 Rugby World Cup Final victory with Jonny Wilkinson in the forefront and the London crowds behind. Always look for a high vantage point for this kind of shot.

Camera Set Up

Follow the pointers below to get the best results from your camera set up.

> **Shutter speed** – needs to be 1/500th of a second, not necessarily to freeze the action but to keep everything in the picture sharp and to avoid camera shake. When using flash use 1/250th of a second if your camera allows.

> **Exposure** – lighting conditions for photographing the Torch Relay will vary as the Torch travels from dawn to dusk. Flash at night will diminish the colour of the Flame, but you'll still need it to illuminate the Torchbearer.

> **Aperture** – mid-range apertures (f/5.6 or f/8) are optimal. As the Torchbearer will be surrounded by people, the depth of field has to be large enough to keep everyone in focus.

> **ISO** –100–200 during the day, moving up to 1000-plus at night.

Positioning

Photographing the Torch Relay procession is similar to photographing the Road Cycling peloton with all its entourage and drama. The Torch will move at a much slower pace, however, giving you time to be more creative.

There are several things to bear in mind when photographing the Torch procession:

> **Look for a focal point.** Every landscape photograph needs a focal point to draw your eye in to the image. Make this the Flame and use the rule of thirds (see p.98).

> **Maximise the depth of field.** In contrast to sports photography use a

small aperture (a large number, for instance f/11). This will create a greater depth of field in your shots and give your pictures a landscape feel.

> **Think about the foregrounds** as these can really improve your Torch Relay image. Use points of visual interest such as fields of flowers or interesting buildings to give your image depth as

TECHNICAL WISH LIST

Your ultimate pro camera kit contains two DSLRs and three lenses:

> 300mm f/4 long telephoto lens, for far-away shots of the Torch Relay procession as it passes through the landscape. This lens is lightweight and easy to carry over long distances

> 1.4x teleconverter to increase the focal length of your 300mm lens to a 420mm f/5.6.

> 70–200mm f/2.8 general-purpose lens gives you a little reach if you need to photograph something in the mid-distance

> 24–70mm f/2.8 wide-angle lens for up-close shots and scenic landscapes

> two flashes for use at night and during the day (spare batteries for your flashguns are a must in your kitbag)

> lightweight camera bag to carry this equipment, as you'll be on the move covering this procession

> waterproof coverings for both photographer and camera gear

> chamois cloth

> laptop and transmission equipment

the procession winds its way through the countryside.

> **Work with the weather**, not against it – the scene can change dramatically, especially in the UK. The Torch is going to all four corners of the country, with the weather along the way likely to range from dramatic to calm. Wait for the right moment to shoot your image, remembering that a sunny day with a blue sky is not necessarily the best day to shoot landscapes. Rain, mist and striking cloud patterns can provide an interesting, atmospheric view.

> **Change your viewpoint.** Generally a high vantage point is good for capturing the Torch Relay; you'll have the line of sight for a longer period, giving you more options. Don't be afraid to change your viewpoint; don't just stand and take a picture. Get down low, lie on the ground, or look up; take a stepladder and shoot from up high looking down.

> **Use the sky.** Many landscape images have a dominant sky. Don't let it overwhelm your shot if it is flat and boring, but award a dramatic, changing sky more space in your image. The Torchbearer doesn't have to fill the frame – he or she just has to be visible.

> **Leading lines.** The challenge is to create a picture of the Torch Relay where the viewer's eye is led towards the Flame. Use lines such as road markings, lampposts, horizon lines or mountains to draw the eye towards the focal point.

> **Vantage point.** If you are trying to take a picture of a specific person with the Torch, choose a high vantage point where you can see the Flame in the distance. You will be able to take pictures on a long

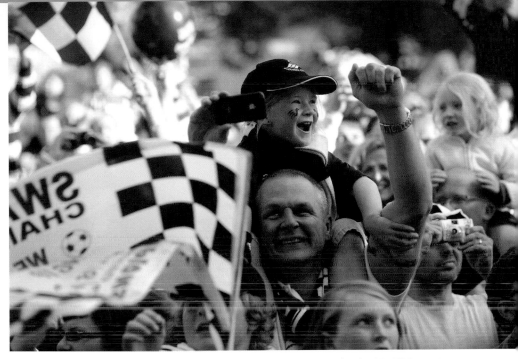

▲ Swansea fans celebrate their team's promotion to the Premier League after the 2010/11 season. Taken from the team coach on a 70mm-200mm lens.

telephoto lens, then switch to a wide-angle lens as the Flame and Bearer get closer.

WINNING SHOT

The winning shot is the ultimate picture of the Torch Relay. It's the picture that the professional photographer has in his mind before he or she goes on the shoot. This shot has to be achievable, but it will only happen if all the variables come together on the day.

This will be a spectacular landscape picture of the Torch Relay procession. It aims less to capture the individual Torchbearer and more to create a landscape image with mood. The procession itself should be really small in the frame, winding its way up a hill in a truly picturesque British scene. Shooting in the evening light at dusk will enable the Flame to stand out in an evocative scene.

TIPS AND IDEAS

> Forward thinking is all. Plan your trip, analyse the route for the best landscape pictures, then wait for the procession to enter your frame.

> A high angle looking down is optimal, unlike sports photography where the low angle works. The high angle gives you a sight line to the procession for a longer time and allows you to shoot more images.

> Watch for people moving in front of you at the last minute. It's an exciting time and spectators can get carried away.

> Keep the horizon straight and use the rule of thirds – position the Torchbearer in either the top or bottom third of your image.

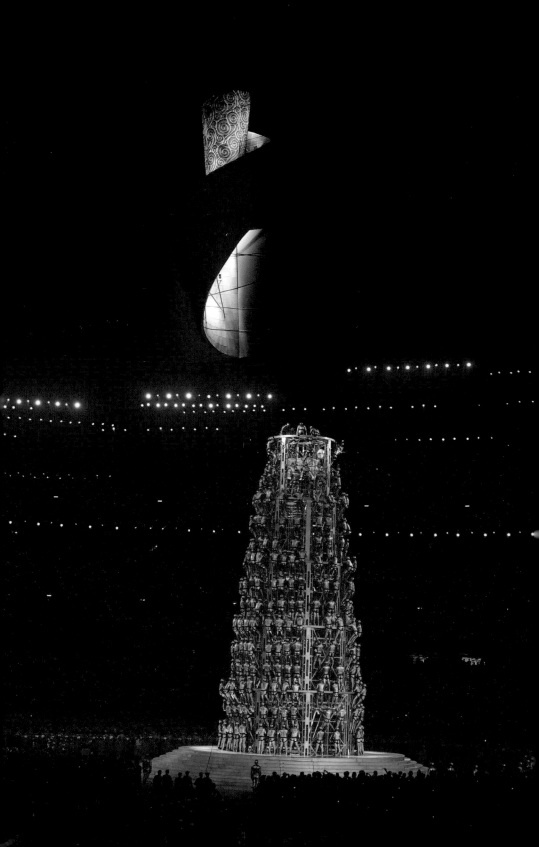

Opening and Closing Ceremonies

The Opening and Closing Ceremonies are high-energy, emotive and full of photo opportunities. Having said that, the conditions can be problematic – mixed lighting, loud music and dramatic movement, not to mention the possibility of fireworks, overload the senses and create challenges to be overcome. Events will also be taking place throughout the centre of London, not just in the Olympic Stadium. With views around the capital looking to be truly spectacular, this section explains how best to capture some remarkable shots.

Challenges

These are music concert conditions, so you'll need experience in dealing with mixed lighting (see p.255) for best results. One memory I always associate with Olympic Games' Opening Ceremonies is all the camera flashes going off round the stadium from the spectators' seating areas during important parts of the display. All these flashes add to the occasion and are an incredible sight. There must be literally thousands upon thousands – but absolutely none of them are necessary! The flash from your camera will only work for a short distance and will not illuminate anything as far away as the track or stadium. Also your camera will produce an underexposed or dark image as it's trying to illuminate the subject with this flash. So turn your flash

off, keep your camera still and use a long exposure instead.

Light intensities can swiftly change, resulting in massive sudden changes in exposure. Also picking out or recognising individuals in the march as the teams parade around the stadium is difficult; every competing nation is represented, and towards the end, many teams will be standing in the centre of the stadium.

Staying focused for the programme, which may last four hours or more, and recognising the key elements of the show can be difficult at the time. You have to think on your feet, as the Opening Ceremonies are usually closely guarded secrets with the lighting of the Olympic and Paralympic Flames the pinnacle of the show. These can be unforgettable moments – at the Sydney 2000 Olympic Games an archer sent the Flame across the stadium to light the cauldron, while in the Beijing 2008 Olympic Games the champion gymnast Li Ning was suspended by wires and appeared to run horizontally along the stadium walls to light the Flame which had appeared

◀ The human mountain in the Opening Ceremony at Beijing 2008. The scene was shot over four hours at 1/320th of a second at f/2.8 on ISO 2500.

▲ This image is of Li Ning racing around Bird's Nest Stadium to light the Olympic Flame and open the Beijing 2008 Games. Captured with a 400mm lens, 1/640th of a second f/2.8 ISO 2000.

during the run. A colossal Torch situated at the top of the stadium towered over the proceedings (p.32). No one yet knows what's in store for London 2012, but the Opening Ceremonies will be very special moments to capture.

Camera Set Up

Follow the pointers below to get the best results from your camera set up.

> **Shutter speed** – long shutter speeds are inevitable to record the general views of the Olympic Stadium or London with the fireworks. Use the bulb setting and start off with a one- or two-second shutter speed, then increase it after looking at the camera's LCD display. Don't use too long a shutter speed as this will pick up light from street lights, windows, etc. For pictures of the Ceremony and dancing you will need a higher shutter speed – try 1/250th, or even shorter if you can.

> **Exposure** – use manual exposures. Bulb is best for fireworks and manual

for intriguing details, teams walking into the stadium and the displays. Remember to keep the camera very still while using these long shutter speeds. You are not allowed to take tripods into the official venues, but a beanbag or mini-tripod will help with this. Tripods are recommended when photographing outside the official venues to steady the camera.

> **Aperture** – when photographing fireworks start off with a mid-range aperture of f/5.6 or f/8. Then after checking on the back of the camera, adjust down (f/11 or f/16) if the image is too bright, or up (f/4 or f/2.8) if the exposure is too dark.

> **ISO** – you will need to use a high ISO (1600 and above) for the Opening Ceremonies to enable you to get a shutter speed and aperture to freeze the display. For the fireworks at the end of the display start off with an ISO of 400 for better quality. Then if you can check on the back of the screen, you might need to increase your ISO.

▲ During the Beijing Opening Ceremony the light was constantly changing. Using my 14–24mm lens I captured this scene with all competing nations in the centre of the track. The exposure for this image was 1/400th of a second f/2.8 ISO 2000.

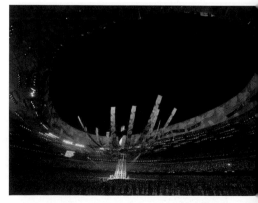

▲ This is the same scene taken a few minutes later where the light has changed dramatically. I used the cameras auto white balance. The camera's exposure is exactly the same as before but the colour balance has changed to a warmer tone.

Positioning

The professional photographers' positions inside the stadium for the Opening and Closing Ceremonies are with the spectators in the general seating area. These tickets are usually allocated, so there is not an option of where we sit. In previous ceremonies, for example, I have been in the top rows at the back and the bottom sections at ground level. The higher angle is better, but it really doesn't matter where you sit as the action will be all around you. The teams will walk in from one of the main entrances and then walk a lap of the 400m track, enabling everyone to get a view of their own country's team as they walk round. Then when the display begins it can take up the whole of the infield of the track.

If I were able to choose any position it would be at the front of the top tier, about halfway down the section of the 400m track that is used for the 100m sprint. This is often a point where official duties take place. The high angle is optimal for using a wide-angle lens to capture the whole view of the Stadium, and obviously any fireworks will be above the structure itself. This spot also allows you to see the patterns and symmetry of the display taking place below you.

At the 2008 Games in Beijing the whole of the infield was covered by thousands and thousands of dancers, all performing in synchronisation to produce fantastic images (p.32). However, this is not a position that many photographers can take up, amateur or professional, so you need to concentrate on getting the best from the spot you do have (see Spectator's Angle sidebar). It's difficult to predict the key moments in the Ceremony, so stay alert and try not to be over-focused on one area of the arena – you'll miss something important happening somewhere else.

If you have a ticket in the lower section you have the advantage of being much closer to the action, able to zoom in on individuals and details. However, it's less easy to see the whole picture from here.

Positioning outside the Stadium is really up to the individual photographer. The section on iconic pictures in Chapter 4 shows where to stand London's best views. If you are trying to photograph the fireworks display, which will probably light up the whole of the capital, remember that a high vantage point works best. Remember that Greenwich Park, Primrose Hill, Parliament Hill, Wimbledon and other good locations will also be very busy with spectators – which can make a fascinating picture in itself.

If you want to photograph the Stadium itself, perhaps with a firework display above, you should find a location approximately half a mile away with as much height as possible and a clean view of the Stadium. Set your tripod up using the camera set up described above and wait for the display.

SPECTATORS' ANGLE

The great thing about the Opening and Closing Ceremonies is that the spectators and professional photographers have just the same view. Your angle is exactly the same as the professionals', and you will be able to see all the unfolding action just as well. Make the most of it.

Key Technique
Photographing Fireworks

Photographing fireworks should be straightforward and produce spectacular results. It's become easier with digital cameras to review the images and alter the most difficult part of this technique – getting the exposure correct.

SIX STEPS TO PHOTOGRAPHING FIREWORKS

1 Use a tripod – a must for photographing fireworks. You have to secure your camera and keep it steady for at least a few seconds, ensuring that it doesn't move during the exposure. The long exposure you will be using not only captures the movement of the fireworks, but also any movement that the camera itself may make. This will be noticeable in the blurring of the Stadium, for instance.

Unfortunately you are not allowed to take tripods inside the London 2012 venues. Instead take with you a mini-tripod, GorillaPod or beanbag to keep your camera steady, or place it on something flat and use a self-timer. You can even keep the camera on your knees if you are sitting down; try to hold it steady and keep as still as possible.

2 Consider remote release – there are a variety of remote releases on the market, and some manufacturers include them when you buy your camera. I think one of the major causes of camera movement when using long shutter speeds is the initial pushing of the shutter release with your finger. If you don't have a remote release another option is to use the camera's self-timer. You'll need to take into consideration the delay when you press the shutter button as the camera counts down.

3 Frame your shot – remember to leave enough space in the sky for the fireworks without cutting any out. (You will probably have the Stadium or skyline in the bottom of your shot.) The height of the fireworks can be difficult to predict, as you cannot prepare for them in advance, but keep the horizon level. The horizontal format is usually best if you want to have the whole stadium in the shot, otherwise vertical can work well.

4 Shoot in manual mode – fireworks are too difficult to shoot in automatic exposure, so use manual mode instead

TIPS AND IDEAS

> Use a remote release to ensure the camera stays still. Trying to trigger the camera by hand usually results in moving the camera, even if only slightly. If you don't have a remote release use the camera's self-timer, but be aware that you have less control to anticipate shots.

> Shoot in manual mode as the camera's exposure meter can be fooled by the changing light.

> Experiment and track results, periodically checking the camera's LCD display for exposure problems. Remember to consider silhouettes (p.79), wider perspectives and people around you watching the displays as possible subjects.

> Switch off your flash. It will have no impact on your pictures as your camera flash only reaches a few metres.

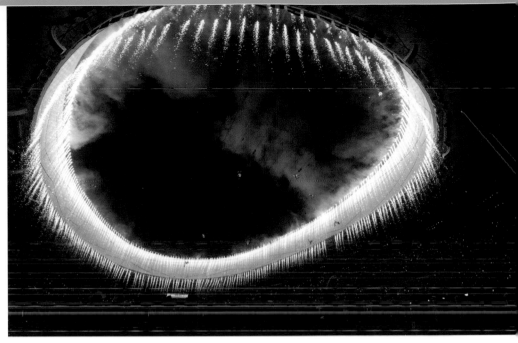

▲ The Beijing 2008 fireworks finale to the Opening Ceremony. I used a slow shutter speed (1/30th of a second) and a strong platform to keep my camera steady. This picture is part of a sequence from page 34.

and set the bulb setting on your camera. This is the feature that enables you to control the opening and closing of the shutter yourself. You will have to count the seconds in your head during the exposure. A useful tip here is to pre-focus on infinity, as the fireworks are impossible to autofocus.

5 Exposures – getting the correct shutter speed is more important than aperture here. Hit the shutter as the fireworks are about to explode and hold the shutter open in bulb mode for several seconds. Don't keep the shutter open for too long as you'll pick up too much ambient light from windows and street lights. The light from fireworks is very bright allowing you to use mid-range apertures of f/5.6, f/11 or f/16. You should select a mid-range ISO of 400 for the best results, and work up if the images are too dark.

6 Experiment – the perfect opportunity to be creative. Try multiple exposures to add more effects to your pictures. Zoom bursts may be effective (p.114). Don't forget to photograph what's around you, and experiment with different perspectives.

WINNING SHOT

The winning shot has to involve the crescendo of the fireworks display at the end of the Ceremony. Add to this all the teams lined up symmetrically in the centre of the Stadium and you have the components for a really gripping shot. I will have several remote cameras set up to capture this image from different locations around the stadium. It can look just as good from outside too, especially if you can reflect the fireworks in the many waterways that surround the Olympic Stadium.

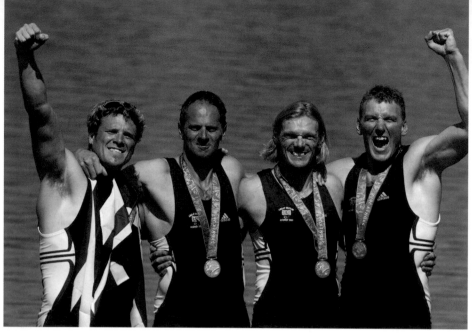

▲ The best reaction pictures are always taken in the seconds that follow victory. Here the joy is shown on the faces of victorious Coxless Four crew, James Cracknell, Steve Redgrave, Tim Foster and Matthew Pinsent as they proudly show off their gold medals in the Sydney 2000 Games.

Medal or Trophy Presentations

Trophy presentations to winners are a regular occurrence at every sporting event, and over the years I must have photographed thousands of them. They are often poorly organised and chaotic. Some, known as 'bun fights', even end up with the photographers running round the pitch surrounding the athlete with the trophy. Casualties among the photographers often follow.

Medal presentations at the Olympic and Paralympic Games are an altogether more orderly affair. Athletes are awarded medals and honoured for their achievements in Victory Ceremonies across the Olympic venues. These are highly charged occasions, and if you are lucky enough to witness the award

of a bronze, silver or a spectacular gold medal you want the best image you can possibly get.

The techniques described below – anticipation, composition, lighting and capturing emotion – can be easily transferred to photographing at a local level. As you hone your skills with practice you'll produce better and more dynamic pictures of your favourite team or children celebrating their cherished medals.

Challenges

Victory Ceremonies at the Olympic and Paralympic Games can be difficult to photograph. Some may be held the day after the event, so always refer to your programme for the running order of a specific sport. Podiums are not always accessible, for example the Cycling podium is inside the track in the

▲ This image is interesting because each girl has a double outline from the girl standing behind her. Always look out for unusual and creative images during medal presentations, it's not always the medal winners that make the pictures.

Velodrome. At the Olympic Stadium the Victory Ceremonies should be halfway down the section of track used for the 100m, just infield. In the Aquatics Centre the podium will be at one end of the pool. If you are seated near the podiums you will have a good view, but if not it is difficult to photograph these Ceremonies up close. Instead you can photograph the image on the giant screen with spectators around it – a powerful way to mark the moment and show that you were there. Victory Ceremonies, or other sporting presentations, are extremely emotional occasions for the winners, many of whom are reduced to tears. Focus on the faces of the competitors to capture the drama of the moment.

The main challenge in photographing teams at less structured trophy presentations is simply coping with the excitement – the euphoric team members are more concerned with celebrating than having their photograph taken. While this is quite understandable it makes it difficult to catch everyone's attention and get everyone looking at the camera. In these situations you have to take charge.

SPECTATORS' ANGLE
Each venue at London 2012 will have its own area for Victory Ceremonies, usually visible throughout the event. Once you have established where the Ceremony takes place you can gauge the best position – although remember not all Ceremonies occur directly after the final. Note the athletes wave to everyone in the venue after the Ceremony so even if you are positioned behind the podium and seem to be at a disadvantage, just be patient.

Be strong, make yourself heard, shout out a countdown: 'I'm going to take a picture on the count of three, two, one...' Photographers use various techniques for this. Getting everyone to laugh is a bonus, but keeping everyone's attention is a must.

Camera Set Up

Follow the pointers below to get the best results from your camera set up.

> **Shutter speed** – 1/250th of a second and above. You are not trying to freeze the action, but just to avoid camera shake or movement.

> **Exposure** – mixed lighting conditions are usually found at Victory Ceremonies or trophy presentations (see p.38). They often take place in the evening and at the end of the sporting event when the light may be at its worst, so allow for high ISOs.

> **Aperture** – mid-range apertures (f/5.6 or f/8) are optimal. You are not trying to throw the background out of focus, but to keep detail in the athletes' faces.

> **ISO** – keep ISO as low as possible during the day, but for evening Ceremonies use 1000 and above.

Positioning

At the London 2012 Victory Ceremonies, as with any Olympic and Paralympic Games, the three medals will be presented in reverse order. After the presentation the winner's national anthem is played – usually the most emotional part of the ceremony, where athletes are often overcome with emotion after winning a medal. Athletes often turn to face their national flags as they are raised during the anthem, so if you are looking for a good facial shot be aware that they may well face to the side. Once the national anthem has finished the athletes wave to the spectators all around the stadium, giving everyone the chance to get a good picture. Professional photographers are placed to look straight at the winners' podium. After the Victory Ceremony the athletes often walk back towards the spectators and may pause to have their photograph taken. Be ready with a wider lens for these spontaneous moments. I always look round to see if I can spot any of the athlete's family or coaches in the crowd, and if so position myself below them – I know the athlete will wave to them and come over afterwards.

The trophy presentation for most non-Olympic events also happens in a pre-designated area. If you are allowed to move, get as close to this as you can. They are usually in a place visible

TECHNICAL WISH LIST

Your pro photographer's ultimate trophy-presentation camera kit is two DSLRs and three lenses:

> 300 or 400mm f/2.8 telephoto lens for close-ups of the winners' faces and capturing the emotion of the occasion

> 70–200mm f/2.8 mid-range 'just in case' lens

> 24–70mm wide-angle for shots of the athletes with spectators and run-around pictures

> two flashguns

> monopod

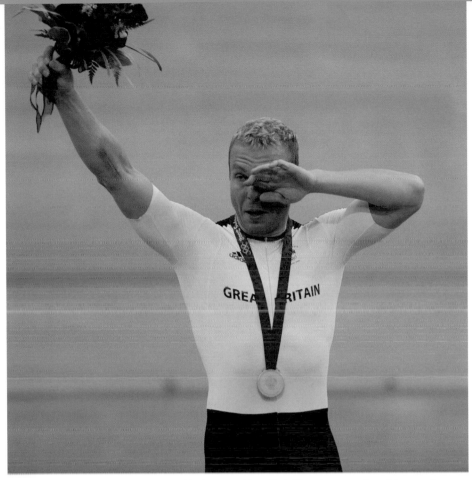

▲ Victory Ceremonies can be emotional high points. Here Chris Hoy wipes tears from his eyes after being presented with the gold medal for his sprint victory. I used a 300mm lens and shutter speed priority with 1/400th of a second at f2.8 with ISO 640 to capture this emotional image.

to as many people as possible. When photographing trophy presentation at a more local level, don't be afraid to walk to the front. Always stand as close as possible without obscuring other people's views. How often have you seen a good shot ruined by someone's hand or head in the way?

Positioning at other sporting events is really an art form, in which the more experience you have the better. At football matches, for example, where the trophy presentation is a long way away and a

WINNING SHOT

I would be looking here to take a close-up picture of an athlete's face, which captures the overwhelming emotion as the winner receives the gold medal. After four years of hard training, this is the point when victory sinks in. Emotions run high as the national anthem is played and the official flag is raised, and a close-up shot is required. Athletes are usually incredibly single-minded and focused, so to see them overcome is a rare sight.

whole team is involved, it's vital to be with the winning team's supporters at their end of the pitch. The captain who lifts the trophy will always show it to his supporters first.

I would say the best place for a photographer is to be the closest, and most importantly – if in a large group of photographers – bang in the middle. Because all the photographers will be shouting out 'over here, over here', always try to stay in the centre. Here you will get the best eye contact with the subject.

Remember to keep an eye on the background, which should be clean and uncluttered: nobody wants a brick wall or school sign in shot. When photographing teams and presentations with multiple athletes, shoot as many pictures as you

can – somebody will always be looking the wrong way or have their eyes closed. If you shoot a sequence you can edit them to find the best frame later.

After the trophy presentation sporting events often feature a 'run around' where the winning team spontaneously runs round the pitch with the trophy. This is usually chaotic and unregulated. My only advice on these occasions is to get as close as possible, but to be mindful of your fellow photographers. Everyone should be able to get their shot, not just the photographer with the widest lens and sharpest elbows!

Sports Days and Swimming Galas

The responsibilities of a parent, relative or friend photographing a school sports day or swimming gala are on a par with a professional photographer covering an Olympic or Paralympic final. Miss it and you're in trouble, because history doesn't repeat itself.

The photographs illustrating this book, which I have been privileged to take, are not more important than those of my daughter's first ballet grade, or any of my sons first goals or egg-and-spoon races. I know which I would choose to save in a fire.

Challenges

The first challenge is checking that photography is allowed at your child's school. Most have now relaxed this rule and allow parents to photograph at school events, but some do not. If you

TIPS AND IDEAS

> Position yourself near the medal winner's family if you know where they are seated, as he or she will invariably look towards them after receiving the trophy or medal.
> Always get teams to stand or sit as close to each other as possible. Pack people together and avoid strung-out lines.
> Avoid people sitting in front of you as you take your shot. A spontaneous jump up to celebrate with the winners can ruin your shot.
> Watch out for the champagne spray: footballers especially love to cover photographers in champagne.
> Use flash, especially on a sunny day to lighten up the shadows.

▲ This picture tells the story of a typical school sports day. The leading boy looks back to see his friends trailing behind him; his face says it all. Always focus on faces and concentrate on points of interest.

turn up with large lenses and masses of equipment you can stand out – people may be suspicious or even ask you if you have permission. Be sensitive, as people may have very good reasons for not wanting their child to be photographed. Concentrate on your own child, but don't be surprised if you are asked to take some pictures for other parents or even the school website. Never assume this will happen though!

Children, as we know, are more unpredictable than anything else. There is a mantra of 'expect the unexpected' in sport, but at school sports days the unexpected is the norm. School sports days cannot be beaten as photographic subjects, leading to a great variety of pictures. Children wear their emotions freely, and even excited parents can often make great subjects.

Sports days often occur in the middle of the afternoon on bright sunny days – not easy for a photographer as the light is at its harshest. Shoot with the sun either over your shoulder or backlit against a dark background (trees, walls and buildings) if you can.

Backgrounds tend to be a lot more

SPECTATORS' ANGLE
At sports day all positions are spectators' angles – there is no advantage or special treatment for the professional sports photographer. See Chapters 2 and 3 for advice on individual sports positioning. Swimming galas are similar to sports days, though spectators may be limited to the seating areas. With some charm and tact you'll very likely be able to get a closer view.

untidy as people and pushchairs walk behind the action. Don't disregard this – it will help to improve your pictures if you are able to keep the background uncluttered and clean.

For swimming galas you will always have to request permission. You will usually be asked to complete an application form for permission to take stills or shoot video. This form usually requires your address and contact details, and you may be asked to provide a passport or photo ID.

Take care at swimming galas not to hinder judges or volunteers when trying to get your shot. This environment is not an easy one to work in, combining slippery floors with high humidity. The last thing you want to do is drop your expensive camera gear in the water. Stay alert.

Camera Set Up

> **Shutter speed** – use in manual or shutter-speed priority mode and stick to 1/640th of a second to freeze the action. You can go higher, especially if it's a bright sunny day. For indoor swimming galas see Indoor Water Sports (p.184).

> **Exposure** – sports days are usually held outdoors in the summer, so the light should be good. Exposure should not be your main problem, but avoid harsh shadows if you can.

> **Aperture** – mid-range apertures of f/5.6 or f/8 are optimal. They will enable you to keep most things sharp without distracting your eye.

> **ISO** – 100–200 under sunny conditions and 400 when it is cloudy.

Positioning

For positioning, see the discussions of individual sports in Chapters 2 and 3. Bear in mind that the school sports field is a very busy place and usually a lot more confined than an Olympic stadium. The key area for athletics events is the finish line, and it should provide you with your best pictures. Here is the spot where all the drama happens, from the egg-and-spoon race to the fathers' race. I would recommend standing in front of the finishing line and as close as your lens will let you (say, 6 metres), without getting in the way of the children as they finish. An important point is to shoot from a low angle at the same eye level as the subject,

TECHNICAL WISH LIST

Your ultimate professional camera kit for school sports day contains two DSLRs and three lenses:

> 300 or 400mm f/2.8 telephoto lens for action shots of the swimming galas. For school sports days a 300mm lens is ideal, a 400mm is too long

> 70–200mm f/2.8 is the optimal lens for school sports days. Use at the 200mm end for action shots of the children running, then zoom out to 70mm for the finish line and reaction pictures

> 24–70mm f/2.8 wide-angle lens for candid pictures telling the story of the day

> lens hood to shield the front element from the sun

> monopod for telephoto lens

> chamois leather to clear condensation from the lens at the swimming gala

so that the faces become the main focus.

Concentrate your autofocus point on your child, then zoom out enough to show the other children either side. The trick is to place your child in the picture in relation to the different positions of all the others. There may be gaps where children are in front or behind, but follow focus on your child, win or lose. Don't stop shooting as the children cross the line – reaction shots are just as important.

As with the Olympic and Paralympic Games, you'll have to arrive early to get a good position. All parents want a place near the front, but unlike professional photographers who ruthlessly guard their position at elite events, be considerate. Everyone should have the chance to take pictures of their own children.

The best positions at swimming galas are on the pool deck, looking straight in to the competitors' faces as they breathe. For a different, creative approach, shoot from above at the top of the spectators' stands.

Normally I would recommend filling the frame and shooting as close up as possible. But at school sports days I think that you need to shoot a little looser. By this I mean to zoom out just a little. Don't fill the frame top to bottom with your child, but allow some of the surrounding scene to be captured as well. It's good to see where the race was won, with perhaps some parents cheering in the background to enhance the drama. No one wants to see a beautifully athletic picture of their son or daughter winning a race in isolation. With no context, no one else in the shot, the picture could have been taken anywhere.

TIPS AND IDEAS

> If you are not the parent or carer of the child or children, ensure you introduce yourself and ask permission to photograph.

> If your camera has a sports mode set it to this. It will set your shutter speed and aperture, improving the image.

> Wait for the defining moment such as the goal, race finish, overwhelming cheer, or 'oops!' moment when it all goes wrong.

> Anticipate emotion – excitement, intensity, dejection on the faces of children and parents – and keep alert for this at all times.

> Get as near to the sidelines as you can for the best view.

WINNING SHOT

A classic finish-line image of the running race is a clear winning shot for the school sports day. Shoot this image head on, leaving room for the children as they cross the line. These pictures should have everything in them – the concentrated drama of the day, focusing on the instant that the tape breaks and the race is won. You could also include, if you shoot wide enough, parents and friends cheering on the sidelines. Take a sequence with your motor drive on high, as you don't want to miss anything. Then choose the best frame later when you edit.

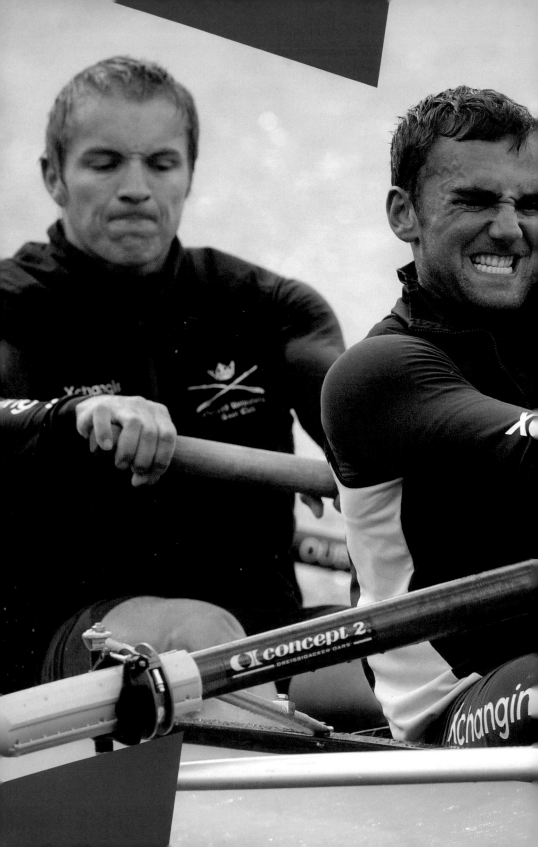

2

Outdoor Sports

Introduction

Sport is the number one leisure activity in the world and a big part of many people's lives. No matter which sport you're interested in photographing, there will be ample opportunity for you to hone your skill. Whether you're kicking a football, swinging a racket or holding the camera, practice makes perfect.

This chapter covers how all outdoor sports are photographed by the experts, and explains the techniques that you can also use. It includes all outdoor sports featured at the Olympic Games, as well as golf, cricket, surfing and waterskiing. Sports featured at the Paralympic Games are often photographed with similar techniques, and any differences are highlighted.

Whether you're taking snaps on your point-and-shoot camera in your back garden or at Premier League football matches, I will explain how you capture the peak-of-the-action moments. This chapter explains the particular difficulties in photographing individual sports, which every aspiring photographer needs to overcome. Such challenges include lighting, the landscape, weather, distance from subject, speed of play, covering a large field of play and more, but I also present tips and shortcuts to help with these as well as the techniques that control them. You will learn how to set up

your camera to manage the 'exposure triangle' of shutter speeds, apertures and ISO, so you know what depth of field works best in each sport. Key techniques, including the use of light, following the ball (or not), timing and anticipation, flash photography, panoramics and telling the story are clearly explained, and ideas for professional 'winning shots' are suggested. Of course you will have plenty more of your own!

Where you sit plays a crucial part in how you can photograph outdoor events. Elite-level sport can be very restrictive to the photographer, with etiquettes to observe and rules restricting your mobility at the event. At the London 2012 Olympic and Paralympic Games, for example, the seating areas are well defined and often rigid. There is still plenty of scope to take good pictures, however, and I explain what you can achieve from these seats in the sidebar, Spectator's Angle. Events such as Road Cycling and the Marathon offer more flexibility and more opportunities to create new images. Here I give possible suggestions as to the best places along the route.

At lower-level sporting events, or those involving children, photographers often have much more choice about where they can go. So, drawing upon 30 years' experience, I advise on the best places to sit for each individual sport,

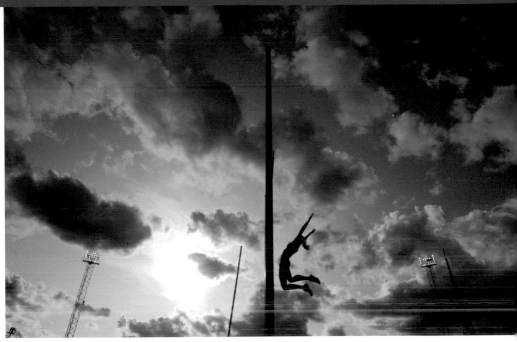

▲ A female pole-vaulter is silhouetted against the evening sky over Crystal Palace during a summer athletics meeting. The camera was set on shutter-speed priority, at 1/2000th of a second at f/13 on a 24mm lens at an ISO of 500. The intention was to expose for the sky and not the athlete.

and illustrate some of the results. The same positioning preferences will apply at every level of the sport, though it will be restricted to professionals (and usually a limited number of them) at high-profile elite events.

Equipment does not create great pictures on its own, but it certainly helps. For those with unlimited budgets or just keen to dream, I have included a 'technical wish list' of camera equipment – the ideal choice for each individual sport. For photographers in the real world who don't have such high-end equipment, I explain how to get the very best results with less sophisticated kit. Remember, technique is just as important – knowing what to do in a particular situation, and doing it, will hugely improve your sporting shots.

Compact Cameras

Most spectators use compact cameras at major events, such as the London 2012 Olympic Games and Paralympic Games, and all the techniques, positioning, challenges, tips and ideas I give can be applied or used with them. It is true that these very popular cameras are more challenging to use for sports photography due to the shutter lag (see Timing and Anticipation p.93). But you still can take great pictures with a compact camera. You just need to concentrate more.

The camera set up sections really apply to DSLR owners. However, the one great advantage with compact cameras is the automatic modes, especially the sports mode. For a less experienced photographer, this does the hard work for you. As you progress you can use this section to improve your photography.

2.1 Athletics

Athletics is the embodiment of the Olympic motto *Citius, Altius, Fortius*, which means faster, higher, stronger. It encompasses 24 track events, 16 field, five road and two combined events, and a majority of these have heats as well. The demands placed on the photographer to cover these 47 events are huge. Focus is key: keep the images you want to capture in your mind's eye and plan your day around that. Of all the different sports, Athletics really needs good advance planning. If you are attending the Olympic Games and Paralympic Games, for example, you can construct your shooting list from the schedule now.

Athletics events in the Olympic Stadium produce some of the best, most iconic pictures of each Olympic and Paralympic Games; other competitions also offer good opportunities to practise your skills. Athletics is a high-pressure arena with events going on all the time and at the same time. All photographers have to be on the top of their game and to remain focused – remember that a Javelin or Discus event may be in progress in between the running events.

At elite events, the majority of professional photographers' positions are on the perimeter of the track – both head-on to the 100m finish and in the moat that goes around the track. However, a lucky few get to go infield on the grass at the centre of the track. Photographing within the track can be very dangerous, particularly when the Javelin and Hammer throwing are in progress. Nonetheless professionals consider infield photography – although arguably not producing the best action pictures – to be a great privilege.

How to Photograph Athletics

Once your plans are in place the demands for each discipline are similar. Whether you are photographing the marathon, high jump or shot put you'll need to think of the picture you want to take, find the best position to take it, use your chosen technique and capture your image. This knowledge can be applied at the Olympic Stadium, the Marathon course, athletics meetings, county championships and school sports days. Experiment with the following techniques, tips and ideas to get the best results from the 47 events.

▶ Phillips Idowu is frozen in mid air as he performs in the Triple Jump at Beijing 2008. I like the way Phillips stands out from a very neutral background as he makes the jump look so easy. I used a 300mm lens and a low angle to shoot up into his face to enhance the image.

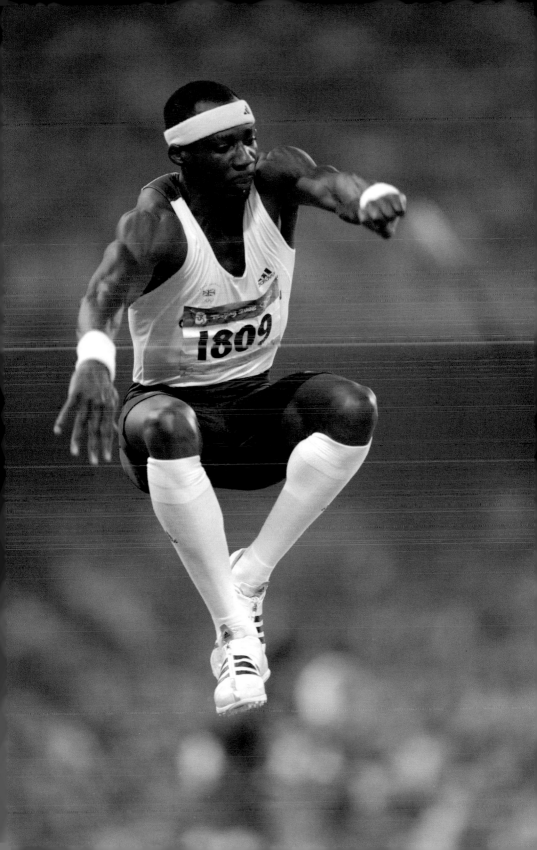

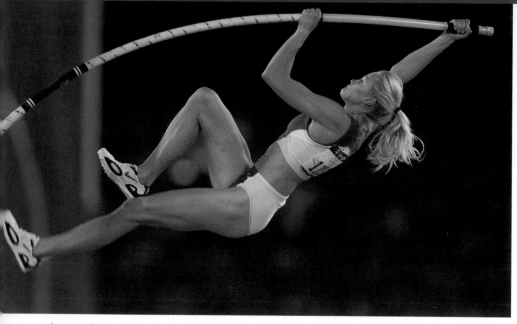

▲ Here Tatiana Grigorieva is competing in the Pole Vault at the Sydney 2000 Olympic Games. I captured this image just as she slowed using the bend in the pole to catapult her over the bar. The pole is bent to its maximum creating a beautiful image. A 400mm lens was used to get close to the action.

Challenges

Athletics is all about movement, speed, ability and competition, and you're trying to show all these in a single photograph. The speed of the athletes is the main problem, and you respond to this by learning how to freeze the action (p.188).

Outdoor lighting can be a problem; even in an enclosed stadium the sun can be with you or against you, so shoot with the light or backlit. I particularly like shooting backlit with the sun on the subject – stadium stands are usually dark and in shadow giving clean backgrounds. You also have to contend with multiple events taking place at the same time. One event comes very quickly after another, with minimal time in between to edit or download your work. Professional photographers' positions are always cramped and moving around is difficult. People are everywhere: marshals, timers, television crews and minders carrying athletes' clothes. Everyone wants to be at the finish line, and as the best position is directly head-on to lane four and five this obviously only works for a few photographers. The rest have to position themselves at the sides.

Covering the Marathon course and the road events sets the challenge of physically covering such a large distance (26 miles, 385 yards through the streets of London) although the photographic techniques you use are the same. Combined events pose the same challenges as individual ones, but are spread over two days. The challenges of photographing at school sports days and in public areas are discussed in Chapter 1.

Remember to think about the background when photographing jumping events, such as Long Jump or High Jump. You want as little distraction

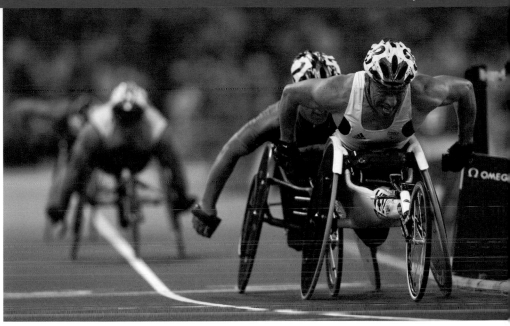

▲ Dave Weir leads competitors around the track during the men's 1500m Athletics event at the Beijing 2008 Paralympic Games. I use a low angle when photographing wheelchair events to look up into the competitors face and always focus on the athlete in front.

SPECTATORS' ANGLE

Here are some ideas for photographing Athletics at seating levels in the London 2012 Games.

Ground-level seats have a great vantage point as you're close to the action, especially Long Jump, Triple Jump, Javelin, High Jump and Track. This is a good spot for all cameras, especially compact cameras and camera phones; remember to turn the flash off. Keep panning techniques in mind for photographing the action (see Track Cycling, p.149).

As well as photographing the action don't forget to zoom in for some intriguing detailed shots of athletes – watch for customised shoes, painted nails, hair braiding or tattoos. Think pan-and-blurs with slow shutter speeds to give a sense of movement and speed. Look out for athletes warming up and cooling down before and after their events.

The higher angle of upper-level seating gives you a better overview of all the action. You might be further away, but you get to see the whole picture. DSLRs, with their slightly longer lenses, will come into their own here; if you have a compact camera or camera phone use your zoom to get closer to the action. When supporting your camera remember to keep your hand steady; camera shake is often a problem when using zooms at their maximum focal length. At this distance look for symmetry in the lines on the track and capture a group of runners rather than focusing on one individual.

Interesting images are often captured at the Hurdles, Steeplechase, Sprint Relays, athletes' celebrations and Victory Ceremonies.

as possible. Out-of-focus spectators are preferable to something too sharp. If photographing at your local athletics meeting dark trees or sky make an excellent neutral background, but avoid anything that is too cluttered or colourful as this will distract the eye.

Throwing events have to be among the most hazardous and dangerous at the Olympics Games; professional photographers have been known to be speared by the javelin after not paying attention. As soon as you walk out to the middle of the track the hair stands up on the back of your neck, and you have to be constantly vigilant to avoid accidents or injuries.

When photographing Paralympic athletes, especially competitors in

TECHNICAL WISH LIST
Your ultimate pro camera kit is two motor-driven DSLR cameras and three lenses:
> 400mm f/2.8 long telephoto lens for peak-of-the-action sports pictures, finishing line, high jump and pole vault
> 70–200mm f/2.8 lens for side-on finish shots, pan pictures, long jump
> 24–70mm f/2.8 wide-angle lens for creative shots, low-down angles, infield celebrations
> remote camera with wide-angle lens – positioned next to the water jump for the steeplechase, head-on for the sprint finishes, or to give a different angle
> monopod

wheelchairs, the challenge is to freeze the action but not the wheels to keep the appearance of movement. A low angle works best in order to shoot up into the competitors' faces. Bear in mind that during the running events visually impaired competitors have a guide running with them, so shoot a little looser (leave space around the subject) in order to fit them all into the frame.

Camera Set Up
Follow the pointers below to get the best results from your camera set up.
> **Exposure** – during the day, work with the light. Athletics heats are usually early morning so shoot with the sun or backlit to make the background go dark. Expose manually for shutter-speed priority. For the evening finals you might need to set the camera up for mixed lighting (see p.255). You will be working under floodlit conditions, so use high ISOs.
> **Shutter Speed** – use the sports photographer's 1/640th of a second or more to freeze the action. Athletics is fast but not super-fast, so 1/640th up to 1/1000th of a second will freeze all the action.
> **Aperture** – needs to be wide open to throw the backgrounds out of focus in the mornings and collect as much as possible under floodlights in the evenings.
> **ISO** – 100–400 in the mornings and 1000 and above for floodlit evening sessions.

Tell the Story
Athletics is an exciting sport to photograph and you can easily get caught up in the atmosphere. Pace

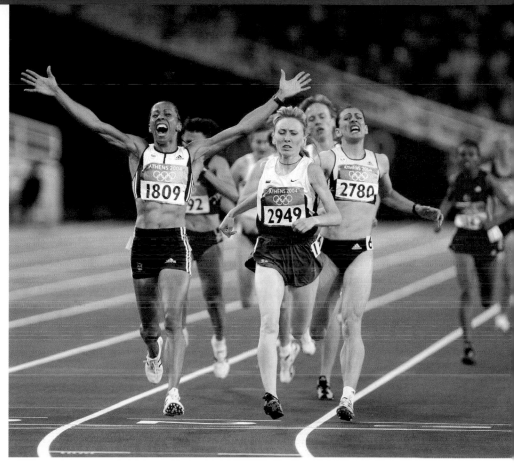

▲ Kelly Holmes celebrates her victory in the women's 800m in Athens 2004. Despite Holmes being the focal point, her celebration is in contrast with the faces of the other competitors. This head-on position really works for big reaction nights at athletics meetings. I used a 400mm lens to fill the frame.

yourself and learn to tell the story rather than always going for the obvious action shots. When you look back at your photographs in six months' time you want to see more than just a great action shot to remember your experience.

Break the day down to tell the story of how events unfold. Start with some relaxed shots of athletes warming up, maybe a panoramic of the stadium to establish where you are. Move on to the athletes getting down on the starting blocks when the crowd goes quiet, then shoot your action images.

The winner crossing the line is the key moment, but don't stop there. Look for reaction in the crowd, on the faces of the athletes and coaches. One athlete wins but the other competitors lose, and these images can be just as powerful. Then comes the Victory Ceremony (p.38) or other award presentation, with more emotion as the national anthems are played. Focus in as much as you can to record the emotion on the athletes' faces. If you can get all that, you really will have a great story to show.

THE WINNING SHOT

Positioning was everything in capturing this great image. Aiming for a big and bold celebration, I decided to walk 30 metres past the finish line. On a fixed telephoto I was a little loose (that is, there was too much else in the frame) for the finish line itself. As Usain Bolt travels so fast it takes a second or two to register winning, so the best celebration picture is usually after the winning line. So I was hoping for a close finish with Bolt celebrating after the line.

The 400mm lens tracked Bolt from 50 metres down the track to finally finishing about 10 metres in front of me. Thank goodness for autofocus – it would be impossible to manually focus this quickly! Amazingly, every frame was sharp. The success of images like this is determined by the exact position – two or three metres to the left or right might have produced a good image, but not a winning shot. Autofocus set to AI server mode (p.250) continually tracks the subject, even when the camera's mirror moves up.

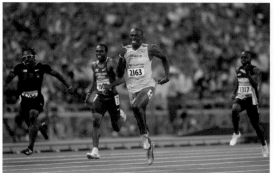

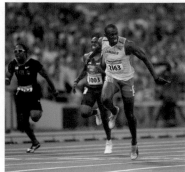

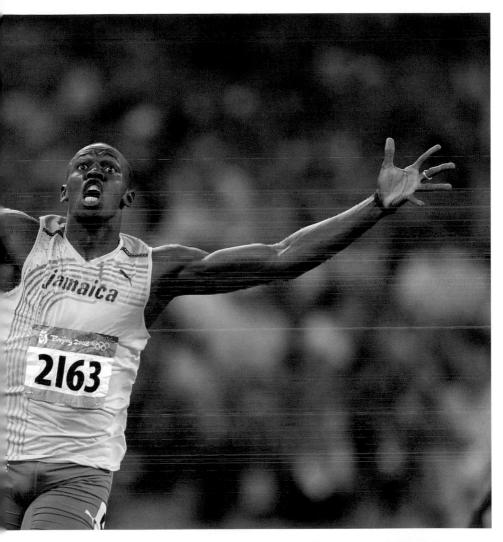

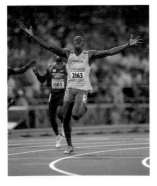

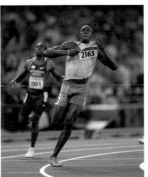

▲ Kelly Sotherton hurdles during the Beijing 2008 Heptathlon. Try to capture the competitor at maximum extension as they straddle the hurdle. Use a fast motor drive for a sequence of shots or your timing technique for one frame. The latter requires more skill, especially with a heavy 400mm lens.

Positioning

Those of you lucky enough to have tickets for the Athletics at London 2012 Olympic and Paralympic Games will be able to take some great pictures. As already explained, you will have to stay in your seat rather than move around the arena to get a better position, but there is still plenty of scope.

Professional photographers can get closer to the action at elite events, although it can be congested and difficult to move around. For track events I position myself at or near the finish line in readiness for the drama – athletes dipping for the line, the photo finish, the dejected competitors who come across after the winner and the euphoria of the

gold medallist. One of the best positions is directly head-on. The lower the angle the better, as this makes the athletes appear stronger and more powerful.

Photographers on the middle Saturday of the Games who want to photograph the men's 100m Final queue up from first light to get this head-on position. There are only a certain number of spots and everyone jostles to get that best place. Tape is then put down to mark out who is where, and nobody dares to go too far away in case they lose their place. It's a long day for 10 seconds' worth of action!

For great action pictures of sprinters it's sometimes worth walking around the track to shoot them when they are at full

stretch, running round the bend. Head-on makes for strong images again, but you can also shoot side-on as they go past and slow the shutter speed to 1/30th or 1/60th of a second for a pan blur. The start makes a good picture too, with all the athletes poised ready to go. In the first few steps of the race they are all at maximum concentration and exertion, close together, so a great place to capture all eight athletes.

Focus is a critical point on a sprinter as he or she is moving so fast. The autofocus system needs to be pointed directly at the sprinter's chest. Centre-weighted focusing is best here, and once the focus is locked on keep the subject in the centre of the frame. Again you need to weigh up the focal length of the lens, as ideally you want to be filling the frame top-to-bottom just as the athlete crosses the line. This means if you want an action picture before the athlete gets to the line, he or she might be a little bit small in the frame; and when the athlete celebrates after the line he or she might be so close that you only capture the torso.

Another good Athletics position is slightly round the bend after the finish line – about 45 degrees on to the finish line. This makes for the best celebration pictures. The athletes are travelling so fast across the line that it takes them a few moments to realise who has won a medal, by which time they have been carried 15 metres or so past the finish line. On a photo-finish the athletes look up to the giant TV screen for confirmation of their victory; you can get some great images as delighted faces explode with emotion.

Field events have their own unique positions. High Jump is best photographed from in front or behind the jump, depending on the style of the athlete's jump. Go for the split-second before or after they clear the bar. Pre-focus your lens on the bar in manual mode as the athlete will be in the same plane when they are jumping the jump. Don't attempt to use the camera's follow-focus as it is impossible to keep up with this sport.

Long Jump and Triple Jump also lend themselves to a side-on position. Here you can pan with the athlete on a slow shutter speed or freeze the action in mid-air at 1/640th of a second or above. Javelin, Shot and Hammer are all photographed from slightly in front and definitely to the side for obvious reasons. Look for competitors' faces showing the strain as they throw.

Outside the Olympic Stadium the Marathon course provides ample opportunity for iconic London imagery. Do your homework as there are a number of really good vistas – Buckingham Palace, the Mall, Trafalgar Square, London Eye, Houses of Parliament, Blackfriars and Waterloo underpasses, and St Paul's Cathedral (see Chapter 4). These are some of the most photographed buildings in London and will make a great backdrop for your images of the marathon runners. Compose the picture first with your iconic backdrop and then wait for the marathon runners to enter the frame. Leave enough space in the foreground or bottom of the picture so the runners do not completely hide the London backdrop. The

TIPS AND IDEAS

> Fill the frame on the finish line then keep tracking the athlete as he or she comes past the finish line and starts to celebrate for the best reaction pictures.

> Pan pictures are best halfway down the finishing straight where all the athletes are running in lanes. You can pan your camera with the athletes on a slow shutter speed to blur the background and keep the most important person sharp.

> Vantage points. The low angle, head-on, is the most dramatic, but the high angle from the top of the stands – combined with the symmetry of the lane markings – can combine to create a strong image as the athletes run below you.

> Don't always focus in on one person as the finish of the Decathlon or the Marathon where you get a lot of people finishing at the same time can produce outstanding images – such as an athlete celebrating among a pile of exhausted competitors.

> Choose your lane carefully. If it's the 100m and it's a close finish, are you going to focus on the favourite in lane five or the outsider who looks like he is going to have a strong finish? Take a quick look at the giant television screen, decide who you're going to go with and stick with them. The nightmare scenario is competitors finishing first and second in lanes one and eight.

> When photographing Paralympic athletes in wheelchairs, be aware that competitors often have their heads low to the ground. The lowest angle possible is best for photography, as you always want to see athletes' faces in the picture. The side-on view also works well for wheelchair competitors as it shows their faces in profile.

Marathon course has several loops built into it, so you should get more than one chance to perfect your picture.

Of course, when you are photographing athletics at amateur level, opportunities open up. You'll have more freedom to choose where you want to sit or stand, but be careful. You want to achieve a clean background, avoid people standing about, bits of building, marshals in fluorescent jackets etc. A cluttered background can destroy even the best image. Think about using a low angle – shooting up into the sky – for jumping events and even for runners rounding the bend. Try using fill-in flash (p.68) to lighten the shadows. Alternatively expose for the sky and make a silhouette by taking a camera meter reading of the empty sky. Set this manually on the camera or lock it down on automatic to take your picture.

At school sports days apply the same positioning techniques as above. Stand at a safe distance directly behind the finish line to get a head-on shot and wait for the moment when the children cross the line. Fill the frame and keep a low angle.

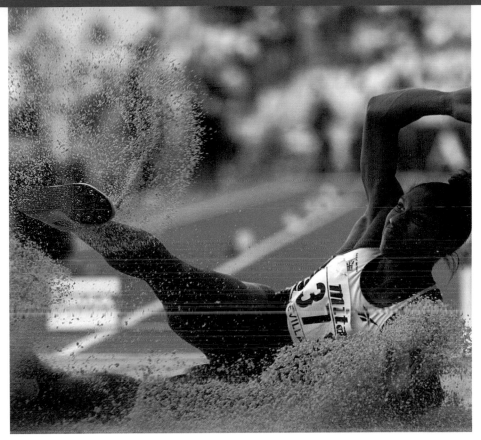

▲ This great image of Denise Lewis finishing her long jump shows good use of a fast shutter speed: 1/2000th of a second has frozen the sand beautifully. Unfortunately the cropping is not the best; I was positioned at the end of the sand pit and cropped her left foot out of shot. To balance up the image and make it look intentional I have tried to fill the frame by cropping the image on the right close by her head.

Always have your son or daughter in the centre of the frame to help the autofocus track.

Key technique

There are a lot of key techniques to use for athletics, with freeze-the-action and pan blur being the two most important. But the panoramic technique is an achievable technique for camera phones and compact cameras at the back of the Olympic Stadium to give you the perfect view of this magnificent venue.

Panoramic Technique

Higher up in the stands the view becomes wider and lends itself to a panoramic. Panoramic pictures usually capture a scene rather than an event so you are aiming for a clean picture that captures the entire scene.

This technique might sound difficult, but it is fun to shoot and easily obtainable. Because athletics finals often take place in the evening it's the perfect time to try out a panoramic with the sun setting over the top of the stadium and the action below lit up by the floodlights.

SIX STEPS TO A PANORAMIC

1. Choose your subject. Ensure an unrestricted view.

2. Set a large depth of field if you can (you can't do this under floodlight conditions) so that everything in the shot is sharp.

3. Shoot six to nine frames with a 50 per cent overlap of each frame. Ideally you need a tripod but if it's not possible think about a mini-tripod. If hand-holding your camera, take your time to ensure the horizon is kept level through all the images. Stand in one spot and as you turn to take each picture, keep the camera close to your body. Don't move from the spot you are standing on between shots. Stay still and steady; use a slow panning technique.

4. A wide-angle lens is ideal, so compact cameras and even some camera phones are perfect.

5. Ideally set the camera's metering to manual. This should keep the exposures in all the images similar and help the stitching together. If your camera only has automatic it might be possible to lock the exposure; if not, shoot the scene two or three times.

6. Stitching refers to the technique of using the computer to merge all the images together to make one panoramic. There are a number of software packages on the market that can do this for you (some are included in the camera) and the finished image should look like one picture taken on a panoramic camera.

Remember the saying 'if you can't get close, get creative'. Look back at the discussion of creativity (p.71) for some ideas with lines of symmetry and pattern. When photographing jumping events, for example, the best angle is head-on; you should also get as low as possible to accentuate the height of the jump. Fill the frame at the height of the jump, not the start or the finish. A 200mm or 300mm lens is perfect, or a 70–200mm where you start off at 200 and zoom out for the landing. If you want an action picture of the jumper running, take it as he or she is running down the track before taking off. For combined events, such as decathlon and heptathlon, use the individual sports' techniques. Look out for the unexpected, however. These athletes are not natural hurdlers or high jumpers, and there will be thrills and spills.

With a compact camera, use the automatic mode, shutter-speed or action priority in the morning for heats. For evening finals, manual exposures work best if you can up the ISO as high as possible to freeze the action at 1/500th of a second. When using your compact camera at night in the stadium turn the camera's flash off as the flash is not powerful enough to illuminate anything more than three or four metres away. If using your camera phones at night only take pictures of people under floodlights as it's too dark without flash at night (most camera phones don't have flash).

2.2 Cycling

Cycling at the Olympic Games is made up of three disciplines: Road Cycling, Mountain Biking and BMX. Even though the surfaces and the bikes may be different, the photographic principles for photographing cycling are all similar. Cycling is about speed; photographing it is about capturing that speed, either by freezing it or blurring it.

In the case of Road Cycling and Mountain Bike, with a course 40km long

(or 150km in Road Races) you can only cover 100 metres either side of you. Luck inevitably plays its part, and it's highly likely the most exciting incidents will happen round the corner just out of your camera's range. But as Jonny Wilkinson once said, the harder you work the luckier you get, so find the time to walk the course. Get to know the best place to take pictures and look for jumps or steep ascents where the riders have to get off

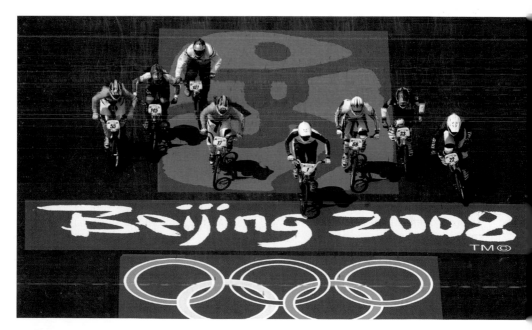

▲ BMX competitors gain speed by sprinting down the start ramp during time trials of the women's race in Beijing 2008. I wanted to incorporate the event's logo into the picture. I used a 400mm f/2.8 lens and released the shutter (1/1000th of a second) just as the first competitor, Briton Shanaze Reade, crossed the word 'Beijing'.

and carry their bikes. Do your homework; don't just blindly go to a corner and hope for the best.

BMX, on the other hand, has only a short course with many twists and turns. The action happens in a very confined venue, giving the photographer the advantage of being able to see the entire course. This is the benefit of having a stadium venue as opposed to a semi-rural setting.

How to Photograph BMX Cycling

A demonstration sport at the 2008 Olympic Games, BMX has become the newest Olympic Cycling discipline. This new and exciting sport is a photographer's dream. Whether you are capturing competition bumps and tight corners or simply photographing someone doing tricks or jumps against the sky in your local park, the action creates exciting images. BMX is a great sport to start practicing on if you want to be a sports photographer. It's easily accessible both night and day, and you can hone your timing and freezing-the-action technique as the cyclists pass you on the track time and again.

Challenges

BMX is a good entry-level sport for the budding sports photographer as it has relatively few challenges. It takes place in a small circuit with the obstacles and jumps providing the only difficulty. A sports photographer needs to capture the competitor at the highest point of the jump, so practice your timing again and again until you get the peak of the moment perfectly.

Camera Set-up

> **Shutter speed** – needs to be 1/640th of a second or more for competition pictures and 1/250th of a second if using flash.

> **Aperture** – use sports photographers' small aperture unless photographing against the sky, in which case you'll need

▲ Working with the light on shutter-speed priority (1/1000th of a second) the autofocus locked on No. 88. The composition draws the viewer towards No. 88 and is helped by eye contact. I was positioned at the end of the first bend with a low angle.

SPECTATORS' ANGLE

From the stands you can take great pictures of BMX racing. Try to use the pan and blur effect as described below (see also p.245). Use your high vantage point to take a great picture of the BMX track (a small bowl ideal for this picture) with the Velodrome in the background. Again look out for riders falling off, which usually happens on the bends; the first and last bend are the favourites for this.

a larger aperture. With flash photography in daylight you will probably be shooting at the f/11–f/22 range.

> **Lenses** – 300mm or 400mm for start and first bend; 70–200mm for pan and blurs side-on; wide-angle 20–35mm for low-down jump pictures with flash.

Positioning

You will discover in photographing racing that whoever leads coming into the first bend will, nine times out of ten, win the heat. The best position is on that first bend where the spills happen. At your local track position yourself to the side underneath the jump, at the landing side,for that dramatic image as the cyclist is airborne. Always go to the largest jump; it's not the speed humps you want but the really big air. Ask around to get riders to pose and perform tricks for you. Remember for the big-air pictures it's probably best to time it and just take one

TECHNICAL WISH LIST

The ultimate camera kit at pro level is two motor-driven cameras and two lenses:

> 400mm lens on a monopod for competition pictures of racing jumps and spills

> wide-angle lens 20–35mm and flashgun for closer shots taken when standing next to the jump. In your local park flash is the ideal way to freeze the bike in the air. If you don't have a flash think about silhouetting the rider against the sky by taking a meter reading against the sky first.

frame of the jump at the peak.

For compact cameras and camera phones this is an ideal sport. Go and stand as close as you can to a jump, taking pictures on the landing side, 45 degrees on to the jumper. It's perfect for your fill-in flash if you have one; if not, shoot with the sun behind you or (for that creative picture) shoot into the sun on automatic.

We've already talked about the battle for the first corner. At the 2008 Olympic Games in Beijing we all got our best pictures on this corner – but we missed the biggest picture when the women's favourite, Shanaze Reade, unexpectedly crashed on the last bend. Sport is unpredictable and this caught us all out; most people were waiting at the finish post to capture her as she crossed the line. Just one lucky photographer, who had gone into the stands to get a creative shot, could see the last bend. His picture became the talking point of the day and we were all envious – it sometimes pays to take a chance! Remember that the 'best' positions don't always get the most dramatic results.

Key Techniques
Flash

Flash photography is an ideal technique for sports photography, but often confuses people. It works especially well for Cycling because the super-short burst of flash freezes the fast-moving subject.

▶ Shanaze Reade is caught mid air as she jumps on her local BMX track. I have used off-camera flash to illuminate and freeze her. From my low angle I used a 24mm lens and shutter speed of 1/250th of a second with an aperture of f/5.6. Timing is the key when taking a single image like this.

This burst of light lasts a mere 1/1000th of a second. It can also be used effectively in running, boxing, fencing, gymnastics and basketball. Note that at the London 2012 Olympic and Paralympic Games you are not allowed to use flash photography, (see p.279).

Flash can be used in two ways. One is as a main light to illuminate the subject in dark conditions called direct flash. The other is called fill-in flash; here the flash is not the main light source but is used, as the name implies, to fill in shadowed areas in the image.

Direct flash is used mainly at night when there is not enough light to take a picture. The flash is used to illuminate the subject. It's called direct flash because there is one main light source on top of your camera, which produces a strong, sometimes harsh light. It's optimal for pictures of family groups and grab shots when time is short. The disadvantage is

THE WINNING SHOT

The winning shot is a peak-of-the-action picture in the middle of a competition. Racers are everywhere, all concentrating on getting to the bend first; a long telephoto lens compresses the riders to make them appear closer together. You need to be positioned straight on to the jump to catch the riders looking with their heads. They are moving over these jumps very quickly and you have to time your shots well. Fill the frame and go in as close as you can with the longest lens you have – you can never be close enough. Watch out for spills as riders fall over the jumps.

that this light is not very flattering and kills any mood in the picture.

A typical flash picture has two regions, the background and foreground. The foreground is the area around the BMX rider, for instance. All camera flash units have a limited range and none can illuminate large backgrounds (such as sporting stadiums and venues) by themselves. The camera's metering system balances the subject and background to produce a correctly exposed picture. This is the one area where cameras struggle, and I'm sure you've seen either overexposed people (white ghost figures) or dark flash pictures (pictures that are so black you can't see detail). Flash metering is set for the foreground subject while the background is set by the camera's normal exposure metering system. If the light conditions are low the background can become underexposed and dark, so most people associate flash with photographing in dark conditions.

Fill-in flash photography is mainly used on bright locations and sunny days, for example when sportsmen or women wear peaked hats or helmets that cast shadows over their faces. Without fill-in flash the image will either be a silhouette or the sky will be over-exposed. The fill-in flash illuminates this shadow area under the peak cap to produce a correctly exposed picture. There is no separate camera switch or button to engage fill-in flash. When you use automatic mode on the camera, however, with the flash switched on and turned to auto, the camera's metering system balances the ambient light with the flash light to create

the image. This is called the fill-flash ratio.

This is easier in BMX as you're usually close to your subject. Flash photography can be a little hit-and-miss, so always check the results on your LCD display and adjust accordingly.

For flash photography exposures, both direct and fill-in, there are two options: manual exposure, in which you set the controls on the camera and flashgun yourself, or auto in which the camera balances the light for you.

When using manual exposure, take a camera meter reading off the sky and set that as the camera exposure. Do a few test shots with the flash on again, set manually to get the right exposure for the rider. You can use a flash meter to get the right exposure, but with a few test shots you should be able to get it right. To make the picture a little more dramatic, underexpose the sky by one stop. An example is the photograph of Shanaze Read (p.67): the flash has frozen her against the sky and picked out the colours of her suit, while the underexposed background appears dark and stormy. If your camera doesn't have manual exposures, or if you are more comfortable with an automatic process, use automatic mode. It's possible to adjust or compensate these auto-exposures slightly if the need arises by boosting or decreasing the flash exposure. Do this by using the compensator button on the flashgun.

These flash pictures are ideal to take on a compact camera. The camera with the flash turned on should balance the exposure correctly for you. Just remember not to keep the camera steady – instead,

TIPS AND IDEAS

❯ Get as low an angle as possible for jumps – even put the camera on the ground as you don't need to look through the camera. A wide-angle lens will accentuate the height of the jump making it dramatic.

❯ Work at dawn or sunset, look for dramatic skies, think about silhouetting the rider against the sky.

❯ Always be aware of competitors, never walk on the track as this is a dangerous sport and accidents do happen.

pan with the subject in one smooth action.

BMX is ideal for pan and blur pictures (see p.245). The trick is to shoot with the action just in front of the crowd. Great panning shots can be had; look for jumps, for example, and use a slow shutter speed to blur the colourful crowd behind with the rider in the foreground. A lot of BMX tracks have distracting backgrounds, but this pan and blur technique will keep the pictures clean, simple and colourful.

How to Photograph Road Cycling

Road cycling is very accessible and a great opportunity for photography, whether at the Olympic Games or another competition. The London 2012 Games features two events, the Road Race (250km for men) and the Time Trial (44km for men). In the former, all competitors start together and the winner crosses the line first, while in the Time Trial, riders start 90 seconds apart and the fastest to complete the course will take the gold.

Road Cycling, along with the Marathon, will be the easiest London 2012 sporting events to photograph without special passes or tickets. Remember the main technique for cycling photography is the pan. Whether you are freezing the action or using a slow pan, ensure a smooth action.

Challenges

The flip-side to the great access and all the vantage points on the Road Race and Time Trial courses is that you can't possibly cover all of it. The cyclists will be travelling very fast, especially downhill. It's very difficult to freeze the cyclists but keep movement in the bicycle wheels – which you need to do to prevent the cyclist from looking as though stationary in the road. Getting a clean shot can be tricky when the cyclists are surrounded by support crews and photographers on motorbikes.

Camera Set Up

> **Shutter Speed** – use the sports photographers' 1/640th of a second to freeze the action. Don't use very fast shutter speeds, such as 1/2000th and above, unless you want to freeze absolutely everything in the picture. 1/640th of a second freezes the rider, but gives movement in the bicycles' wheels.

> **Aperture** – needs to be wide open to eliminate backgrounds. When panning, especially slow pans, you can use a large aperture.

> **Exposure** – road cycling is usually outdoors, so work with the light. Be aware of harsh shadows with an overhead sun and avoid if possible. Try and work with soft, warm morning and evening light. Use manual or shutter-speed priority settings. Automatic exposure is fine for

compact cameras and camera phones; use sport or shutter-speed priority modes

> **ISO** – 100 as low as possible to give you the sports photographers' norm and under cloudy conditions 400 and above.

Positioning

In Beijing 2008 the iconic picture from Road Cycling was in Tiananmen Square as the cyclists raced past the Forbidden City. For London 2012 the iconic image could come from any number of landmarks. I am putting my money on Buckingham Palace; it's only a short walk from the start/finish so it'll be possible to take this iconic picture and get back

▲ Taken at Athens 2004, cyclists ride up the cobbled streets with the Acropolis in the background. Always try to use well known landmarks to place your image and add interest. To keep the foreground and background still I used a shutter speed of 1/640th of a second.

for the finish. My alternative is Hampton Court Palace, a beautiful building set right on the bank of a stunning section of the River Thames (see p.210). Both these pictures will show the traditional side of London.

The London street section of the course is going to be very busy, with large crowds of spectators. If you know anyone who works in an office along the course or you can gain access to a roof terrace,

a high vantage point looking straight down makes for fantastic pictures. When looking down on the cyclists use the road markings as leading lines and shoot loose, leaving plenty of room in the picture. Remember to take a wide shot to capture the atmosphere (people leaning out of all the windows and lining the streets, crowds waving flags and cheering),

SPECTATORS' ANGLE

As this event is accessible to everyone and takes place on the first couple of days it is going to be very busy. Get your spot early. With a Road Race spanning 250km, you need to decide on your location and find a good vantage point – high or low. If you have two cameras and lenses use the telephoto first, switching to the wide-angle as the cyclists go by. If you have a camera phone or compact camera it's best to use a panning technique and try and use the background: either keep it clean or use a picturesque scene such as Box Hill, Hampton Court Palace, Richmond Park, Buckingham Palace and the Houses of Parliament.

Having stated the obvious, bear in mind these iconic London landmarks will be extremely busy. Try going against the grain and looking for something new. Use the crowds along the route – everyone will be waving flags, making for a colourful backdrop. The best pictures aren't always of the cyclists. Consider recording the crowd who will be in festival mode: look out for painted faces, children with flags, people poised on lampposts and leaning from balconies to gain a great view.

which will bring colour to the pictures.

Hills will not dominate at London 2012, but normally at road cycling you can use the climbs to get the best position, with riders off the saddle showing the strain on their face as they climb. They will be slower on the ascents, giving you more time to take your shot, while the fast descents are best for pan blurs. The steepest hill on the London 2012 course is at Box Hill, which has a beautiful view of the Surrey countryside. The classic cycling shot is taken low down on an ascent or tight bend, looking up into the cyclist's face with the sky as the background.

You can highlight the graphic nature of the bikes, whether through a low angle for silhouettes against a preferably dramatic sky, or as shadows when shooting from above. Use the golden light and the long shadows it creates for shots. Also look for fields with brightly-coloured flowers or crops to use as foreground and background as the riders cycle in a country landscape.

Key Technique
Shooting Wide Open

Shooting wide open will give your pictures the professional photographer's look. In sports photography it's usually a necessity, especially indoors. Shooting wide open is the term given when using the largest aperture your lens allows, typically f/2.8 or f/4 or in some cases f/5.6. By doing this you are allowing the maximum amount of light your lens allows through it. This creates a small depth of field – that is, the part of the image that is sharp is incredibly small.

▲ Leontien Zijaard van Moorsel crashes during the women's Road Cycling event. The grim determination of other cyclists to get past her makes this picture, which was captured on a 300mm lens from the side. Freezing the action was the only technique for this picture, and 1/640th of a second froze this crash perfectly.

THE WINNING SHOT

This award-winning image of Leontien Zijaard van Moorsel crashing is a classic example of 'be prepared'. I was standing on the start/finish straight of the women's Road Race in Athens 2004, with competitors coming round every few minutes on this loop. I wasn't expecting anything to happen, I was simply following them through the lens, just in case. The pile-up was a once-in-a-million, as it happened on a straight rather than a tight corner or tricky part of the course. We had chosen the position and were waiting for the end of the race for the cyclists to cross the line.

Most of my colleagues were taking a break and having a chat. I was joining in the conversation but had one eye on the race – never take your eyes fully off the action. Even though I wasn't really meaning to take a picture, my camera still had the correct settings (1/640th of a second and f/5 shutter-speed priority, ISO 250) and I had focused on the riders, just in case. I took a sequence of six frames and was able to pick the best frame out of the six, where the cyclist has ridden over van Moorsel.

The benefit to this small depth of field is that the background is thrown completely out of focus, which creates the professional look. The longer the lens you use the smaller your depth of field becomes. When using lenses of 200mm and above wide open, there is a real art to keeping the subject sharp. I would recommend practicing your focusing technique when shooting wide open on these lenses.

Try using this for cycling photography, especially when shooting head-on. An example would be when shooting the finish line of a cycling road race. Shoot wide open with your exposure and focus on the winner. The other cyclists behind him will be thrown out of focus, concentrating your eye on the most important part of the image – the winner. The challenge here is the small depth of field, which makes your focusing critical. Make sure you keep the focus point on the winning cyclist's face or chest.

Here are a few useful tips:
❯ When shooting in bright sunny conditions you'll have to use a low ISO and a fast shutter speed in order to shoot wide open.
❯ Always focus on people's eyes when taking a portrait.
❯ Focus is critical: practice, practice, practice.
❯ Aperture-priority mode or manual mode are optimum settings for shooting wide open.

◀ The peloton passing Mao's Tomb in Tiananmen Square on a foggy morning at the Beijing 2008 Olympic Games. The image was shot on a 70–200mm zoom lens at the short end with 1/1600th of a second at f/6.3 and an ISO of 800. I wanted to freeze the cyclists and the Portrait of Mao in the background, so I kept the camera still.

TECHNICAL WISH LIST

Your ultimate camera kit at pro level is two motor-driven DSLRs and five lenses:
> 500mm f/4 hand–held lens. This is the easiest big lens to hand-hold and is great for long-distance views and light (close-in) action shots
> 300mm f/2.8 general-purpose long telephoto lens is easily hand-held and can be used with f/1.4x teleconverter for cycling action pictures. If you are walking the course you will want a light lens to carry with you; and with the converter it becomes a 420mm f/4 lens
> 70–200mm f/2.8 general-purpose zoom lens for creative/action pictures. This allows you to get close to the action, but can also be used at the 70mm end for a good establishing shot
> 24–70mm f/2.8 wide-angle zoom lens for cycling landscape pictures and general views
> ultra wide-angle/semi-fisheye lens for tight bends and fill-in flash photography in and around the streets of London
> flashgun for close-up fill-in flash photography (p.68)
> laptop and transmitting device
> waterproof cover

TIPS AND IDEAS

> Photograph on the inside of tight bends for close-up pictures.
> Shoot high and low. A bird's-eye view can make an interesting picture of cyclists below you.
> Choose a part of the course where a rider will look up or lean to avoid seeing the tops of helmets.
> Be prepared for fast riders: cyclists come and go in the blink of an eye.
> Get two different shots off. Take a picture with your long lens when the riders are a few hundred meters away, then quickly pick up a short lens and shoot as the riders pass you.

How to Photograph Mountain Biking

Mountain Biking is a relatively new sport to the Olympic Games, with Hadleigh Farm in Essex offering an exciting new venue. Generally it takes place over rough and hilly countryside on long courses, between 40–50km. For a sports photographer this is an ideal event to show off your creative techniques such as slow-sync flash. You're really photographing a landscape with cyclists in rather than capturing the winner crossing the line, so you are in control of creating the image. The mud-splattered, sweat-covered speeding competitors make great shots.

If you visit a purpose-built trail centre there will be ample opportunity to practice; mountain bikers will willingly show you their tricks. Try the technique of slow-sync flash (see p.245), which combines a slow shutter speed with a burst of flash. The slow shutter speed captures the blur while the flash captures the sharp image of the subject, in this case the mountain biker himself.

Camera Set Up

> **Shutter Speed** – use the sports photographers' 1/640th of a second at f/2.8 for action pictures. Use slower speeds for pan blurs.

> **Aperture** – wide open for action pictures but stop down the aperture for your landscapes; typically f/5.6 – f/11.

> **Exposure** – during the day work with the light but remember it can be very dark in the trees. The best light is the golden light of early evening. Also think about shooting backlit and silhouetting the riders.

> **ISO** – as low as possible: 100–400 in the sun outdoors;higher in the trees.100–200 on a sunny day; 400 and above on a cloudy day.

▲ Sailor Giles Scott mountain bikes on Portland Bill in Dorset with the panorama of Weymouth Bay and Chesil Beach in the background.
This is the venue for the Sailing events during London 2012. I used a 70–200mm lens set on 70mm to bring the background closer and create a more interesting image than you would get with a wide angle lens. Lens choice is key for pictures like this.

WINNING SHOT

The winning shot would be a bunny hop or big-air shot with the rider travelling at speed, jumping through the trees with a blurred background and using fill-in flash (p.68). Use the flash to freeze the rider, combined with a slow shutter speed to blur the ambient light; this will give a real sense of movement. A wide-angle lens used from a low angle to accentuate the height of the rider can produce a dramatic image.

Positioning

Mountain biking has it all as a photographic subject – you are so close to the course and action that you have many options. You can choose to be near the bend or at the top of a steep hill, or anywhere on the course where there are jumps and water splashes. Decide whether to shoot head-on or side-on and whether to use a long lens or get low with a wide-angle. Don't forget to use the landscape as the main image and insert or drop your cyclists into it.

Remember that the riders only have to be a small part of the image: this is not a sport where you have to fill the frame. You could try using the sky or the trees to frame your subject. Take a position near the start line if you want a large group of riders, as they do spread out towards the end of the course.

TECHNICAL WISH LIST

Your ultimate pro camera kit includes two motor-driven cameras and three lenses:

> 300mm or 400mm f/2.8 lens to separate the subject from the background for peak-of-the-action pictures, finish line and jumps
> 70-200mm f/2.8 lens for when you are closer to the action, pan blurs and jumps etc
> 20mm f/2.8 and above, wide-angle for low-down action pictures on bends and jumps. Remember to pan with the subject even at fast shutter speeds
> Off-camera flash kit

Key Technique
Photographing Silhouettes

Silhouettes make dramatic pictures. You need the background to be brighter than the subject, although you can see silhouettes all around you even on a dull day. A good example of a silhouette is this mountain biker photographed against the bright sky behind, which gives impact to a simple picture. In my experience it's best to keep silhouettes obvious: a head, a bike or a runner silhouetted against the sky. Skies are the most obvious backdrop for silhouetting, but the effect can also be created by using an off-camera flash placed behind the subject and directed towards the camera.

SIX STEPS TO CREATING A SILHOUETTE

1. Find your subject – that is the area that will be blacked out on the picture.
2. Place your subject in front of a bright light. The best silhouettes are captured when there is only a single source of light.
3. Turn off the flash on your camera.
4. Expose for the bright light behind. If it's the sky take a meter reading off the sky and dial into your camera. You can even underexpose this reading by a stop or two.
5. Lock the exposure, if using auto, once you have taken the reading of the background/sky. Alternatively, use manual exposure if your camera has this facility.
6. Focus on your subject rather than the background.

Most photographers prefer to shoot silhouettes at sunset as the sun is lower in the sky. Remember to use a lens hood.

▲ Mountain biking lends itself to silhouettes. The sunset has been used effectively in this picture. Always expose for the sky and take a reading with your camera's in-built metering system. Keep it simple in situations like this.

SPECTATORS' ANGLE

Use the hills around to take your landscape pictures during the competition. The high angle gives you a great perspective on the action below. Zoom in on the individual riders to get close to the action. The temporary grandstand seating at the finish line is great for reaction shots as the riders cross the line. There are only two gold medals up for grabs at London 2012, so pick your time for the celebration pictures. With your compact camera and camera phone you'll need to get close to the action. Try using that low angle to capture the rider against the sky.

TIPS AND IDEAS

> Walk the course to find the best photography position.
> Tilt the camera angle to accentuate the steepness of the hill's ascents and descents.
> Underexpose the sky by one stop when using a low-down angle shooting up into the sky with fill-in flash to add drama.
> Use the sky as a backdrop or shoot through the trees.
> Corners make good panning spots as the riders will not be travelling so fast going round them.
> The course is usually marked out by plastic tape and riders do crash sometimes, so be careful.

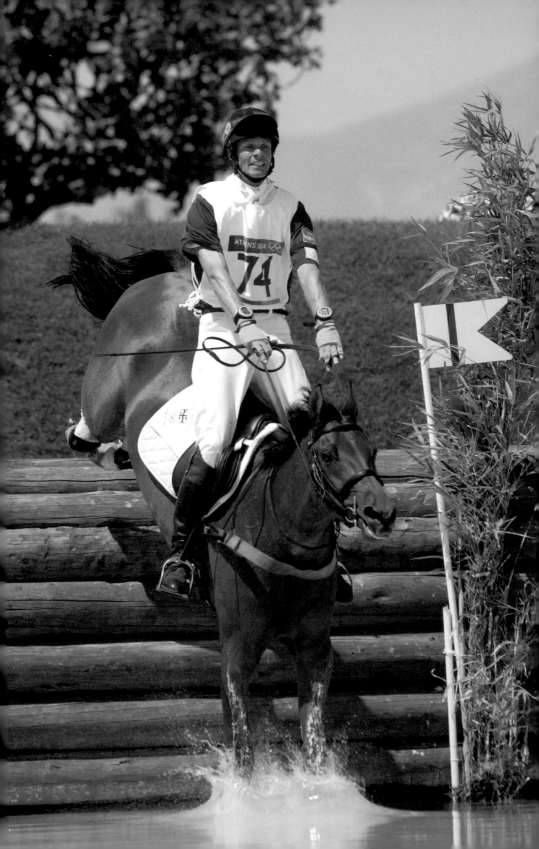

2.3 Equestrian

The Equestrian events at London 2012 are Dressage, Eventing and Jumping. For the sports photographer, Eventing and Jumping are classic peak-of-the-action sports and are similar to photograph, except that one happens on a large outdoor course and the other is in a stadium environment. Contrast this with the technical sport of Dressage where you have the time to produce some creative images at a more leisurely pace.

How to Photograph Equestrian Events

If I were choosing an event to go and watch at the London 2012 Games, this would be high up on my list. You can see most of the course as a spectator and Greenwich Park, one of London's foremost parks, has a stunning skyline. The atmosphere will be incredible, with tens of thousands of spectators watching from the hill. As each rider is announced, excitement mounts and the thunder of hooves is heard before you see the rider enter the arena.

The techniques and advice below

◀ William Fox-Pitt competes in the Cross Country element of the Team Eventing Competition at the Athens 2004 Olympic Games. I used a 300mm lens with a 1/1000th of a second at f/4 ISO 100 to capture this beautiful image in full light.

can also be applied to other equestrian sports especially horse racing, polo, point to point and your child's gymkhana. I enjoy photographing horse racing 'over the sticks', as the photographic potential is huge. When you have up to 20 horses and riders competing over large fences, pictures can be dramatic. Some of my most memorable pictures have been from Cheltenham festival or the Grand National. Choosing the right fence is vital, but luck always plays a part.

SPECTATORS' ANGLE

The grandstands for Dressage and Jumping are ideal places from which to take pictures. Even though you might be some distance away, all the action is straight in front of you. Your high angle means you won't miss a thing. Remember to take scene-setting pictures with the crowd and stadium in the shot, then zoom in for the action pictures. If you're lucky enough to be near the finish, look out for reaction pictures. Olympic and Paralympic Victory Ceremonies or other Equestrian presentations usually take place in the centre of the arena for ease of viewing. After the Ceremonies or presentations the winning teams usually do a high-speed lap of honour, which is very dramatic. Don't leave your seat too early!

Challenges

When photographing Jumping at London 2012 the challenges are being able to get close enough to take a picture when you've got horses thundering past. Because of health and safety everyone has to be kept at a distance from the action, so long lenses are a priority. Even if you are allowed to put any kind of remote camera down near the jumps you have to be extremely careful not to spook the horses with the noise.

Producing a great image from Dressage is a challenge. The discipline is a controlled, technical one where movements are small and graceful, and a freeze frame from a routine can look very static. The riders are not moving fast enough to pan blur, nor do they show much emotion. The best way to tackle

TECHNICAL WISH LIST

Your ultimate pro kit would be three motor-driven DSLRs and four lenses:

> 400mm f/2.8 for action pictures of horse jumps and filling the frame from a distance

> 70–200mm f/2.8 for action shots and dressage routines

> 24–70mm f/2.8 for landscape images of dressage and cross-country

> 20–24mm remote camera for low-down action pictures of horse jumps on either takeoff or landing

> monopod for 400mm

> mini-tripod for remote camera

> transmitter-receiver units for remote camera

Dressage is to think of a landscape with the rider small in the frame.

Eventing is just the opposite. It combines all three elements of horsemanship – harmony between horse and rider, the contact and speed of cross-country and the precision, agility and technique involved in Jumping. Another challenge is that you can only photograph one jump at a time as they are so far apart. The professional photographers usually congregate at the water jump. Here they get a great action picture as the horses jump into the water, then charge out of it at full pelt. They are always looking for any dramatic shots if riders are unseated over this jump.

Camera Set Up

Follow the pointers below to get the best results from your camera set up.

> **Shutter Speed** – use a sports photographer's 1/640th of a second at f/2.8. This speed is perfect for Equestrian photography as the horses aren't moving too fast and you are usually panning with them. This changes for the remote camera angle, which is fixed to the ground. Where the camera is static and the horses are moving across the digital sensor, a fast shutter speed of 1/2000th of a second is required.

> **Aperture** – when photographing horses head-on it's worth using a larger depth of field to get both horse and rider in focus. Your target is the rider and the camera's autofocus system often focuses on the nearest point – usually the horse's head or chest. If you're using the sports photographer's wide-open aperture the horse rider would not be sharp, so use an

aperture of approximately f/5.6 to give you more latitude.

For remote cameras which are pre-focused on the jump use a medium aperture of f/5.6 – f/8 to give you enough depth of field (horses don't always jump over exactly the same part of the jump).

> **Exposure** – horses as a subject can be dark in colour. It's worth noting that you can open up or brighten your image by a third to one-half a stop when photographing a black horse to get detail in the blacks. If the horse is part of the overall picture, just expose as normal. Most equestrian events are outdoor so work with the light or backlit. For indoor dressage events and show jumping see Mixed Lighting (p.255) and White Balance (p.252).

> **ISO** – 100–400 for outside shots and 1000 and above for indoor arenas. Be prepared to use very high ISOs as some indoor arenas can be very poorly lit.

Positioning

Plan your positioning carefully. Usually you choose the jump that has the cleanest backdrop. This may seem strange, but all jumps or jump sequences are similar and the backgrounds at show jumping can be very intrusive. Choose the jump carefully so that the rider clearly stands out and is not lost in the picture. It's best to shoot head-on or slightly at an angle to the jump, depending on what you are looking for. Always shoot a sequence of the horse just before and during the jump to give you a choice of images: there is always one that stands out. The frame you don't need is when the horse is directly over the jump and looks like it's

balancing on the rail. The peak-of-the-action picture is that split-second before and after the jump when the horse's legs are fully extended.

Reaction shots can be captured at the finish line, in the moment when the rider punches the air and salutes the crowd. It always takes a few seconds for this to happen. The best angle is as low as possible, shooting up into the rider's face as he or she is often looking down or at

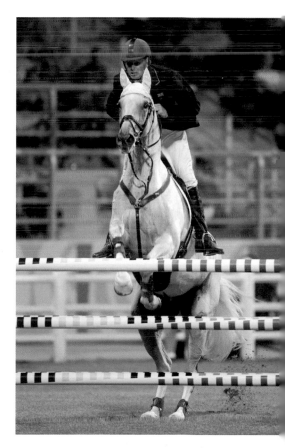

▲ Great Britain's Leslie Law wins silver in the Jumping Individual Competition at the Athens 2004 Games. Generally horse riding lends itself to the portrait format rather than the landscape format for shooting.

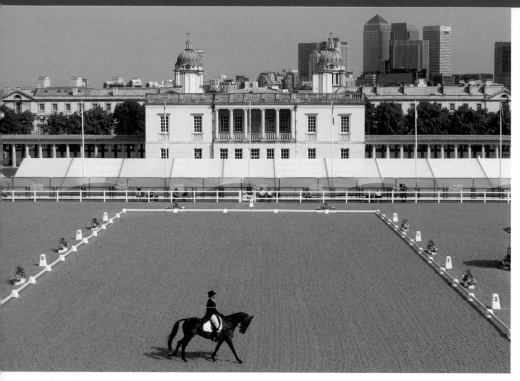

▲ A lone dressage rider practices at the test event the year before London 2012. An image of the rider on their own would be far weaker without the Canary Wharf backdrop. Always strive to make your backgrounds as relevant as possible.

the next fence with a peaked cap on. Remember that dressage routines usually follow a figure of eight pattern using the whole arena; to fill the frame shoot from the corners as the riders come towards you. Alternatively go to the back of the stands for a landscape picture. If the dressage is outdoors in a country setting use any trees to frame the subject.

With compact cameras and camera phones zoom in as much as you can for horse jumps and action pictures. Remember to pan with the subject and follow through. Shutter lag is the biggest problem here, so practice your timing to release the shutter just as the horse jumps. Be aware that some compact cameras can be very noisy, so remember to turn off the camera's flash.

Greenwich Park has many great photographic opportunities, so don't limit yourself to the action. Make sure you get the London skyline in, for example, to place the action in context.

Key Techniques

The following key techniques apply to all three equestrian events. The first is how to decide whether you should shoot loose (leaving plenty of space in the shot) or fill the frame. The second is something that every budding sports photographer needs to do – develop an individual style.

Shoot Loose or Fill the Frame?

The term 'shoot loose' means that the photographer zooms out from the subject, leaving space for the scene. In

effect this creates a landscape sports picture, featuring other elements apart from the main sporting action. Filling the frame is the opposite. Here you zoom in and concentrate solely on the action.

You will come across these choices every time you go on a sports shoot. It's one of the first decisions that you need to make as you compose your image. A straightforward example is when photographing the Show Jumping event at the London 2012 Games.

Show Jumping takes place in an arena surrounded by distracting colours and shapes, for example spectators, other fences and gates. The best way to produce a strong powerful image is to zoom in and fill the frame with just the horse and rider as they clear one jump. Your eye is then drawn to the rider and is not distracted by anything else. You can choose to zoom out to shoot loose, of course, but be careful as the image becomes weaker. You should really only do this if you want to take a general view or an establishing shot, showing the horse and rider at that venue. To fill the frame at a Show Jumping event, shoot with a telephoto lens of 200mm, 300mm or 400mm in length.

Dressage is a better event for shooting loose. Here, filling the frame with just the horse and rider creates an image that can be photographically less interesting. If you zoom out and incorporate the view of the arena – in the case of the London 2012 Games the very picturesque setting of Greenwich Park with Canary Wharf in the background – you have created an extremely strong image. An image like this should be shot on a lens ranging

TIPS AND IDEAS

> If photographing close to the horses wear neutral colours, keep quiet and don't make sudden movements as these may spook the animals.

> For Dressage events sit near the judge's stand (if you have any flexibility) for a view straight down the centre line.

> Use your best judgement when moving position.

> Avoid the use of wide-angle lens as it causes distortion. The horse's head can look unnaturally large and its body and legs look too small.

> Use the rule of thirds technique (p.98) and place the horse so that it seems to be walking or running into the photograph rather than moving out of the scene.

from 20–35mm, ideal for compact cameras and camera phones.

Interestingly, Eventing falls into both camps: on some jumps you might want to fill the frame with the horse and rider; at others you might want to zoom out and capture the landscape, leaving the horse and riders smaller in the frame.

Developing a Style

A photographic style is your unique way of photographing. It evolves over time, using all your experiences.

To develop your individual style, take the time to view as much of other photographers' work as you can. We live in a digital age in which information

and photographs are highly accessible, so draw influences from other people's work. Just because you're interested in sports photography doesn't mean you should only research the top sports photographers – look too at high-fashion photographers, landscape photographers and portraiture. Research the latest computer manipulation techniques; can you apply any to sports photography? Once you've found images you like, try to replicate them. Take inspiration from artists: learn the rules, then break them. Lens flare, for example, traditionally a 'no-no' for photographers, has now become fashionable in portrait photography.

It can be hard to develop your own style of sports photography. You are often working in a controlled environment where sport is happening at a certain place, time and distance, and you are in a fixed position. It's easier in more creative sports such as road cycling, mountain biking, sailing, marathon running and football. However, there are two main styles that emerge here. Are you a fill-the-frame, peak-of-the-action sports photographer, or are you a stand-back-and-take-the-wider-view – or fluffy-angle – sports photographer?

Developing a style involves many areas: the subject matter, angles used, preferred lens, use of light, editing and post-production. Experiment, as trial and error will tell you most clearly what you like. Digital photography is instantaneous; whereas before you had to post your roll of 36 images to be developed, which might take a couple of weeks or more, you can now review your images instantly on your LCD screen. This has made the whole process of developing a style that much quicker. Be prepared to be criticised for your style but don't let it deter you – this is your style, the way you like to shoot.

THE WINNING SHOT

The winning shot is a remote-camera picture of a horse captured mid-jump with the London skyline beneath, giving the illusion of jumping over the skyline. The remote-camera angle is the only way to capture this image. You need to be as close as you can get to the action. The use of a wide-angle lens at a low angle accentuates the height of the jump. You want to make it appear as if the horse and rider are soaring over Canary Wharf. This is a slight optical illusion but stunningly effective; it will be one of the iconic pictures of London 2012.

2.4 Tennis and Golf

Tennis is a fast-moving sport played on a variety of surfaces: grass, clay, hard-court and indoor. The colour of the surface, especially grass and clay, really brings something extra to tennis photography. The warm evening light with its long shadows is especially important for tennis photography, and some extremely creative images are possible at this time.

Add to this the physical nature of the sport where you can zoom in to show the power of the players, and you can see tennis offers sports photographers a lot of creative choices.

Wimbledon is the home of tennis and will host the sport at the London 2012 Olympic and Paralympic Games. A world famous venue, it hosts the oldest

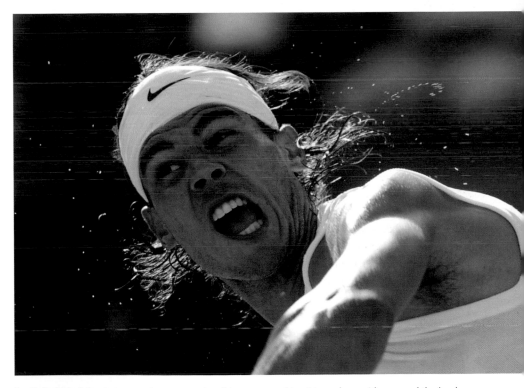

▶ Rafael Nadal puts tremendous power into his serve, as this picture shows. I have used the back-lighting to enhance the sweat coming off his wet hair. I also chose a 400mm lens to get in close and a shutter speed of 1/8000th of a second to freeze the drops of sweat, f/4 and an ISO of 250 with manual settings.

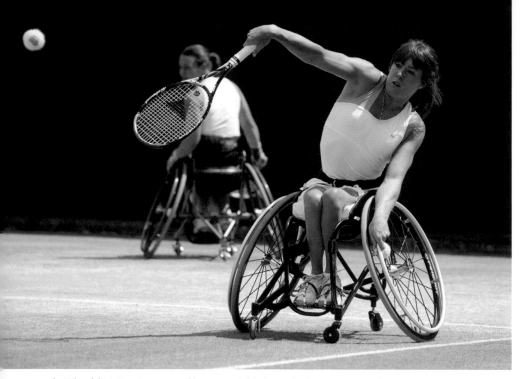

▲ Wheelchair Tennis, captured here at Wimbledon, is both interesting and challenging to photograph with two players at each end. The trick is to get both team members in the picture at the same time which is easier said than done. I used a 70–200mm zoom for this action shot.

tennis tournament in the world. The grass surface, the fastest in the professional game, gave 'lawn tennis' its name, and it is certainly a photographers' favourite, with its green backgrounds and the serve-and-volley game that it promotes. We are all looking out for the diving players. The slower, red clay courts, such as those at Roland Garros in Paris, are used by sports photographers to create stunning shadow images and baseline action pictures. The angle from above looking down is optimum for clay-court tennis photography.

While golf is only due to be readmitted to the Olympic Games in 2016, it is a hugely popular sport and extremely attractive to photograph.

The settings can also be challenging, however, so it helps to know a course before you photograph an event on it. This will enable you to predict the changing light at a particular time of day and be aware of the best positions or vantage spots.

How to Photograph Tennis and Golf

Taking a decent tennis picture is relatively easy. There are usually only two players on the court at any one time, the court is small enough to cover with one lens and you will only focus on one player at a time. To capture a great picture

you will need a lot of patience however; concentration throughout the match is key. Great pictures come along rarely. Remember it could last 11 hours and five minutes as the battle between John Isner and Nicholas Mahut did at Wimbledon in 2010!

Golf can be more difficult to photograph, not least because you are constantly on the move. You need to be alert at all times and to watch where you're going. A sports photographer's nightmare is walking along the golf course and feeling a lump under your shoe, then looking down to see you have trodden a golf ball into the ground.

Challenges

The challenges in photographing tennis lie in capturing a fast-moving small ball on the end of a racket. A tennis ball can be travelling at nearly 250 kilometres per hour, so you need precision timing to capture it on the strings of the racket. Hand-holding a camera weighing in the region of two kilograms for many hours is a challenge not to be underestimated. Using a monopod with your long lens helps, but you generally use your short lens most of the time for volleys and dives. Maintaining concentration is key, as you don't want to miss the important picture that may only last a second after waiting three hours.

Camera exposure metering systems can sometimes be fooled when photographing a white-clothed tennis player. The camera senses too much light and tries to expose for the white clothing, which creates a dark image especially of the player's face. To expose tennis photographs in bright sunshine, you should open your exposure up, for example by using the exposure compensator button in automatic mode to dial in an extra one-third or two-thirds of a stop to give a natural exposure. In manual mode, open up the exposure by one-half or two-thirds of a stop to give the same natural exposure. This problem occurs less in cloudy or indoor conditions

SPECTATORS' ANGLE

The spectator seating is a great place to take pictures of tennis looking down on the player hitting the ball. Use the lines and colour of the court to make a graphic image and zoom in to the server's face when he or she looks up towards you in the stands.

Use the position by the net to take pictures with your compact camera and camera phone, not forgetting the shutter lag, and allow more time between pressing the shutter and taking the picture. Practice like the professionals do to get your timing perfect. Tennis photography is ideal for these cameras as you are near to your subject. Use shutter-speed priority mode, and concentrate on keeping the central focus-point locked on to the player.

In golf the spectators' angle can also be close to the players, if you are lucky, or you may be stationed further away. Do check on the rules of the golf course as some golf events do not allow you to take a camera in. Some compact cameras and camera phones can be noisy, so be aware of, and sensitive to, what is going on around you.

as there isn't as much light reflected back off the white clothing.

Covering an 18-hole golf course requires stamina, concentration and fitness. Sports photographers have to carry around enough equipment for every eventuality on the golf course, come sun or rain. It is a long and exhausting day, as you are following an individual or group for a few holes, then moving forward or back to pick up another group from around 7am until 8pm. The pictures won't come to you as they do in football or rugby – you have to go out there and find them. Familiarity with the course is a great help in finding

TECHNICAL WISH LIST

The ultimate pro camera kit for these sports is two DSLR cameras and four lenses:

> 400mm f/2.8 long telephoto for baseline action pictures and serving shots

> 1.4x converter to make 560mm f/4 for extreme close-ups of serving action

> 70–200mm f/2.8 for action pictures near the net including dives and volleys

> 24–70mm f/2.8 for golf photography (to shoot landscape pictures and general views)

> wide-angle lens for crowd shots (an ultra wide-angle lens in golf for teeing off, pictures of golfers and special effects)

> monopod

> sunhat and sun lotion; waterproofs for camera and photographer

> camera and lens belt

a good picture. Where will the light be at any one time? Where are the best positions and are there any high angles you can use? Are there open tees that can be silhouetted against the sky or trees around the green where competitors can get into trouble? Are there water obstacles or lakes for reflections?

Camera Set Up

Follow the pointers below to get the best results from your camera set up.

> **Shutter speed** – needs to be at least 1/640th of a second or faster to freeze the action.

> **Aperture** – needs to be wide open or f/4 to throw the background out of focus and draw the subject, in this case the player, into focus. Sometimes in golf photography you want to draw in the background, so use a mid-range aperture of f/4.6.

> **Exposure** – for tennis manual exposures are best or shutter-speed action mode. Tennis works better backlit as the subject is wearing white and the background becomes dark in the venue when there is no direct sunlight on it. For golf use manual or AV (aperture priority) for the wide-angle pictures. If you are able to, use the evening or early morning light to create interesting shots.

> **ISO** – 100 to 400 during daylight. Try and keep the ISO as low as possible for better quality.

Positioning

At tennis matches the professional photographers sit courtside in the middle near the net, the prime position for photographing the sport. This is because

▲ Maria Sharapova lunges for the ball at Wimbledon 2011. On an overcast day, no sun means no shadow, always fill the frame and shoot tight. I used a 400mm lens from the back of the spectator's area to capture this image.

you have an unrestricted view of the court and the player is usually facing you when running towards the net. This spot is ideal for capturing the volleyer coming to the net on your 70–200mm zoom and on a longer lens (300 or 400mm) for baseline action pictures. Unsurprisingly there is a pecking order for these seats at Wimbledon, with the best seat being the one next to the net. At the back of the court is another good position, as by using your long lens you can focus on the player in the far court, which is good for serve pictures and even volleys near the net. A high position looking down on tennis can be used for creative shots. Use the shadows of the evening light to fill the frame, especially when players stretch or dive for the ball.

Choose which side of the court to sit on. The main deciding factor is usually the sun. Do you shoot into the sun or with the sun? Backlighting by shooting into the sun creates atmospheric pictures, especially with low evening light. You need be to be careful of getting too much flare, but if you get it right the pictures can be fantastic. Try to get a black background, either the crowd in shadow or trees if you're lucky enough. The players' white clothing really stands out. To expose for this back lighting either leave it to the camera with shutter-speed priority mode or manually expose (by taking a reading off the grass then applying this to the camera).

Working on a golf course can sometimes be very controlled. At the British Open, for example, you have to have a special pass to work inside the

▶ Tiger Woods tees off in a practice round at the British Open. I have positioned myself with a wide-angle lens right behind him using the trees as a frame and releasing the shutter after he has hit the ball (the sound of the shutter would put him off his stroke).

TIPS AND IDEAS

> On golf swings time your shutter to release as the ball is struck. Take a sequence and choose the best frame. It's golf photographers' etiquette never to take a picture until the ball is struck.

> Stay low for short-game golf shots, such as putting and pitching.

> Best golf action shots are at the tees, bunkers and near the greens.

> The key to a truly great golf picture is the light so think landscape photography.

> Work early in the morning or late in the evening to capture the warm light and when the course is less crowded.

ropes – a level of access granted to only a few. These photographers are carefully marshalled because they are so close to the action; golfers constantly complain that photographers are in their view, even when we are usually not. Moving around in these positions is extremely difficult.

There might be four golfers on the green at any one time lining up their putts. You can only move when there is a lull in the game, so choosing your position is key. You want to be shooting head-on (at the green) to your chosen golfer. On any other part of the course you need to shoot at 45 degrees to the golfer. Be very mindful that even these exceptionally talented pro golfers can sometimes shank the ball. It hurts if it hits you or your equipment.

When applying these techniques at your local golf club, be mindful of the club rules. Go out with friends to practice particular shots (bunker shots, for example) over and over again to get your techniques right. Try to be as creative as possible when photographing

golf. Techniques such as the rule of thirds (p.98) will help improve your composition.

Key Technique

The tennis ball moves so fast and is such an important feature in all your photographs that you'll need good timing and anticipation to capture the racket striking the ball. In golf timing is key to capturing the player's all-important swing.

Timing and Anticipation

These sports are all about timing, whether it is a racket or club hitting the ball. As with other sports you always need the ball in the picture, but getting the tennis ball on the racket strings is a real challenge. At the start of the British tennis season, sports photographers accustomed to photographing other sports often need to practice their timing. They start off by photographing players warming up at the practice area to get their eye in. The key thing is to watch the player's racket as he

▶ Justin Gimelstob dives for a close net-volley at Wimbledon Centre Court in 2005. I used 70–200mm zoom lens set at 105mm with 1/1000th of a second at f/3.2 and an ISO of 160.

TIPS AND IDEAS

> Avoid moving during play. Be considerate and remain still and quiet while the ball is in play, only changing position between games. The sound of the shutter can put players off, and Wimbledon Centre Court is a quiet venue where noise travels.

> Autofocus is particularly good at following players as the player fills the frame well.

> Pay attention to the scoreboard as players often celebrate at crucial turning points in the match.

> If you are up in the stand, use shadows to fill the frame.

> Fill the frame if there are distracting advertising backgrounds. Shoot as close as you can get. On a grass court use a wider lens, however, as the action is not restricted to the baseline.

or she swings it back, and to get ready to take your picture as the racket moves forward. To hone your timing, check your LCD display. Decide whether you are pressing the shutter release too early or too late then adjust accordingly.

If you have a fast motor drive you could let go with a sequence of pictures and hope to get the important action shot of the ball on the racket. Even with a fast camera, however you can still miss this picture. I prefer to use my timing and take one frame only to capture the ball and

racket. While you are concentrating on timing you still have to remember to keep your horizon straight, frame the picture and concentrate on the player.

In tennis and golf photography you focus on the individual player, rather than following the ball – in fact you don't even see the ball. If you can see it when you take the picture, it will be long gone by the time your shutter opens. This applies to all racket sports: you need to be one hundred percent focused on the player, not on the ball. So, with your camera to

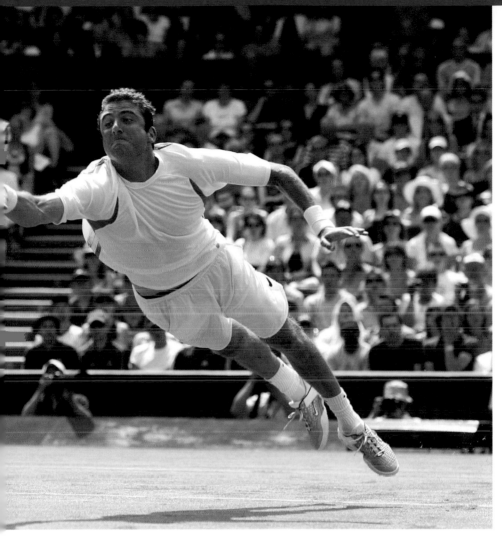

your eye, use your peripheral vision to keep a look out for what the opponent is doing. What you mustn't do is to copy what spectators do at a tennis match – follow the ball left right, left right. Watch out for the unexpected.

THE WINNING SHOT

The winning shot is typically a player diving at the net with the ball on the racket. Such dives are very rare, however, even at Wimbledon. It helps to know your player, as some will stick to the baseline while others come into the net. Players are also more likely to dive at key times of the match, such as tie-breaks and breaks of serve. Find out whether your player is left-handed or right-handed and has ever dived before. Does he or she favour backhand or forehand?

With dives the first frame you take is always the best, so be alert and shoot fast. A shutter speed of at least 1/1000th of a second is needed to freeze the action.

2.5 Target Sports

The two target sports in the Olympic Games – Shooting and Archery – are extremely dangerous to photograph. For the sports photographer the idea is to capture the competitor's concentration and to possibly produce a quintessential English scene as both these sports will take place at very traditional and picturesque venues. The Archery will be held at Lord's Cricket Ground near St John's Wood, while the Royal Artillery Barracks plays host to the Shooting, Paralympic Shooting and Paralympic Archery.

How to Photograph Target Sports

At London 2012 the arena sports of Archery and Shooting will be difficult to photograph, so prepare to bring out your creative side. You will have more options when photographing these outdoor summer sports away from London 2012, so follow the tips and advice below to improve your target sports photography.

Challenges

Archery and Shooting are both very dangerous sports, as noted above. You need to have your wits about you as a photographer and never stray into the danger area. Always stay behind the competitor. You can't realistically hope to capture the bullets or the arrows, although it is possible with special techniques to capture the arrow leaving the bow. You are really concentrating on photographing the participant. Working

SPECTATORS' ANGLE

For Archery and Shooting the spectators' angle will be from the crowd stands. Your best shot will be a beautiful, scene-setting image with the archers or shooters small in the frame, offset by the classic London backgrounds. Zoom in on the details if you can and look out for reaction shots when medals are being decided.

TECHNICAL WISH LIST

Your ultimate pro camera kit is three DSLR cameras and four lenses:
> 400mm f/2.8 long telephoto lens for far-away action shots and detail shots
> 1.4x converter to make 560mm f/4 lens for closer-up shots
> 70–200mm f/2.8 for action pictures and crowd scenes
> 24–70mm f/2.8 for landscape pictures and general views
> monopod
> waterproofs for camera and photographer
> camera and lens belt

▲ This mid range picture is a good starting point for later shots. It allows you to zoom in to capture the competitor's faces and zoom out to take a scene setting picture showing where the action is taking place.

quietly is essential, as the noise of the camera can distract the competitors. An important sports photographers' rule is not to take a picture until after the arrow has been released or a bullet fired.

Camera Set Up

Follow the pointers below to get the best results from your camera set up.

> **Shutter speed** – needs to be at least 1/640th of a second – not to freeze the action (you would need a shutter speed of 1/8000th of a second to freeze an arrow) but to capture the concentration on the competitors' faces.

> **Aperture** – needs to be wide open or mid-range depending on whether you want to keep the background out of focus.

> **Exposure** – manual or shutter speed are best for shooting and archery. If possible photograph in the soft evening or early morning light to give your

pictures atmosphere, contrasting long shadows with pools of light.

> **ISO** – 100–400 during daylight.

Positioning

Follow the marshals' advice for positioning at archery and shooting. You will be positioned behind the competitor, a frustrating spot for a sports photographer wanting to always show the competitor's face. This is something you might be able to do in the practice rounds with permission. A low angle can help when shooting to silhouette the competitor against the sky, or when photographing shooting competitors in the prone position.

Key Techniques

One of the most creative rules of photography is the rule of thirds. Using this rule helps produce pictures that are

easy on the eye and well balanced. You will hear people telling you to break this rule – and I do on occasion – but it will ultimately improve the composition of your images.

Rule of Thirds

For archery and shooting photography, position the subject following the rule of thirds. This technique lends itself to target sports as you will be positioned further away from the subject. Take time to balance the elements of your pictures. Imagine dividing your picture into nine squares with two horizontal and two vertical lines drawn at equal distances It will contain the following:

> nine equal boxes
> four intersecting points
> two vertical lines
> two horizontal lines

Figure 1: The rule of thirds

As a general rule if you have a horizon, track or pitch in your picture use the horizontal lines – preferably the lower-third line – and if you are photographing competitors use the vertical lines. Important elements should be positioned where these lines intersect. As well as using the intersections you can use the bands.

Important elements are foremost positioned: one-third of the way up, one-third of the way in from the left. Elements placed exactly in the centre of the frame or very near the edges are less well placed.

Sports photography happens so quickly that it is likely you won't always have time to implement this rule. There will always be the exception, of course, but it's important to have it tucked away in the back of your mind. Position the subject in archery and shooting photography following the rule of thirds

— a technique that lends itself to target sports as you will be positioned further away. Take time to balance the elements of your pictures. Apply the rule of thirds to all the decisions you make when composing any type of photograph.

▲ A detail shot shows an archer's arm extended amongst all the other competitors at Athens 2004. I used the rule of thirds as an important part in my composition, along with a 400mm lens with 1.4x converter.

TIPS AND IDEAS

❯ Don't move or distract players in any way, especially when they are about to release the arrow or fire their shot.

❯ Always wait until all the archers have fired before you move position.

❯ Remember that wildly squeezing the shutter button doesn't necessarily lead to better pictures — it just leads to more of them!

2.6 Outdoor Team Sports

This section covers the largest sports group of Football (including 5-a-side and 7-a-side in the Paralympic Games), Hockey and Beach Volleyball. I have also included information on rugby, cricket and basketball sports photography. These sports usually take place in large arenas and stadiums, some of which are the biggest in the world. The playing surface can also be large, but the benefits for the sports photographer are the constant interaction of the players and their (sometimes surprising) reactions to one another.

How to Photograph Football

Football is the lifeblood of English sport. Love it or hate it, it is the national game and I cover nearly a hundred games a season. Action photo opportunities come thick and fast during a football game, although the really great images only come round once in a while. This section shows you how to develop your sports football photography, so you can then apply it to everything from Premier

League games to those in the London 2012 Games, fixtures in the lower leagues or games on Hackney Marshes. The same techniques can be applied to children's football matches on a Saturday morning or even to a kick-about in the back garden.

Challenges

There are many challenges to consider. The playing surface is huge and the game involves 22 players, two goalmouths and a ball that is fast-moving on the ground and sometimes hoofed into the air. It's non-stop, often end-to-end – predicting where the action is going to happen is an art in itself, but the more matches you photograph the better you'll get at this. You can help yourself by knowing which team is technically better and should win, and which has the home advantage. Is it

SPECTATORS' ANGLE

The action can seem a long way away so concentrate on the overview of the stadium with the play going on below you. Remember that when a team scores, people jump up in front of you to celebrate; this can frame the picture perfectly for you. As action pictures are difficult to take from here, think laterally. It's more about recording your day than a peak-of-the-action sports photograph.

◄ Tottenham's Luka Modric and AC Milan's Flamini tangle when going for the ball. This is a classic football action shot.

worth taking a chance on the underdog winning? Which striker is most likely to score and which players are controversial and likely to react?

Weather conditions on a cold and wet night when the game is played under floodlights make photographing difficult; there is no shelter and the rain hitting the front element causes smears on the lens. You also have to contend with your hands and fingers freezing for 90 minutes and the searing pain as they defrost in the press room afterwards!

When photographing your children having a kick-about in the back garden keep a low angle, as this adds a sense of power to the players. Kick-abouts are a perfect subject for compact cameras; you're close to the action so your wide-angle lens is ideal. The shutter lag will be a problem, though, so practice your timing to get both foot and ball into the frame. You want to press the shutter just before the child makes contact with the ball, as the shutter delay means that the picture will be taken just after the ball has been kicked with the ball still in the frame. So shoot, review, repeat.

This is where digital makes things much easier for the photographer. Learn from your mistakes, check each picture after you take it and then adjust your timing accordingly. This also applies to exposure and composition: try, try and try again until you get that perfect picture. As compact cameras don't have a motor drive, you have to choose the right opportunity to take a picture – the shot on goal, the offside strike, the header or even the penalty miss.

Camera Set Up

Follow the pointers below to get the best results from your camera set up.

> **Shutter speed** – needs to be 1/640th of a second or faster to freeze the action.

> **Aperture** – needs to be wide open f/2.8 or f/4 to throw the background out of focus and draw attention to the subject, in this case the players.

> **Exposure** – manual exposures are best. The light is usually even and

WINNING SHOT

With this dramatic picture, taken in-doors at the Millennium Stadium in Car-diff during the 2007 Carling Cup final between Arsenal and Chelsea, I won the Sports Photographer of the Year award. The peak-of-the-action shot featuring the ball was actually the frame before, but this illustrates the impact of Abou Diaby's boot making contact with John Terry's chin. Capturing the moment of impact, with the grass and mud spraying behind, is very rare and makes a great 'don't follow the ball' shot. It is my all-time favourite football image. When I saw John Terry throw himself at the ball to head it away, I let go with a sequence of 12 motor-driven frames. I was using my 70–200mm goalmouth lens at the 200mm end of the scale. The shutter speed was 1/640th of a second with an aperture of f/2.8.

▲ This image of a winter afternoon football match looks like it was taken in the lower leagues but was actually a Premier League game. It shows you that you can use silhouette to produce great pictures in any level. This shot was taken on a remote camera situated behind the net.

controlled under floodlight or in shadow in the stadium. Take a meter reading off the grass with your camera meter to get the correct exposure.

> ISO – is set as low as possible to give you the sports photographer's norm of 1/640th of a second at f/2.8. Under sunlight the ISO starts at 100 and goes up, while in the shade it starts at 400 and goes up. Under floodlight conditions the ISO will start at 1000 and go up.

Automatic exposure is also fine as the light is usually even. Compact cameras and camera phones should be set to sport.

Remote Cameras

The quality of digital cameras and the improvement in radio transmitters has made the use of a remote camera at the back of the net popular. You are not allowed to put a camera with a lens poking through the net, but a metre back from the net you can set a camera up with a wide-angle lens on a mini-tripod. The lens is pre-focused just beyond the goalkeeper, and a radio receiver on this camera is triggered to take a picture every time your goalmouth camera (70–200mm lens) takes a picture. This gives another angle on the goal; one you otherwise wouldn't be able to get, as you can't sit behind the goal.

As you can see from the picture of Chelsea's Petr Cech diving (p.107), this low angle accentuates any dive the goalkeeper makes and produces some of the most dramatic pictures of football. Be aware that stray footballs often hit the remote cameras and can do a lot of damage. This low angle works because all the action is concentrated

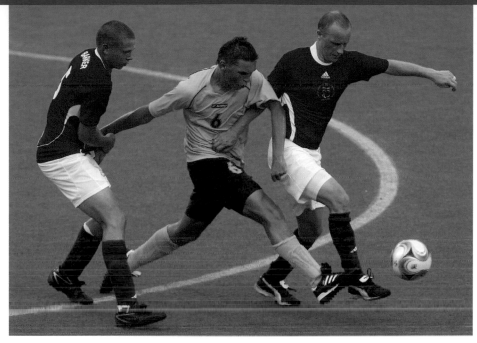

▲ A Paralympic Football match shot from a high angle emphasizes the colours red, yellow and green. When photographing from this high up always look out for shape and symmetry in your subject. This was shot on a 300mm lens from the spectator's seating area.

in the goalmouth and you'll capture the goal scorer, the keeper diving and the ball crossing the line. The low angle accentuates the power of the action and gives the effect of bringing the viewer into the game.

Football at the Paralympic Games

Paralympic 5-a-side Football games are played between two teams with four blind athletes and one sighted or visually impaired goalkeeper. Each team has a guide behind the opponent's goal to direct the players when they shoot. Use the techniques described above. The 5-a-side version is slower paced, but the pitch is surrounded by a rebound wall and there are no throw-ins. This results in a flowing game, which allows you more time to compose your pictures. If a penalty is awarded, move your position nearer to the goal, depending on whether the penalty taker is left- or right-footed.

Paralympic 7-a-side Football teams are made up of ambulant cerebral palsy athletes on a smaller pitch, with smaller goalposts. Photographically it is easier to cover the entire pitch from one position. Use the techniques of timing and anticipation to freeze the action and highlight the athletes' speed, agility and ball skills.

A 300mm long telephoto is the optimal lens to photograph both these sports. Set your shutter speed at 1/620th of a second and use a wide-open or mid-range aperture.

Positioning

Never underestimate the importance of position. Ask any football photographer

TECHNICAL WISH LIST

Your ultimate camera kit at pro level is two motor-driven cameras and two lenses:

> 400mm f/2.8 lens on a monopod, for goals at the other end of the pitch, mid-field action, managers, action pictures and close-ups of players' faces

> 70–200mm f/2.8 goalmouth lens for the all-important goals and celebrations. Used at the longer end of the scale pointed towards the goalkeeper and the goalmouth when you are waiting for someone to shoot. Look out for the celebrating player running towards kiss-badge corner (players run to the corner flags after scoring to celebrate by kissing the badge on their shirt).

> remote camera (to position behind the goalmouth)

> wide-angle lens (24mm) and radio transmitter and receiver

> mini-tripod

> waterproof camera bag for both camera equipment and laptop

> waterproof clothing

> waterproof cover for both cameras and both lenses

> converter 1.4x for free-kicks at the other end of the pitch

> monopod to keep large telephoto lens steady

> laptop and transmitting device

how many times they have returned to the press centre and said the dreaded words 'I was at the wrong end' for all the goals. A football photographer's worst fear is to spend 90 minutes watching 22 players run away from him! I memorably went to Istanbul for the Champions League final between Liverpool and AC Milan in 2005. Milan scored three goals in the first half at the other end of the pitch to me, so I stayed where I was for the second half. Liverpool then scored three again at the other end of the pitch. The game went to penalties which Liverpool won 3-2 on penalties, meaning I was at the wrong end for 11 goals – this must be a record!

The best place to photograph football is pitch-side either side of the goalmouth. If you watch a Premiership game on television, you'll see all the professional photographers huddled together either side of the goal. The reason for this is that when the team attacking the goal run with the ball, or shoot at the goal, they are usually facing the goal and you want to be able to see everyone's faces in your picture. If you sit on the sidelines, the players are running across you towards the goal and are in profile – better for individual pictures of the players, but not for dramatic action pictures.

If the list of kit for professionals looks daunting, a single motor-driven camera with 70–200mm lens can produce exciting shots. The positioning stays the same: sit or stand beside a goal and wait for the action to come toward you. Don't be impatient if the action seems a long way away, just wait and the players will come nearer to you.

For compact cameras and camera

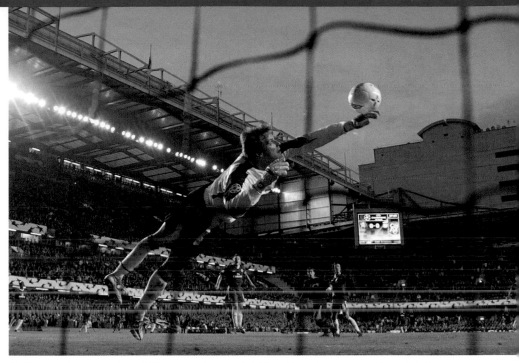

▲ This remote-camera shot of Chelsea goalkeeper Petr Cech diving to save a goal-bound shot was taken with a 17mm lens. I used a manual exposure of 1/640th of a second, f/2.8 and an ISO 1000.

phones the same principles apply. Stand or sit to the side of the goalmouth. Your zoom lens might be shorter so remember to fill the frame and wait for the action to come to you. Goals often make better pictures anyway. Shoot on a slightly wider lens as both goalkeeper and goal scorer are in the picture.

The goal being scored is the peak of the action, the ball going in the back of the net – that's the key image. My picture editor used to tell me that no two games are the same, and that there is always something unique that happens. Whether it's the way that the goal is scored, the sending off, the collision of players or the personalities involved, there is always one moment from that game that sums it up. This is the moment for which, as a photographer, you've always got to be ready.

Key Techniques

Photographing football games requires many skills, but two of the most important techniques are highlighted below.

To Follow or Not to Follow the Ball

The general rule when photographing football is follow the ball. Normally in sports photography you concentrate on the player or athlete. Football is different: with 22 players and a fast-moving ball you've got to concentrate and keep it in sight just as the players do. Whatever is going to happen during the course of the game will happen around that ball, so stay with it. When I say follow the ball, I don't mean point your AF spot on the ball. Point it at the player nearest the ball, but don't let the ball escape your frame.

The important point for the focus is to keep the AF sensor on the main player

TIPS AND IDEAS

> When photographing at a football match don't let your long telephoto obscure the person sitting to your left and right (this is against photographers' etiquette). This is also true for the crowd behind you. Keep low so that everyone can see the action.

> Check your background – particularly important at lower-level football, Sunday league or in the local park. Try to keep the background as clean as possible, avoiding the man walking his dog or bits of buildings, cars and pushchairs. If the background's messy you can always move!

> Keep it all level. Always keep the camera level so that the action is on a flat pitch and doesn't appear to be going up or downhill. Photographers quite often forget to keep the horizon level with all the action going on in front of them.

> If you're following the home team sit in front of the home crowd not the away fans. When a player scores he usually celebrates to his fans, not the opposition.

> When photographing penalties lock the focus on the ball and wait for the player to strike the ball. Take one frame just as the player kicks the ball. If you just let the motor drive take a sequence you risk missing the frame where the ball has just left his foot, ending up with the frame before and after.

> At pitch level players run through very, very quickly. It all seems much faster than when viewing from the stands, so be ready to change lenses – goals can be scored in a matter of seconds. At this low angle you don't see the play developing, so stay alert.

> Shower caps from hotels make excellent waterproof covers for cameras, especially remote cameras.

in the frame. Fill the frame and look for players tugging each others' shirts, pushing each other as they try to tackle. If you've got two players running towards you with the ball keep them in the centre of the frame. Keep your focus locked on them, stick with them, just keep shooting the closer they get from full length – and if the ball is in the air you can end up with a portrait of each of them and the ball. The camera's focusing system, once locked on, keeps up with the action. Even if another player walks in front of you just keep panning with the players on the ball. Sometimes you lose the auto-focus

frustratingly, but just wait for it to come back in.

One of the key decisions you have to make as you sit behind the goal and a player is running through from midfield, is when to drop your long lens and pick up your goal-mouth lens. You want to get that great bold action image of the players, but you don't want to miss the goal. It takes a couple of seconds to change from the long lens and pick up the shorter lens around your neck. This decision is vital. Leave it too late and you will be taking a picture of the goal on too long a lens, when all you can see is half

the player. Drop the long lens too early and you end up with lots of small images.

Having said that there are times when you don't follow the ball. Players might fight, managers shout, crowds scream – reaction takes place all around you. When a player is running down the wing, at some point you have to swing from photographing him to look for where he's going to cross the ball. If you follow the ball as he crosses it you'll be too late. You need a split second to lock the focus on the player receiving the ball, so you're anticipating where the ball is going to be crossed to and which player is going to jump highest. No one gets this right every time. The other time you don't follow the ball is when the goalkeeper kicks the ball or someone hoots it in the air. Look for two players jostling and focus in on them and wait for the ball. This is all about timing – hit the shutter button the moment you think one of them is going to head the ball. This is where you find out how good your timing is. Some photographers get this right every time, even when they are really close to the players. It's an art.

Action and Reaction

Football photography is the classic action and reaction sport. The action is obvious, it's happening in front of you – headers, two men and a ball, clashes, dives, tackles and shots. The drama and emotion of reaction comes in two forms – celebration when a player scores or dejection when the opposing team does. Football celebrations are notoriously over the top: you always get a picture when someone scores and players know where the cameras are – they come and find

you! They want their picture taken when they've scored a goal. Pictures of dejected players can be just as dramatic.

Penalty shootouts are a photographer's dream. As the players line up behind the penalty kicker their faces tell the story, whether it's a hit or miss. When the shootout is decided the winning team leap in the air and run towards the goalkeeper, making a great picture. You could fill a book with celebration pictures as every player has his own signature, from Ronaldo sucking his thumb in dedication to his new baby, to the simple arms outstretched running towards the cameras. Always look out for players jumping in the air.

Watch out for crowd reaction too, especially at lower-league levels or Sunday-morning football. Off-the-ball photographs at school football are often humorous – look out for the over-enthusiastic mum or dad on the touchline, younger siblings with their ice creams dripping or kids on the subs bench giggling!

THE WINNING SHOT
When it comes to photographing football the winning shot is usually the winning goal – whether scored in the Champions League Final, a game in the Olympic or Paralympic Games or a school match. A photographer next to the goal always needs to be ready, poised to anticipate what's going to happen. Remember goals can be headed in or jabbed in, shots can be fired from a long way out or crossed from a corner, so you need to have your wits about you.

How to Photograph Hockey

Things can happen in the blink of an eye during a hockey game so preparation is key. It's similar to photographing football and is sometimes called football with sticks. The action is quicker, though, and the ball more difficult to spot. This sport is a rarity in that sports photographers are hoping for bad weather, as water on the artificial surface creates an added dimension to the photos.

SPECTATORS' ANGLE

The spectators' angle in hockey is usually in the seating area. Think about shooting slightly wider to capture the whole goalmouth scene as players celebrate a goal with their arms up. Zoom in to get specific action shots. You can use this high angle to shoot down on to the action. Look for long shadows in the evenings, and get creative by using the colours of the hockey jersey with a zoom burst effect.

A pan blur from this high angle can also work and produce an interesting image. Don't zoom while you're following a play, just leave the zoom lens at the longest setting and concentrate on following the play. That part is hard enough. Take a look at pro photographers' work, or in sporting magazines to see where those pictures are taken from. Of course use very fast and long lenses, but you can still take good pictures with your equipment and a little practice.

Challenges

The challenge is the speed of the hockey ball and the main priority is not being too close to the action – you really don't want to get hit by this very hard ball. You are usually standing behind the advertising hoardings, which help to screen you; if you are at a school tournament, stay very aware of the dangers. The action is really quick and can be taking place at the other end of a large pitch. Be patient and wait for the action to come to you.

Camera Set Up

Follow the pointers below to get the best results from your camera set up.

> **Shutter speed** – needs to be 1/640th of a second to freeze the action. A slower shutter speed, maybe 1/125th of a second or less, is better for a pan blur.

> **Aperture** – needs to be wide open to keep the background clean. Concentrate on your focusing with this narrow depth of field.

> **Exposure** – use manual exposures or shutter-speed priority for this action sport. You can shoot backlit especially if you have dark spectator stands in the background, but remember the camera's autofocus can struggle when shooting

TECHNICAL WISH LIST

Your ultimate pro camera kit consists of two DSLRs and two lenses:

> 300mm or 400mm f/2.8 for action shots and bench shots

> 70–200mm f/2.8 for goalmouth action shots

> monopod

into the light (there is less contrast for the AF system).

> **ISO** – 400 and above on a cloudy day; 100 and above on a sunny day.

Positioning

Because of the dangers of photographing hockey, the best angle (if you are allowed there) is on the sidelines shooting into the goal. Unlike football the goalkeeper is very heavily padded, so follow him or her. You can also get good pictures of the midfield action from the side. Think about your background and avoid having empty seats, fluorescent jackets or bits of buildings in your background. If you can, use a low angle – it is better to sit down than stand up. Don't forget to look at the bench to spot interesting moments, or to turn around to look over the stands – there are a lot of emotions and expressions to capture there.

Capture the Crowd

While not a true photographic technique, capturing the crowd is an important part of your sports photography. It is most rewarding at occasions of high drama where a lot is at stake, such as the London 2012 Olympic Games.

Sport is exciting, with the atmosphere generated by action and crowd together. I know this may seem contradictory as I stress in this book that overly busy backgrounds detract from a great image, suggesting you should always try to get the crowd as far out of focus as possible to keep a clean background. However, here we are talking about using the crowd as your subject, which is a very different thing altogether.

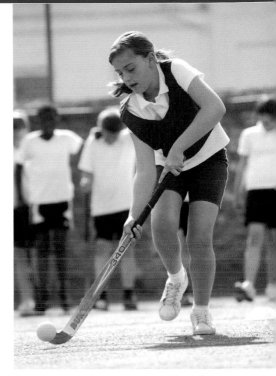

▲ Positioning is a key technique and here the photographer has positioned himself head on as the hockey player runs towards him. The background of other school children places the image.

TIPS AND IDEAS

> Remember to pack waterproof gear if it's raining.

> Be alert for that small, hard ball – once struck, you'll not forget it.

> Watch out for the crowd, a good source for colourful pictures.

> A low angle is best because competitors have their heads down looking at the ball.

> Know your sport and know your stars – find out which is the favourite team.

> On the final whistle focus on the winning team's bench or subs, as they can leap in the air celebrating and run on to the field.

Crowds are colourful, noisy, gesticulating, moving and full of emotion. Sometimes you need to step back from the action and wait for key moments in the sport. In hockey, for instance, wait until one team gains the upper hand over another after scoring a goal – the crowd's reaction to this goal is the picture you're after. You can shoot on a wide-angle lens photographing the people around you, or if you prefer, zoom in to catch people unawares. These shots complement action pictures well, adding to the visual story of your day.

One of the biggest challenges with shooting the crowd is the subject itself. The jumble of colours under a harsh midday sun can create a very busy image, but it is just such a busy, dramatic picture that you are looking for. As you are unable to use flash, use a shallow depth of field, focusing in on one or two interesting faces in the crowd. Watch out for players' expressions of extreme delight or utter despair.

THE WINNING SHOT

The winning shot for hockey is a peak-of-the-action moment – a player off the ground diving after hitting a really hard shot. This is a classic freeze-the-action image. Key points are a fast shutter speed, a shallow depth of field and concentrating on getting the focus sharp. Timing is critical. Motor-driven sequences will help if you have a fast camera as you can choose your best frame from the sequence.

How to Photograph Beach Volleyball

This very popular sport is a real challenge to photograph – much quicker and fast-moving than you'd think. At the London 2012 Olympic Games it will take place at Horse Guards Parade, one of the most picturesque and beautiful locations in London (p.226). From the back of the stands we hope to get a view of the London skyline including the London Eye above William Kent's Horse Guards building.

Challenges

It's difficult to know where the ball is going in volleyball or which player is going to return the ball in this fast-moving team sport. It's therefore better to concentrate on one player, following him or her and take the best picture you can. If you hunt around following the ball you can sometimes miss the action, especially where this is fastest near the net. Beach volleyball often has intruding backgrounds, which get in the way of your beautiful diving shot, so pick your position carefully.

Camera Set Up

Follow the pointers below to get the best results from your camera set up.

> **Shutter speed** – needs a fast shutter speed, 1/1000th of a second, to stop the action.

> **Aperture** – wide open to mid-range aperture to keep the backgrounds clean in this busy arena.

> **Exposure** – always held outside with lots of light bouncing off the sand,

▲ This image was taken at the beach volleyball test event at Horse Guards Parade. I used a 24mm lens to capture this colourful image.

manual exposures work best or shutter-speed priority. If photographing on the beach in the midday sun, remember to open the exposure up one-third to two-thirds of a stop.

> **ISO** – 100–400.

Positioning

At ground level position yourself near the net if you are allowed, using a wide-angle or mid-range zoom to capture players diving for the ball. Don't shoot too tight (going close in on the ball); leave plenty of room for the action as this is a fast-moving sport. Another option is to position yourself at the end of one court on a longer lens, shooting towards the far court for action pictures.

A high-up position in the stands (see Spectators' Angle) makes for strong pictures with the sand as the background,

SPECTATORS' ANGLE

The spectators' angle in volleyball can be very good. Being high up and looking down on the courts is a good angle for capturing both action pictures and the view of London behind. Zoom in with your camera, and from the higher angle you can follow the ball.

TECHNICAL WISH LIST

Your ultimate pro camera kit consists of two DSLRs and three lenses:
> 300mm f/2.8 for action pictures
> 70–200mm f/2.8 for general action pictures and diving shots around the net
> 24–70mm f/2.8 for wide-angle views from the back of the stand

especially when the players serve or jump up at the net to spike the ball. Get creative with this high angle, using shadows and evening light for more interesting images.

Key Technique
Zoom Burst

Zoom burst is a creative photographic technique, which is used to produce a striking photograph from a not immediately dramatic scene. The first thing you need is a zoom lens, either a mid-range or 70–200mm zoom. Then find a colourful subject such as a volleyball player standing in front of a crowd of spectators.

Place the volleyball player in the centre of your frame. On your camera dial in a long exposure of approximately 1/60th of a second (shutter-speed priority) or below, then rotate your manual zoom ring on your zoom lens as quickly as possible. This will produce blurred streaks emanating from the sharp part of the picture, which is at the centre, creating a colourful special effect. It's great fun to practice this technique at sports venues and on people's faces.

TIPS AND IDEAS
> Follow one active player through the game. It's easier to concentrate on one player in this very busy and fast-moving team sport.
> If working near the net, pre-focus where you think the action is going to happen. Sometimes the camera's auto-focus system isn't quick enough and pre-focusing with a smaller aperture, such as f/5.6-f/8 will be more successful.
> Don't get carried away with the atmosphere – always stay focused on the action.

▶ This beach volleyball action shot is taken on a 400mm lens from the end of the court. It is slightly spoilt by the empty seats in the background. Always bear in mind the background when choosing your position.

How to Photograph Rugby and Cricket

There's a real art to photographing rugby. The ball is passed quickly along a line of players in this fast-moving physical game, so you need knowledge of the game and know how to anticipate. If you follow the ball along the line, even with a top-of-the-range professional camera and lens, the autofocus takes a split second to lock on. This is sometimes too long and you miss the picture. You could pick a player instead and wait for the ball to come to him – it's your choice.

From scrums and line-outs to tries and conversions, there is a lot going on in a rugby match. This creates plenty of opportunities for the sports photographer, with the action providing a good narrative framework. Show the power of the forwards and the speed of the wingers. When there's a ruck or maul follow the scrum half: a key player whose job it is to feed the ball out. Players have their heads down when carrying the ball requiring a low shoot-angle, so sit on a low stool or on the floor.

Don't shoot when the action is at the other end of the pitch – be patient and wait until it comes to you. I find the optimum position (which may be reserved for professionals at elite level) is behind the try line in a corner where the players

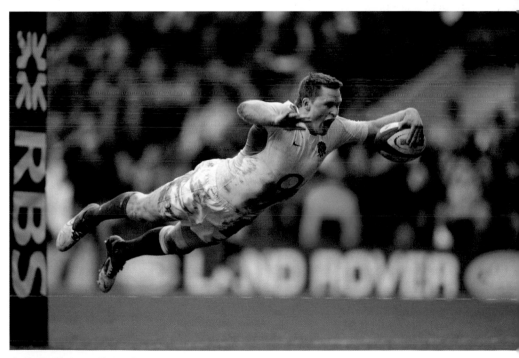

▲ England winger Chris Ashton dives over for a try against Italy in the Six Nations, 2011. I used a 400mm lens, 1/6400th of a second f/2.8 and an ISO of 1000. This picture looks straightforward but the posts confuse the camera's autofocus system, so pan with the player.

run at the camera. For full-frame action images shoot if possible on the side of the pitch, as this position is good for line-outs and individual running shots.

If photographing at your local rugby club with a compact camera, stand at the end that your team is attacking. Choose a corner, stick to it and hopefully you'll successfully capture that winning try. Remember the shutter lag on a compact camera, so time one shot as the player touches down.

Rugby is usually played during the darker winter months, often in stadiums with poor lighting. The darkness is not necessarily a problem, however. It can add to the atmosphere of your image – especially if it's raining and you have literally steaming, powerful, mud-spattered forwards battling for the ball. You'll need a high ISO and shutter speed of 1/620th of a second.

Cricket is the quintessential English summer sport, usually played in county cricket grounds or on attractive village greens. The demands it places on a sports photographer's concentration are high. You need to be ready for six balls every over, all throughout the day – I can guarantee that if you take a break that's when the action will happen!

You will need a very long telephoto lens to capture cricket action, usually a 600mm f/4. Photographers are stuck out on the boundary, a long way from the action. Position yourself at either end where you can photograph both wickets. Shoot the batsman when he is at the far wicket and the bowler and fielders when the batsman at the near wicket is active. Pre-focus on the batsman and wait for him to hit the ball. Your position at either end will be either side of the wicket, depending on whether the batsman is left- or right-handed. Make sure you can see the batsman without the bowler getting in the way. If a wicket falls quickly re-focus on the bowler as such images make the best reaction shots.

Great cricket shots are rare, with a run out, diving catch or stumping being among the most dramatic. If the action is slow, compose scenic pictures of your favourite village green with a compact camera, using the golden light for a memorable, evocative image. Spectators at cricket matches make their own quirky snaps – such as an old gentleman asleep with his paper and a pint.

▲ Toby Flood stopped in his tracks by two Scottish players. A rare image so be patient and concentrate. I used a 500mm lens at 1/640th of a minute at ISO 1200.

▶ This is a classic cricket image with Australian Shane Watson's position making a great shape. Shot on a 500mm lens with a 1.4 x converter from the boundary.

2.7 Outdoor Water Sports

Outdoor water sports are a popular subject to photograph, though not an easy one. Water is an unknown quantity and brings an element of unpredictability into your shots. This can be hugely effective or it can make your life as a sports photographer difficult.

This section ranges from canoeing, rowing and open water swimming, which are always popular with photographers, to the really photographically challenging sports of sailing, waterskiing and surfing.

How to Photograph Open Water Swimming

This endurance sport, which at the London 2012 Olympic Games is called the 10km Marathon, takes place over a course in the Serpentine in London's Hyde Park (p.227). For the sports photographer the end of the race is key: the athletes have really been pushed to their limit over 10km and when they finish it's an intense time. The crowded swimmers are fiercely competitive, kicking and punching their way across the water like a shoal of frenzied fish.

◀ This frantic image shows the open water swimming discipline of the Beijing 2008 Triathlon. With arms everywhere it's difficult to tell which way the swimmers are going. I positioned myself on the lake edge and waited for the swimmers to enter the frame.

Challenges

All the action in open water swimming happens under the water and out of sight. The competitors keep their heads down during the racing, so it can be pretty tough for a photographer. The one thing going for you is the fact that the event goes on for 10km, giving you plenty of time to practise and to wait for that shot. And if you're not on a press launch (see below) don't worry – it's still possible to take interesting pictures from the shore.

Camera Set Up

Follow the pointers below to get the best results from your camera set up.

> **Shutter speed** needs to be 1/1000th of a second to freeze the action.

> **Exposure** – exposing on water can be tricky, see sailing (p.130).

SPECTATORS' ANGLE

The spectators' angle is the same for the Triathlon at London 2012 – either grandstand seating or ground level around the Serpentine. Don't forget to take general views and establishing shots. In this traditional venue identify other picture possibilities, as the large crowd will be spread all over Hyde Park. Let your imagination play, and capture the potential.

▲ This is the beginning of the Triathlon from Beijing 2008. The dive into the water always produces interesting images. I decided to use the Beijing 2008 logo as the backdrop. The angle I chose shows excellent colour and form.

> **Aperture** – needs to be wide open to mid-range.
> **ISO** – 100–200 use in sunshine, and up to 400 on cloudy days.

Positioning

There are two positions for photographing open water swimming. If you are standing on the bank use a low angle and a long telephoto to reach out to the competitors. The start makes for great images as the competitors all dive in together: this is the frantic part of the race. As the race goes on the competitors get slower and slower, so it's worth being patient to photograph them when it becomes easier. Remember to look for which side the swimmers breathe on (p.190).

The finish produces great reaction shots as the winners and losers emerge from the water. They have so little energy left that they often collapse on the floor so be ready to zoom in on their contorted faces.

Professional photographers' favourite spot is on board a press launch, which travels to the side of the racers. This makes it easier to get your shots and a shorter lens is required. You can look out for interesting buildings or scenes in the background to make your images more varied. Don't just hone in on the swimmer.

Key Technique
Adapting to the Action

A sporting environment can be unforgiving. As a photographer you must adapt to it, as it won't adapt to you. The lighting may well change, and the harsh outdoor conditions almost certainly will. Add to this the variable of marshals and spectators and you have a volatile mix.

Even professional photographers have to compromise and don't always get the shot they want. You might even miss something you really need.

Adapting to the action involves both planning ahead and being able to adjust your positioning and gear in response to changes on the spot. When photographing open water swimming, for example, be prepared for the weather to change. Find out the tide times and when sunrise or sunset will be. It might be a bright and sunny day when you start your shoot, but you can't guarantee that conditions will not have changed by the end of the day. Have you packed your rain gear? Waterproof covers for your cameras? Or if you start off wearing waterproofs and the sun comes out, can you fit your gear into your camera bag? With camera equipment we all try to travel light and not carry everything, but deciding what to leave is a difficult call. If there is a chance that you might need that ultra-wide lens, long telephoto or off-camera flash on your shoot, you may have to carry them all day just

to nail that great picture.

The best positions for photographers can also change at the last moment. You've selected the spot to take your dream picture, only for a marshal to tell you 10 minutes before the race starts that you have to move. The best bit of advice is not to argue; be proactive and move on. The picture angle may not be as strong, but it's better to get something than nothing. Last-minute changes in position can be frustrating, but they happen regularly to professional sports photographers and you have to be able to deal with a sudden change.

Essentials for Working Outdoors on a Full Day Shoot
1 Sunblock and hat
2 Waterproof coat and trousers, both easily stowable
3 Comfortable walking boots
4 Waterproof covers for your cameras and lenses
5 Supply of drinking water
6 Energy bars and bananas for a quick energy fix

TECHNICAL WISH LIST
Your ultimate pro camera kit contains two DSLRs and three lenses:
> 300mm or 400mm f/2.8 long telephoto for action shots
> 70–200mm f/2.8 telephoto zoom lens for action pictures from press launches and general views
> 24–70mm f/2.8 wide-angle for general views and candid shots

TIPS AND IDEAS
> Frame your pictures with trees near the water to give your pictures more depth. You are photographing landscape as well as sport.
> Look for tight shots that go close in on the action to highlight the exertion on the swimmers' faces.
> Tell the story by capturing the frenzy of the race with a crowded, foam-filled shot.

WINNING SHOT

The winning shot for open water swimming is a competitor overcome with emotion after finishing the course. Swimmers sometimes have to be pulled out, and this is an opportunity to get the big reaction shots of the winners and losers. Don't always focus on the winner. Remember that disappointment plays a big part in sport, and can be just as powerful in a photograph.

How to Photograph Canoe Slalom

Canoe Slalom is a high-action, exciting sport that draws a lot of photographers. The new Lee Valley White Water Centre, created for the London 2012 Olympic Games, offers a cutting-edge, brand new venue with strong visual appeal – foaming white water in a controlled environment, with really good access and positions close to the action.

SPECTATORS' ANGLE

The spectators' angle at London 2012 is quite high from the grandstand seating. Zoom in on the action using manual exposures and, if you can, avoid shooting into the light. Use the longest lens you have and concentrate on tricky gates. Look for drama: capsizing and broken paddles are common in this dramatic sport.

If you are on the riverbank, shoot from a low angle. Watch for promontories or areas that jut out into the river, and possibly for bridges over the river. Getting close to the action is the name of the game.

The drama of the timed run down a white water course with up to 25 gates to negotiate is heightened by a two-second penalty if you touch one of the gates and a 50-second penalty if you miss one out – what a disaster!

I will certainly be photographing at the Lee Valley White Water Centre during the Games. The powerful combination of white water, fast action and excited crowd means the potential for capturing great images here is high.

Challenges

One of the challenges of photographing Canoe Slalom is the light reflecting off the white of the water. It confuses the camera's metering system by telling it there is too much light coming into the camera, then automatically darkening down the image to compensate. This is especially true shooting into the sun, which is almost impossible unless you want a silhouette.

It's best to shoot with the light and with a manual exposure if this is possible on your camera. Use a handheld light meter or grey card to take a reading (this gives you the reading for the canoeist's face). Of course if the picture has a lot of white water in it you will have to darken the image down by half a stop to give detail in the water.

▶ In a picture like this, expose for the water and don't let the highlights bleach out. Get ready to shoot when the competitor's head pops out of the white water. Here the canoeist's eye is just visible in the white water, creating a dramatic effect. The picture was taken using a 400mm lens with a 1.4x converter, 1/2000th of a second at f/4 with an ISO of 100.

▲ David Florence of Great Britain on his way to winning a silver medal in the C1 Canoe Slalom at Beijing 2008. Freeze the action with a fast shutter speed when photographing this exhilarating sport.

There's a bit of trial and error with exposure, so make sure to have a practice. If you have time, download the images to your laptop for proper analysis. Be aware that the back of the camera's LCD doesn't give enough information with this critical exposure problem. Even professional photographers usually share information on exposing this difficult sport.

Camera Set Up

Follow the pointers below to get the best results from your camera set up.

> **Shutter speed** – needs to be 1/1000th–1/8000th of a second to freeze the droplets of water. 1/8000th of a second gives an incredible effect of frozen water droplets.

> **Exposure** – correct exposure is critical (see Challenges above). The contrast range from the competitor's face under a helmet to the highlight of reflected sun on the water is huge for the camera to capture. You have to be spot on with your exposure, making canoe slalom in effect a manual-only sport.

> **Aperture** – wide open to f/5.6. With so much light around even at a low ISO to get the exposure triangle you can end up with a mid-range aperture.

> **ISO** –100: as low as possible (see above)

Positioning

With the careful use of light, really dramatic images are possible. Use long telephoto lenses, longer than you would normally use, to focus in on the canoeist's face as he or she is surrounded by the frothing water. It is unusual for professionals to be able to stand so close at a Canoe Slalom event, but

the man-made arena of the Lee Valley White Water Centre allows them to get a lot closer than they normally would to photograph canoeists on a large mountain river. Even in the spectators' seats you will be nearer to the action than usual, so use this to your advantage to get bold action pictures.

Choose your position carefully. Head to a gate where the canoeist has to turn and paddle upstream to get round the pole. This gives you time to grab a shot while the canoeist is still for a split-second. Don't shoot on a fast stretch of water where the canoeist is paddling at full pelt downstream, as this can be too fast for the camera's autofocus system. Try to capture some of the great expressions pulled as canoeists grimace through the white water. Keep a low angle on the deck.

Key Technique
Expect the Unexpected

In sports photography you need to keep the unexpected constantly in mind. Favourites do get beaten, horses fall at jumps, own goals are conceded, bikes crash and canoeists turn upside down. It's very easy to think ahead and plan your day, only to have a situation change very suddenly. Always have your wits about you and keep a look out for the unexpected, as these moments usually produce brilliant pictures. At the 2008 Olympic Games in Beijing a Canoe Slalom competitor's paddle snapped in half in the powerful white water. As the competitor bobbed up from under the foam he was holding a broken paddle aloft, and went on to finish the course using it. This humorous image stood out among the hoards of regular Canoeing images.

WINNING SHOT

The professionals aim to take a winning shot of a competitor's face showing his determination while surrounded by white water frozen by the fast shutter speed. In this picture (p.123) the water hides his canoe, but you don't miss this as you are looking for the eyes.

TECHNICAL WISH LIST

Your ultimate pro camera kit consists of two DSLRs and two lenses:
> 400mm or 600mm f/2.8 or f/4 long telephoto to freeze the action
> 70–200mm f/2.8 for pan blur shots
> 1.4x converter
> monopod
> chamois leather lens cloth to clean the front element of water
> incident light meter or grey card

TIPS AND IDEAS

> Always make sure there aren't any water drops on the lens as it will ruin mist photographs. Even a light film of water on your front element will soften the image significantly.
> Always be ready for action. Unpredictable things happen in this sport.
> Study white water canoeing pictures that you admire and notice what the photographer did to make the picture appealing to you.

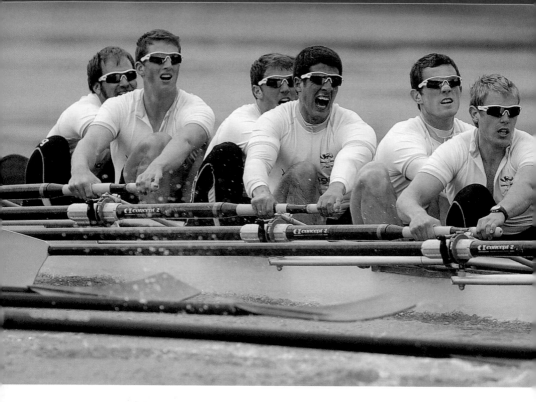

TECHNICAL WISH LIST

Your ultimate pro camera kit contains two DSLR cameras and three lenses:
> 500mm f/4 hand-holdable long telephoto for use from a press launch. Sometimes if shooting from the river bank a 600mm or 800mm telephoto is required
> 70–200mm f/2.8 for action pictures featuring more than one boat or when you are extremely close to the boats
> wide-angle 24–70mm f/2.8 for generic views and landscape pictures of rowing
> chamois leather to clean spray off the front element of your lenses
> waterproof box to keep you camera equipment dry

How to Photograph Rowing

A great creative eye and persistence help the sports photographer take stunning rowing images, whether it's a peak-of-the-action Rowing event from the Olympic Games or a more romanticised scenic picture. It might seem as though you need the longest telephotos possible to photograph this sport, but in reality it requires only a 70–200mm zoom lens and a good position from a bridge. Competitive rowing is known for its legendary displays of strength and stamina, and is the only sport in which competitors cross the line backwards. Paralympic Rowing will feature for only the second time at London 2012, having made its Games debut at Beijing 2008.

◀ The Cambridge team shot during the annual Oxford v Cambridge Boat Race on the Thames. The focal point to this picture is the competitor's faces to show the physical demands of rowing.

the image, making it appear dark – an especially common problem on sunny days. Even with the most recent cameras this remains a problem you'll have to master if your image contains a lot of water.

Camera Set Up

Follow the pointers below to get the best results from your camera set up.

〉 Shutter speed – needs to be 1/640th of a second to freeze the action or 1/30th of a second or below for a pan blur.

〉 Aperture – f/4–f/8 mid-range apertures. Rowing boats are long and you need a larger depth of field, as you are not trying to throw the background out of focus.

〉 Exposure – shutter-speed priority or manual exposure. Watch out when photographing on water in direct sunshine as the camera's exposure meter can be fooled, so either do a test shot and have a look on the LCD display or use an instant light reading. Remember you are usually exposing for the scene/water and not the person so slightly underexposing the image is better than any kind of overexposure.

〉 ISO – 100–200 in sunny conditions; 400 on cloudy days.

Positioning

If there's a bridge available head for it: you get a perfect overhead view when the rowing boat passes beneath you. Be creative and use a slow shutter speed for

The photographic challenges and techniques outlined below, as well as the positiioning advice, apply to Paralympic Rowing as much as its Olympic equivalent. Other events such as the Boat Race also require them.

Challenges

Weather can add to the atmosphere of the image, so don't wait for a bright clear day. Dark stormy days provide powerful images as the dark sky is reflected in the water. On a bright sunny day you have the contrast of light, so use the highlights and shadows. If it looks good, shoot it. Photographing on water always proves challenging for the camera's light meter. The reflected light off the water tricks the camera meter into thinking there is more light than there actually is. To combat this the camera meter underexposes

▲ Get up early to capture lone oarsmen in the beautiful early morning light. The water is often still and mirror calm, perfect for photography. This picture was taken from a bridge overlooking the river and gives a great angle.

TIPS AND IDEAS

> Stow your camera gear away to keep it dry when working from a launch. Only have it out when you're going to use it.

> Lens teleconverters 1.4x and 2x can be a help to reach this distant sport, enabling you to fill the frame.

> Press the shutter when the rower is under maximum exertion. This is called full paddle and is the moment when the strain shows on the crews' faces.

> Don't stand still and always remember that eye level isn't the only position for taking a shot. Crouch down to shoot at water level for an alternative.

this or shoot tight (coming close in on the rowers) and use the symmetry of the oars and boat.

Don't become fixed in one place; move around and find different angles to enhance the shot. You can use trees, for example, to frame the picture if you're by the water's edge. Don't always shoot from a standing position, and instead get down low at water level. A long telephoto lens is required, either on a tripod or monopod, if you are panning with the subject. Keep your horizon level at all times.

If you're lucky enough to be on a motor launch (professional photographers only at elite events) you need a handheld lens 70–200mm or 300–400mm. Focus on the rower with the best facial expressions. Some people show the stamina and exertion on their faces more than others.

Rowing lends itself to creativity. On the water the light can change in minutes, especially if you're working in the early mornings or evenings. Be patient; you often think you have the shot and put your cameras away, only for the sun to come out or a dramatic cloud to come overhead as you are driving off in your car. Sunsets are a photographer's friend when photographing rowing. If you can capture the reflection of the sunset in the water along with a lone oarsman paddling up the river, you've got a winner.

If you're walking up the river in the evening, look for places to photograph where the crews come closer to the shore on a bend or where you can shoot with an interesting background. Crews preparing to race also produce great pictures, for example as they are carrying the boat out on their shoulders. Use a wide-angle lens with a low angle. When the crews get in the boats they throw their wellingtons out. Try positioning your camera on the ground, looking up to accentuate the height of the boot in the air. This type of picture will be hit-or-miss at any level. Don't look through the camera viewfinder; just point the camera and hope.

The Greatest Race

People say my job as a sports photographer is one of the best in the world. When I'm photographing the Oxford and Cambridge University Boat Race, on a sunny afternoon in April from a launch directly behind the two boats, I have to agree. The photographers' launch is as close to the rowing crews as anyone can get; we charge up the

Thames about 10 or 15 metres behind. The riverbank is lined with tens of thousands of people cheering, creating an amazing atmosphere. There are only eight photographers' places on the launch, so it's a real privilege to have the opportunity to photograph this great race. The Boat Race is always in my diary.

Key Technique
Mastering Long Telephoto Lenses

Any lens of 600mm and above is considered a super-telephoto (p.242). These lenses enable you to capture a

SPECTATORS' ANGLE

The spectators' grandstands for the Rowing at London 2012 provide a great vantage point from which to zoom in on the action. If you are unlucky enough to be sat facing the sun with this high angle, you may struggle with the sunlight reflecting off the water. In this situation you have two choices. One is to keep the camera mode on automatic; this will give you a silhouette as the camera's meter exposes for the overall picture. Alternatively you can open up the exposure manually. However, the exposure range can be so huge that it is difficult to produce the perfect exposure even with a top-end professional camera. You will notice the symmetry of the lanes and boats from the spectator's angle. Remember that just past the finish line is the point where the crews will react and celebrate. It's not always the winners who make the best pictures; losing teams also make powerful images, sat in the boat with their heads in their hands.

sport that is taking place a long way away from you, for example the finish of a rowing race.

The two most common lenses are the 600mm f/4 and 800mm f/5.6, both of which can be used with teleconverters. The 600mm f/4 becomes an 840mm f/5.6 or a 1200mm f/8 lens. The 800mm f/5.6 lens becomes a 1120mm f/8 or 1600mm f/11 when used with a 1.4x or 2x teleconverter. With these lenses you have to have a stable platform, a sturdy tripod or similar, to keep the lens still. There are three advanced techniques to master with long telephoto lenses.

1 Keep the lens still on a sturdy tripod.
2 Have enough light to enable you to expose the picture. These lenses have apertures of f/5.6, f/8 or f/11 and require a lot of light to work properly. Really they are only used in the summer months outdoors.
3 Manual focus is needed with long telephoto lenses. Autofocus systems don't work, so you have to use manual mode. Remember focusing is extremely difficult and requires a smooth action.

Use long telephoto lenses to photograph cricket, rowing, surfing, sailing and baseball. These lenses are very expensive so consider hiring one if you need it for a particular event.

WINNING SHOT
One of the iconic photographs from the 2004 Olympic Games in Athens was the shot of Sir Steve Redgrave being hugged by Matthew Pinsent and James Cracknell after winning his fifth gold

medal in five Olympic Games. It's not often you see grown men crying – especially rowers! This was a special moment and well worth the early start for us pro photographers (around 3am). It was almost as if the race didn't matter – we were all waiting for the reaction of the crew.

It's difficult to convey the immense exertion of the crews in a single image: how do you show that just one of the crew is winning his fifth gold medal? We positioned ourselves 100 metres after the finish with our longest telephotos, waiting for the relief after the British boat had passed the finish line. Judging how far the boat drifts after the line will enable you to get the best position.

How to Photograph Sailing

Sailing is a seriously photogenic sport. The light on the sea can be exceptional; there are no obstacles to cast shadows such as buildings or trees. Nothing is more evocative than a white or colourful sail contrasted against a blue sea, with the sun dancing upon it far away on the horizon.

If you can get the access and get on the water, that's half the battle. If you're in among the boats when they're sailing you can take great images, even with a wide-angle or small zoom. Luck still plays a part, as you need the light to work for you. So does skill, however; a lot of great sailing shots are masterpieces of lighting. If you're confined to the shore don't worry – you'll still have plenty of opportunities for great sailing shots.

▲ I took this picture of the Finn class racing from a launch off Palma in the Mediterranean. I was using a 400mm lens and taking distance shots when the two middle ones created this interesting shape. Shooting into the light or sun has also enhanced the image by producing the highlights on the water.

Challenges

When the light's good on the sea, sailing photography becomes a lot easier. When the lighting is poor, however, you're in for a tough time. On a grey day with no wind pictures will look very flat and lacking in contrast. No matter how good a photographer you are, you can't change the weather conditions. Some days are simply very hard.

Salt water is a camera's enemy. It corrodes from the inside, and you should always wipe your equipment dry at the end of a shoot, making sure to get rid of all the salt. Working from a small moving boat in a rough sea requires good balance, timing and sea legs. Timing comes into play when you whip out your camera, take your picture and put it back in the box before you get covered by the next big swell.

Camera Set Up

Follow the pointers below to get the best results from your camera set up.

> Shutter speed – 1/1000th of a second when working from a boat. It's not a question of freezing the action as obviously sailing boats aren't moving ultra-fast, but more about the photographer's balance and keeping steady in a rough sea.

> Exposure – light is the key. Manual exposures give you more control, but are difficult and require a higher level of expertise. Shutter-speed priority can be used, but this will need to be adjusted with the exposure compensator dial.

> Aperture – f/2.8–f/5.6 small to medium apertures. Backgrounds aren't intrusive in sailing, so use your focus zone to fit your subject.

> ISO – 100–200 in sunlight; 400 on cloudy days.

Positioning

With your compact camera, zoom in as far as you can if the action is on the horizon. Alternatively use something in the foreground – such as the beach, a groyne or pier – to add depth to your picture. When photographing sailing you don't need to fill the frame when standing on the beach. The main tip with a camera phone is to keep the phone steady and the horizon straight.

Professional photographers prefer to photograph sailing from inflatable boats – fast, rigid and hopefully dry. This type of boat enables you to manoeuvre in and around the yachts without causing any trouble. During the London 2012 Olympic and Paralympic Games, however, all press boats will be kept to a distance as the sailboats are quite small and can be affected by other boats. You need to know your sport to photograph sailing well. Favourite shots include photographing on downwind spinnaker legs, gybing or tacking round buoys and busy start lines.

Sailing photographers use 500mm lenses that they can hand-hold in a choppy sea to get into the faces of the sailors. It is not easy to use and focus this lens from the moving boat in high seas. Photographers are always looking out for sunlight on the boat they're photographing, set against a massive dark black cloud in the background. If you catch this right you get crystal clear sunlight on what looks like a winter's day.

Some specialist yachting photographers even photograph from in the water near a buoy, using a waterproof camera. A helicopter, even

▲ You don't always need good weather for sports photography. Here Giles Scott sails his Finn class boat in Weymouth Bay in truly appalling conditions. I was working from a speed boat very close up and using a wide angle tilt and shift lens (p.222).

though very expensive, is the professional photographer's dream platform for photographing sailing. The unusual angle it offers makes dramatic pictures possible. It gets the adrenalin going and I love it.

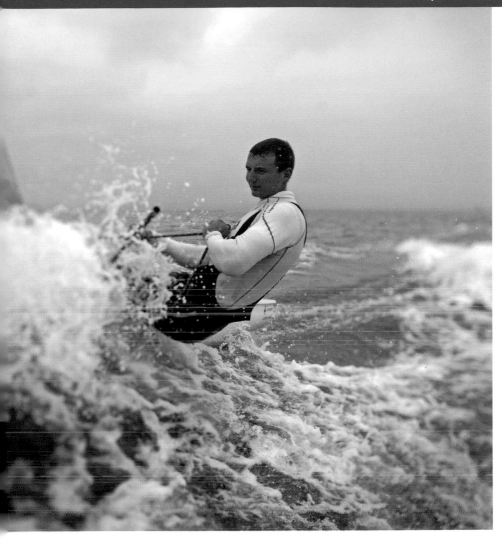

SPECTATORS' ANGLE

Spectators' positioning breaks down into three areas. Shooting from a distance on the beach doesn't necessarily require a long lens, but it does help. The Olympic and Paralympic Games Sailing events are taking place in Weymouth and Portland, and some of the races come further inshore than others. Use whatever lens you have to create a scene. If shooting from beach level, remember the rule of thirds. Even if the sailing boats are small in the frame, keep the sky as two-thirds and the sea as the bottom third.

Spectator boats are closer to the action than the beach, but you will still be quite far away. Use the longest lens you have and keep the horizon straight. Hopefully it will be possible to photograph the racing with the backdrop of the hills in the distance lined with spectators.

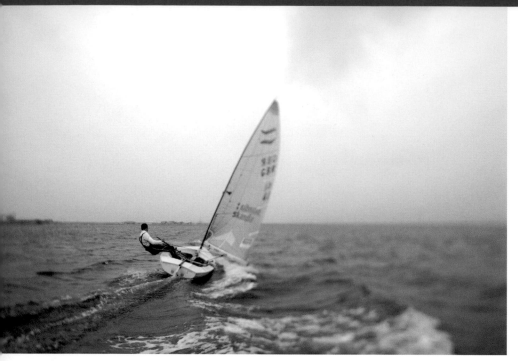

▲ This image, shot on a tilt and shift lens to narrow the band of focus, shows a lone sailor on a grey day. I converted the picture to black and white to accentuate the starkness of the sky using a 24mm lens, 1/2500 of a second at F4, ISO 400.

TECHNICAL WISH LIST

Your ultimate pro camera kit contains two DSLRs and four lenses:

> 500mm f/4 long telephoto that is still hand-holdable for far-away action shots and close-ups of sailors during racing

> 300mm f/2.8 or f/4 telephoto for action pictures

> 70–200mm f/2.8 for close-in action or shots from helicopters

> wide-angle 24–70mm for onboard shots of sailors

> waterproof box to stow camera gear in rough seas

> chamois leather to clean the lens's front element

> towel for wiping equipment dry

Key Technique
Working with the Light

How you manage to work with intermittent and difficult light can be the factor that determines whether your pictures will be spectacular or not.

Light, considered in more detail in Chapter 5, is crucial in sailing photography because the sky and sea are integral to the image. As with all photography, try if possible to work in early mornings and evenings when the light is at its most photogenic. Obviously you may have to compromise as sporting events take place throughout the day.

With sailing photography the light is constantly changing – dark and gloomy one second, bright sunshine the next. This is especially true when photographing around the British coastline, where the

constantly changing light means that you have to be right on top of your exposures. Add to this the amount of available light from the sky that falls on the subject and the light bouncing back off the water onto your subject, which combine to fool a camera's exposure meter into thinking there is more light than there actually is. You often come away from sailing with dark images.

The ideal way of overcoming this problem is to take a meter reading with a handheld exposure meter or to use a grey card with your camera meter. Always check the exposure on the back of your LCD display, even though this provides only a rough guide.

When photographing sailing you are usually moving around the boats and are constantly shooting with or against the light. Both positions can be very effective, but you will have to be constantly adjusting your exposure readings. Exposure is covered in more detail in Chapter 5.

WINNING SHOT

The winning shot could well be a large yacht under full sail close to the wind. Shot at a 45-degree angle, it shows the crew sitting with their legs over the side, in full sunlight with stormy clouds as the backdrop. Another great shot features a fleet of boats sailing downwind together under spinnaker. These colourful sails make a dramatic image and really bring the picture to life.

Windsurfing, with the board and rider leaping off the waves, can also produce a winning shot. Such photographs don't happen very often; you have to spend

TIPS AND IDEAS

> If you're on the water shooting a beautiful sunset, turn around to see what the golden light is doing to the rest of the world.

> Constantly check your light meter readings as the light can go up and down very quickly.

> Adapt to the action. Always be prepared – conditions can, and do, change quickly at sea. It might not be worth ruining your very expensive camera to get a shot in challenging conditions.

> Always dry off your camera gear thoroughly with a damp towel when you get back to shore. Seawater is very corrosive to electronic equipment.

> If you're standing on a rocking boat use a faster shutter speed, especially with long lenses to keep the image from blurring.

> Keep your horizon straight as even a slight tilt will affect the quality of the final image.

> Don't affect the race. If working from a press boat don't steal people's wind or create wakes unnecessarily.

hours on the water to be ready for the best lighting conditions. Be prepared to practice, practice, practice, rather than just turn up expecting to get good shots.

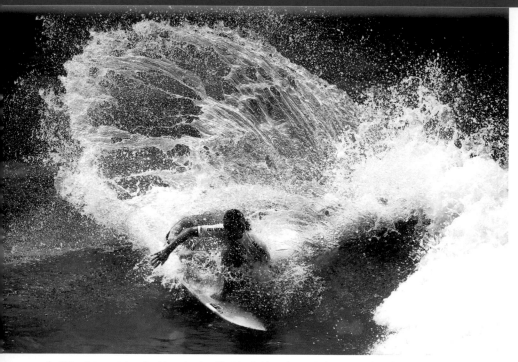

▲ This picture, taken by Marc Aspland in North Narrabeen, NSW, Australia, shows the Billabong ASP Women's World Junior Championship. Here the globe's finest under-21 female talent Justine Dupont tears through three rounds of competition. A 500mm lens was used from the shore.

How to Photograph Surfing and Waterskiing

Surfing is an exciting sport to watch, execute and photograph, but like most other outdoor watersports it is also a challenge. The bright boards set against a beautiful seascape amid intense surfing action make for thrilling shots.

You'll need at least a 400mm lens from the beach to get close enough to the action. A shutter speed of 1/2000th of a second or higher is needed to freeze the action, and it is also worth investing in a good tripod to keep your large telephoto lens still.

Light can make or break a surfing shot. Try and use the golden light; don't shoot under a strong sun at midday and always avoid shooting backlit straight into the sun. Surfing is a sport that is best shot with the sun. Track the surfer through the viewfinder, picking up an individual as he or she catches a wave. Shoot a lot of images and pick out the best ones from your sequence. You will learn to spot the best surfers who do the most outrageous tricks. Use manual exposures only when you are photographing from the shore on a long lens.

Professional surfing photographers like to shoot in the water with waterproof housing. You really need to know what you're doing here: it's a dangerous area to be in if you are not experienced and competent. You have to work with individual surfers so you both know where you are relative to one another.

▲ A classic surf image: bright colours, water spray and plenty of action. Marc Aspland has captured Ellie-Jean Coffey of Australia as she performs during her competition. A shutter speed of 1/2000th of a second was used to freeze the action.

Numerous waterproof cameras and housings are now available on the market. Even relatively inexpensive ones can be fun to use and produce interesting shots; experiment first in modest waves before you scale up. Automatic exposures can be used here if shooting with the light, but really you should dial in a manual exposure. Recently photographers have been using jet-skis to shoot along the wave – a creative and new angle, but not for the faint-hearted.

Just as photogenic as surfing, waterskiing is a little less dependent on the weather. You are closer to the action than with surfing, but ideally need a 300–400mm lens for best results.

For waterskiing photography there are three main vantage points:

> **Judges' podium:** these are stands on the bank with a great view up and down the lake.
> **The bank:** this is a great position for water-level shots.
> **A boat:** this arguably provides the best vantage point, but it is also the most unsteady so a higher level of skill may be required. The advantage to being in a boat is that the waterskier is always at the exact same distance from you, wherever they are, as they are on a fixed rope. Once you lock your focus on them that is it – everything will be sharp from then on.

Use shutter speeds of 1/1000th of a second, with the aperture wide open to mid-range. You will need low ISO for best quality, with the shutter-speed priority on manual exposure.

3

Indoor Sports

Introduction

Indoor sports cover a broad spectrum, ranging from combat and power sports to the artistic and creative rhythmic gymnastics. They provide a tremendous opportunity to create exciting images even in a fixed, controlled environment, although they also pose more of a challenge to a sports photographer than outdoor sports. Positioning is more restricted, leaving you less freedom to move around. It is important to have done your research and preparation in advance: keep the picture you want to take in mind and work back from that.

This Chapter shows how to photograph all of the indoor sports featuring at the London 2012 Olympic

▲ Basketball players jump for the hoop. This image was taken in summer 2011 at the Basketball test event in the Basketball Arena in the Olympic Park and shows the action that you will see at London 2012.

and Paralympic Games, as well as popular alternatives such as darts and snooker. I highlight the challenges of photographing in the silent Goalball arena and capturing routines in which multiple events take place at the same time. Most importantly I show you ways of dealing with mixed lighting, a crucial technique to master for taking good shots indoors. Each individual sport has a separate camera set up, so I advise on selecting the correct exposure, shutter speed, aperture and ISOs. The lighting at the indoor venues for the London 2012 Olympic and Paralympic Games has already been calibrated to daylight (5200k), and an exposure of 1/500th of a second at f/2.8 at ISO 1600 is anticipated. For all other indoor events, however, you will have to make your own decisions following the advice in this book.

Getting the best positioning possible is key to photographing indoor sports, whether at elite level, such as the London 2012 Olympic or Paralympic Games, or at local leisure centres. Strict rules often govern photographers' seating areas, and these may be frustrating at times. Some areas give better results than others, so I'll give tips on shooting head-on, above or below.

The Spectators' Angle sidebar explores strategies for shooting from the stands at indoor events. Your ticket requires you to sit in a specific seat,

▲ Chris Hoy goes to sign autographs after winning gold. I positioned myself near his family as I knew he would come over to celebrate if he won. A wide angle lens is useful for candid pictures in a situation like this.

so I'll discuss how to shoot from these individual angles and what you can expect to achieve. Remember that spectator seating can sometimes be the optimal angle for photographing a particular sport, as in the case of Diving, Boxing and Gymnastics at the Games. Bear in mind too that rules also govern the size of photographic equipment that you can take in to London 2012 events as a spectator (see p.279).

As in previous chapters the Technical Wish List covers the ultimate professional camera equipment – the kit you would choose if budget weren't an issue. This is an aspirational list and only professional photographers are lucky enough to have the full range. Perhaps you have one or two pieces of gear and are looking to upgrade your equipment. Remember

there is the budget alternative option of hiring for a special shoot. How many cameras would you ideally use and with which lenses and accessories? Is a 400mm or 200mm lens preferable, and why?

Each sport concludes with a description of a winning shot. This illustrates the ultimate picture that you should be looking to capture, and explains the ways in which it can be done. It is ambitious – the sort of picture that a professional photographer has in mind when he or she covers that particular sport. As you become more confident and versatile, with a range of techniques at your fingertips, you will reinterpret this idea in your own creative style.

▲ Table tennis is an incredibly quick sport to photograph. Either position yourself near the table or up high as the photographer did here.

Compact Cameras

Compact cameras have developed considerably in the last few years. Manufacturers regularly update their models with new functions, and the sports modes have been greatly improved. You are now able to use them indoors and produce quality sports images. All the sections below, aside from camera set up, apply to these popular cameras.

The first thing to remember when using compact cameras at the London 2012 Olympic and Paralympic Games is to turn your flash off. Once this has been done, follow the suggestions in the Spectator's Angle sidebar to help you achieve the best results from your seat at the Games. For other events, use the Positioning section to determine where to take your pictures from; you will usually find more flexibility at lower-level sporting events. Timing and anticipation, panning and freezing the action are important tools for the sports photographer. The compact shape and weight of these cameras

allows you to be ever-ready to shoot those key moments.

The automatic nature of these cameras means that exposure and focusing are set for you, so concentrate on composing your image. The mixed-lighting section below applies primarily to DSLR owners, but it may be helpful to any photographer who is really struggling with unusual colours indoors.

Mixed Lighting

Photographing indoor sports has one challenge larger than all the rest, which we have already referred to – mixed lighting.

As its name suggests, photographers have to deal with the problem of two or more types of different light source. This could be a case of tungsten floodlights in the roof of the arena, for example, combining with fluorescent sodium lights round the side or natural light coming through a window. All these types of light are a different colour – an effect known as colour temperature.

Our eyes are very good at judging what is a true white under different light sources. Digital cameras, however, using a system of auto or manual white-balance, often have great difficulty in doing this. White balance is the process of removing unrealistic colour casts, enabling a subject that appears white to your eye also to appear white in the photograph you take.

Camera manufacturers know that their Automatic White Balance (AWB) setting doesn't always get it right, so they also include several white-balance presets for you to choose. See p.252 for examples of these and how to use them.

3.1 Combat Sports

Combat sports are by their very nature head-to-head, aggressive, fast-moving, strong and explosive – perfect for the sports photographer. Encompassing boxing, fencing, judo, taekwondo and wrestling, they bring a variety of opportunities from the knockout punch to the beauty of an artistically blurred fencing image. The majority of these are classic peak-of-the-action sports,

aside from fencing which gives the photographer more creative scope.

The difference between Olympic and Paralympic combat sports is relatively small. In Paralympic Judo, for instance, the only difference is that the visually impaired competitors are allowed contact with their opponent before each contest begins. In Wheelchair Fencing the wheelchairs are locked into a steel frame,

▲ This creative image was taken at Beijing 2008 with a long manual exposure of 1/25th of a second f/22, ISO 1000 with a 70–200mm f/2.8 zoom. The focal length was set at 102mm proving that you don't need long lenses to take good images. The long exposure has created a ghost effect helped by the competitors in white standing out against the black background.

making it easier for the photographer to cover the action. It's possible to use a tripod (but not at the Games due to security measures) if you want to use slow shutter speeds.

How to Photograph Combat Sports

These sports are extremely fast-moving, which can make photographing them more a matter of instinct than considered judgement. When looking through the viewfinder the action can be so quick that you only know whether you have captured the image when you look on the rear screen of the camera. At the London 2012 Olympic and Paralympic Games these sports will be held in the ExCel arena, a venue that offers spectators an interesting angle for photography.

Challenges

The low light and fast pace of these sports challenge the sports photographer, as

◀ In this picture, taken by Richard Pelham, Winston Gorden beats Geraldino in the men's 90kg Judo competition at the 2004 Olympic Games. The image's power comes from the contorted facial expressions. It was taken on a 400mm lens at 1/640th of a second at f/2.8 ISO 1600.

TECHNICAL WISH LIST

Your ultimate pro camera kit contains two DSLR cameras and four lenses:

> 200mm f/2 or 300mm f/2.8 prime telephoto for action shots

> 400mm f/2.8 or 600mm f/4 for boxing photography from up in the gods

> 70–200mm f/2.8 for mid-range action shots

> 24–70mm f/2.8 wide-angle for ringside boxing pictures and creative images of the arena

> monopod

flash photography is prohibited. In Boxing, for instance, it is almost impossible to get the peak-of-the-action shot as the knockout punch is landed. This takes real anticipation and luck as the mind simply isn't quick enough. If you see the punch, you've missed the picture. Judo brings its own challenges. It's a very technical sport with holds and complex grappling, making it very difficult to show in a single image.

Taekwondo is explosive. Not only are the two competitors moving about the arena, but so also is the referee. This makes it very difficult to get a clean shot. Wrestling by comparison is more straightforward – you're waiting for a throw. Watch for the competitors' faces; they show intense concentration and make a great picture.

Fencing doesn't have too many challenges for the photographer, but the key to great fencing pictures is to show competitors' fronts rather than their backs. Focus on the competitor coming toward you, not the one facing away.

Camera Set Up

Follow the pointers below to get the best results from your camera set up.

> **Shutter speed** – needs to be 1/640th of a second to freeze the action and 1/60th or below for pan blurs at the fencing.

> **Exposure** – mixed lighting conditions mean you need to test the colour temperature at the North Greenwich Arena. The setting will be relatively dark and require a high ISO.

> **Aperture** – needs to be wide open to maximise the exposure triangle under dark conditions. Ideally f/2.8 or f/4, which allows the maximum amount of light through the lens (see Chapter 5).

> **ISO** – usually set at 1600 and above. The maximum ISO setting is governed by your individual camera.

Positioning

At combat sports events, positions for photographers are tightly controlled. Only a handful of professionals are allowed to be ringside for the Boxing tournament at the Olympic Games, for example, although it is the best position. Anyone photographing from here needs only a wide-angle or 50mm lens, and it is not unknown for photographers to push a boxer back into the ring after he has been knocked over, so close to the action is this position. Shooting ringside involves kneeling with your elbows on the canvas tucked under the bottom rope – very uncomfortable, but worth it if you have the opportunity.

The other position that professional photographers often choose at boxing matches is up in the gods. This is, in effect, the same as the spectator's angle (see below) where amateurs are located. It is usually near the back of the arena, and requires a long telephoto lens, 400mm or 600mm. This is a great spot to photograph heavyweight boxing in particular.

The best positions for Judo, Taekwondo, Fencing and Wrestling are to the sides of the mats, though this is also the preserve of professionals at elite events such as the London 2012 Olympic

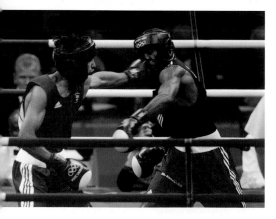

▲ This Boxing shot from the Beijing 2008 Olypmic Games was taken by Richard Pelham from a high vantage point looking down into the ring – one of the best positions to capture the sport. Use a 600mm lens to capture the action on 1/640th of a second at f/2.8 ISO 2000.

SPECTATORS' ANGLE

The indoor arena's seating area makes for a high angle, looking down on to the combat zone. This is a good platform from which to photograph. Set the basic functions of your camera up before you go into the arena as the lighting can be quite dark in the spectators' area. When using the zoom remember to turn off your flashgun if it's built into your camera. Long shutter speeds of 1/30th of a second and less are ideal to create ghost-like images of Fencing. Multiple exposure (p.175) is another good technique for Fencing, as the competitors stand out against the black backgrounds.

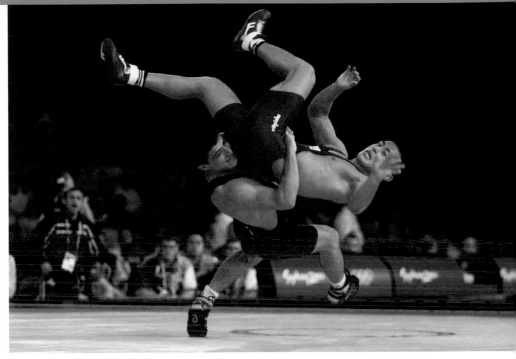

▲ One of my favourite images from Sydney 2000. This Greco-Roman throw is truly amazing, and I was really pleased to photograph it as it happens so rarely. I used a 200mm lens in the dark indoor conditions.

Games. Lower levels of the sport may be more flexible; if possible consider shooting from near the judges' platform, as the competitors often look across towards them. These spots are relatively close to the action and require only a 300mm or sometimes 70–200mm zoom.

An overhead angle (ideally from the roof, although access will not be possible at events such as the Games) provides creative images. The mats for some of these sports are multi-coloured and circular, creating visual interest from above.

Getting the right background is vital to photographing these sports well, wherever you are placed. Ideally the lights will be dimmed on the spectators in the background, giving you a clean black background that won't distract from your picture.

Key Techniques

Every sport has its defining moment when one competitor or team gains the upper hand over another – turning points which a sports photographer seeks to record. These are particularly challenging in photographing combat sports, when it is essential to identify and capture the heat of the action cleanly.

Catching the Key Moment

In combat sports the key moments are explosive and exceptionally quick. Your senses are heightened and your trigger finger is half-pressing the shutter button, requiring super-quick reflexes. The adrenalin is pumping, the crowd noise rises to a crescendo. Concentrate on the subject and not on the camera settings. Defining moments in fencing, apart from

the contact of the épée, foil or sabre on the opponent, are the reaction shots of the winner. The competitors at both the Paralympic and Olympic Games only remove their steel masks at the end of the bout. This reveals their faces for the first time, a dramatic moment to record some great reaction shots. Try to get the winner and loser in the same picture.

The knockout punch is the peak of the action in a Boxing match; as a professional photographer, you always get asked whether you have got the knock-down punch. It's the critical point of most Boxing matches, including those at the London 2012 Olympic Games, and is the start of all the best images of the sport. After the knock-down you get the reaction shots and the dejection of the losing boxer.

The key moments in Judo and Wrestling are again the winning throw and the reaction of the competitors after the event. In Taekwondo the speed of the sport makes capturing the kick to the body difficult, but the critical moment occurs when one competitor is completely off the ground, using his full force to make contact with the other. Look for reaction shots when the competitors take their protective helmets off.

WINNING SHOT

There are a number of winning shots to these combat sports. Ideally you are seeking the peak of the action – a match-defining punch at the point of impact, complete with blood and sweat droplets spraying into the air. Action is frenetic: each of the four rounds of Boxing at the Olympic Games, for example, only lasts for two minutes. Your mind is concentrating on focusing and framing the shot, so you just let go with the shutter when you think a punch is being thrown and hope for some luck. Bear in mind that knock-downs are rare and very fast.

TIPS AND IDEAS

> If you need to, slightly underexpose your shots then correct the exposure in post-production. This will allow for faster exposures under dark conditions.
> Find a local gym that allows photography to hone your techniques and practice in a less pressurised environment.
> Keep a low angle and shoot up into competitors' faces. Shooting through the ropes allows for a far cleaner image of ringside boxing, from where you may be able to photograph lower levels of the sport.
> One of the hazards of working ringside, apart from being hit by a boxer, is blood and sweat. Cut boxers can spray blood everywhere, so be prepared with a towel for you and your gear.
> Anticipate, anticipate, anticipate. Learn when the defining blow is going to be landed. Whether it's a kick or a punch, learn to read the build-up and be prepared.

3.2 Cycling — Track

Cycling in a velodrome can produce really exciting images. The banks are so high and the riders travel at such speed that it's a real thrills-and-spills sport. Add in the bright colours of the riders' futuristic jerseys and you have the makings of some great photographs. There are 10 different Track Cycling events at London 2012 and between them they test speed, endurance and teamwork. Work out in advance whether you need to concentrate on an individual cyclist or a team.

For Track Cycling at the Olympic and Paralympic Games, the design of the Velodrome means you are guaranteed a great view. Seeing the inclination of the track as you enter the Velodrome the first time is vertigo-inducing – you have to get a shot of it.

However, cycling is a sport that needs

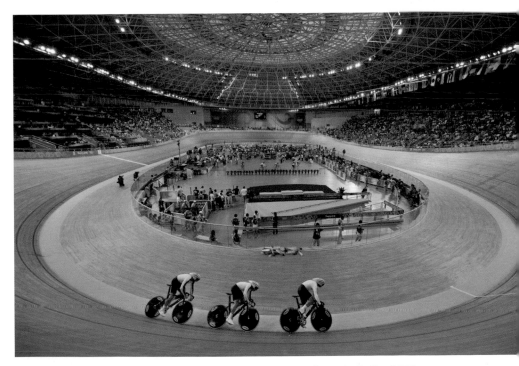

▲ Team GB cyclists race round the track in the Beijing Velodrome during the Beijing 2008 Olympic Games. This dramatic general view shows the arena with the action in full swing. It was shot on a super wide angle 14mm lens with manual exposure of 1/1000th of a second at f/3.5.

some knowledge and experience to capture well. This is true whether you're photographing at an elite or amateur level. Once you've mastered the basic techniques and sorted your light and exposures out, it really is a question of waiting for the right moment. Do your research so you are as well prepared as possible. With 338 athletes taking part at both the Olympic and Paralympic Games, you will have a good choice of who to follow and photograph. And you do not need expensive camera equipment: a wide-angle lens or medium telephoto will produce great pictures.

How to Photograph Track Cycling

Track cycling is a fascinating sport to photograph, once you have adjusted to the speed and factored in the unique aspects of a velodrome. These are all basically the same for photography purposes, but lighting does vary a lot and you will need to be familiar with mixed lighting techniques (p.255). Remember that flash is prohibited at the London 2012 Olympic and Paralympic Games.

Challenges

A velodrome provides a very controlled environment for photography. Your position on the outside of the steeply inclined track means that you are always looking down on to the riders. This can be great for some shots, but it is difficult to look right into the faces of the cyclists. If you are lucky enough to get infield (within the track), you can shoot with a low angle

– looking right at the riders as they cycle past on the high-banked track. Their speed means you can't follow the riders all the way round the track; you must just choose a position and hope for the best. This is true if you are working both inside and on the outside of the track.

The speed also makes autofocusing critical when working with a shallow depth of field. You have to be very quick-witted to capture any spills, which happen in fractions of a second. It's also important to know your sport well – in

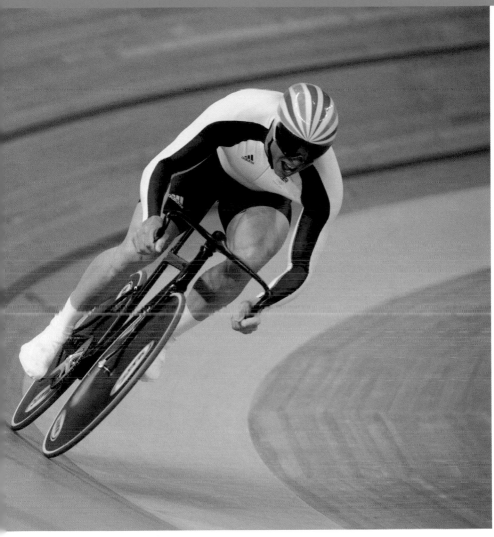

▲ A lone cyclist sprints off the bend. This is as near to a head-on shot as possible at the Cycling at London 2012. Use a fast shutter speed of 1/1000th of a second to freeze the action with ISO 1000 and an aperture of f/4.

some events such as Team Pursuit riders cycle at speeds up to 83km per hour while in the Sprint it's a game of cat and mouse with riders coming to a complete standstill! There are a lot of tactics involved, and the more you appreciate these, the better you can anticipate the action.

Camera Set Up

Follow the pointers below to get the best results from your camera set up.

> **Exposure** – mixed lighting techniques apply (see p.255). Manual or shutter speed should be used in priority mode.

> **Shutter speeds** – to freeze the action use sports photographers' 1/640th of a second or more. For pan blurs use 1/250th of a second and below. It's also possible to try going even lower, down to 1/60th of a second or 1/30th for creative blurred shots.

▲ A classic pan blur that uses the colourful background of the spectators to create an interesting image at the Beijing 2008 Games. Always choose one rider to pan with, in this case the cyclist in red. This picture was shot at 1/20th of a second f/13 with ISO 400 using a 35mm lens.

> **Apertures** – wide open to collect as much light as possible under indoor mixed-lighting conditions.
> **ISO** – set at 1600 and above to freeze the action and 400–1000 for pan blurs.
> **Flash** – Turn the flash off during competitions in the Velodrome. Set the camera on shutter-speed priority and use the pan blur techniques described below. Keep the focus point on the main rider and pan with them.
> **Zoom** – Presentations (or Victory Ceremonies at the Olympic and Paralympic Games) normally take place inside the track. Use your zoom at its maximum length to capture these events.

Positioning

If you are watching Cycling events at the London 2012 Olympic and Paralympic Games, your position will be determined by the seat number on your ticket. There are still plenty of opportunities to take good and creative shots of this highly photogenic sport (see Spectators' Angle below).

The high angle on the outside of the track works well for professional photographers. This is a popular spot, close to the action and the riders, and it's suitable for medium telephoto and wide-angle lenses. The best position is at the end of the straight, looking towards the finish line for those frame-filled shots. The back straight works well for reaction pictures. Bear in mind that when riders actually cross the finish line they are usually dipping and cycling too fast to celebrate. Instead they slow down after winning medals to acknowledge the fans and their families.

The other good position is on the deck

▲ Great Britain's Bradley Wiggins prepares to propel Mark Cavendish during the Madison race at the 2008 Olympic Games. The image captures both the tension and precision of the changeover, highlighting the teamwork required in this race of endurance.

SPECTATORS' ANGLE

Seating in the brand new London 2012 Velodrome consists of a concrete lower tier and two suspended upper tiers. The upper tiers are located in the two curves of the Velodrome roof.

The lower tier is right up against the track. It is great for action shots especially at the end of the start/finish straight, and similar to the professional photographers' angle. The suspended upper tiers offer a great position from which to test your slow pan techniques.

It is also well worth shooting a general view of the whole venue both inside and out: the Velodrome is an inspirational, futuristic piece of architecture.

TECHNICAL WISH LIST

Your ultimate pro camera kit is two motor-driven DSLRs and four lenses:

> 300 or 400mm f/2.8 long telephoto lens for peak-of-the-action pictures, finishing line and Victory Ceremonies (if you're shooting from the top of the track looking down)

> 70–200mm f/2.8 for some pan shots of individual riders and action pictures

> 20–35mm f/2.8 wide-angle for slow pan and blur shots from the top and pan and blur with fill-in flash from on the deck (not during competition)

> ultra wide-angle lenses/fisheye lenses 20mm and below for views of the Velodrome with cyclists.

inside the track. This is a very privileged spot to be in, however, and only a handful of professional photographers will be allowed here at the London 2012 Olympic and Paralympic Games. It's very busy and you have to keep your wits about you. You can't distract the riders and there is no flash photography, as noted above, but as the closest person to the cyclists you're really involved with the action. After the races, award presentations (or Victory Ceremonies in the case of the Olympic and Paralympic Games) are usually inside the track area. As well as action pictures from this

position you are able to photograph in the garage area as competitors warm up. Once again, this is only available at elite events to professionals with special pool bibs.

Key Technique

Sports photography is normally all about freezing the action (see p.188), but cycling, whether at the Olympic and Paralympic Games or in a lower-profile event, gives you the chance to experiment at the other end of the scale. Practice will help you master the pan blur technique below, which will really improve your track cycling photography.

Pan and Blur

A pan blur is a great technique to learn. Your subject stays sharp, but the rest of the image blurs. Instead of holding the camera steady, try moving slowly and steadily with your subject – a process known as panning. It's really important to pan at exactly the same speed as the subject, so don't speed up or slow down. It takes a bit of practice to keep level through the whole pan.

FIVE STEPS TO A PAN BLUR

Use these five simple steps to create fascinating images.

1. Choose your subject – the fastest cyclists, for example.

2. Set exposure with a relatively slow (1/125th of a second) shutter speed (note that for really fast-moving sports you still need to have a fairly high shutter speed). For the cycling image overleaf the shutter speed was 1/250th of a second. The cyclists are sprinting extremely fast

TIPS AND IDEAS

> During the race the cyclists will often be cycling one behind the other – exploit this graphic shape to help your composition.

> Use the repetitive nature of the sport to fine-tune your shots and vary your lenses to get different angles.

> Use fill-in flash with a slow shutter speed (if allowed during non-competition days). Known as slow-sync flash, this enables you to freeze part of the rider while the slow shutter speed blurs the background to give the impression of speed. It is a similar effect to a normal pan blur, but the flash gives more detail and brightens the subject.

> Look for detail – the riders wear futuristic clothing, aerodynamic helmets and mirrored glasses, which will produce some strong and powerful pictures.

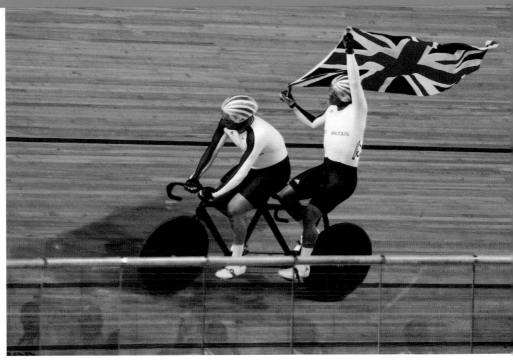

▲ This Paralympic Cycling shot is taken infield from the centre of the Velodrome at the Beijing 2008 Olympic Games. The photographer is panning with the subject as the Paralympian and guide celebrate their victory.

(80km/h), so you don't need to slow the shutter speed too much to get this movement.

As a guide pan blurs normally range from 1/125th of a second to 1/30th of a second. For Formula 1, one of the fastest moving sports, a speed of 1/500th of a second creates a pan blur if you are shooting side-on.

3. Start moving the camera at the same time as the subject. Stay with the subject all the way through the pan.

4. Press the shutter button, but still keep panning.

5. Experiment with different shutter speeds to find out what works best.

THE WINNING SHOT

The pan and blur technique is perfect for cycling. Riders come round in an almost continual succession and you can use very, very slow shutter speeds to get artistic and colourful pan shots. Colourful flags and excited spectators create a beautiful blur in the background. Team pursuits are ideal for pan and blur as four riders race, one behind another, round the track. One striking thing about cycling track photography is that 90 per cent of all the pictures you take are a pan, whether you blur it or not.

▶ Here I have panned with the second rider to keep them sharp where everything else in the picture is blurred. Paul Manning, Ed Clancy, Geraint Thomas and Bradley Wiggins win gold at Beijing 2008 Team Pursuit. Shutter speed 1/25th of a second f/14 ISO 500.

3.3 Gymnastics

Gymnastics consists of three disciplines known as artistic, rhythmic and trampolining. Artistic is the best known and most popular with sports photographers due to the variety of apparatus. As it takes place in a small arena it's fairly easy to cover, and there is constantly something exciting to catch your eye. Men compete on the floor, pommel horse, rings, vault, parallel bars and horizontal bar while women compete on the vault, uneven bars, balance beam and floor.

Rhythmic is one of the most beautiful spectacles of the Olympic Games. It is a great subject for creative shots, especially with the use of slow shutter speeds to show the controlled movements of the gymnasts. Competitors perform short routines to music using hand apparatus, a ball, clubs, a hoop and ribbon. Trampolining is a fairly new sport in the Olympic Games, in which gymnasts perform short routines containing a variety of somersaults, bounces and twists. These offer new opportunities to the sports photographer looking to capture peak-of-the-action movements as each individual routine unfolds.

SPECTATORS' ANGLE

The seating in the main arena for Gymnastics is high up at the back – a good vantage point for looking down on the action. You'll need to zoom in to focus on the event. It's difficult to photograph the action at the far end of the arena, so concentrate on what is happening in front of you. The lower seating is much closer, and its great view is similar to that of the professional sports photographer. Look for offbeat shots of competitors warming up with their coaches. The Victory Ceremonies are usually held in the centre of the arena and not too far away so you should be able to get some good shots (p.38).

◀ A detail shot of a gymnast's hands as they perform their routine on the pommel horse.

How to Photograph Gymnastics

With the advent of digital photography it is much easier to capture the grace, strength and skill of gymnastics. The really fast disciplines such as vaulting, parallel bars and asymmetrical bars are impossible to freeze without shutter speeds of at least 1/1000th of a second. A decade ago we were all photographing gymnastics on 1/500th of a second, and most of our images had blur in them. The advent of fast, accurate autofocus systems has also helped. There is, as yet, no such thing as a 100 per cent success rate, however, so you do need some experience.

▲ This beautiful peak of the action shot captures Rhythmic Gymnastics in a stunning way. The black background emphasises the colour and form of the girl as she performs her routine. She is positioned in the third to the left hand side of the picture using the Rule of Thirds for composition.

Challenges

As noted above, some of the problems of photographing gymnastics have become easier with new technology, but others remain. The speed of the (usually small) competitors is tricky, especially when combined with the relatively long telephotos you have to work with to get near the subject. Each of the different elements sets its own challenges for the photographer.

> **Rings** – the difficulty lies in freezing a fast-moving subject spinning through the air. Use a shutter speed of at least 1/1000th of a second and pre-focus on the rings as the subject usually stays in that plane of focus.

> **Beam** – here the challenge is freezing the action and keeping a clean background during this quiet, intensive element. Use 1/1000th of a second and don't shoot too close up (which is called

being over-lensed or shooting too tight). Leave space for the action, especially if trying to capture leaps and full turns where the gymnast is upside down in mid-air. This technique applies to all the gymnastic disciplines.

> **Asymmetric Bars** – freezing the action here needs 1/1000th of a second shutter speed. You are looking for that split-second when the gymnast takes his or her hands fully off the apparatus to change position or alter the height of the dismount.

> **Parallel Bars** – the challenge is to follow all the swoops and movements, and again 1/1000th of a second is needed to freeze them. Keep one eye open on the background.

> **Rhythmic** – the difficulty lies in simply covering this large area photographically. Remember that the tumbles and jumps usually come at the end of a diagonal

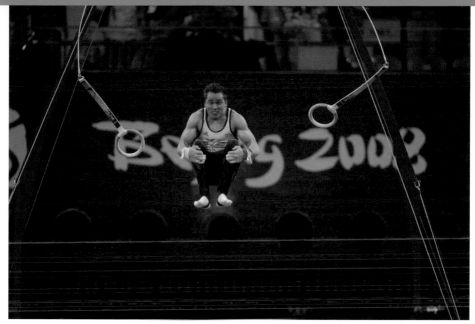

▲ Daniel Keating performs on the high rings in front of the Beijing 2008 logo. I have captured him using a 400mm lens from the far end of the arena. 1/640th of a second was just fast enough to freeze him as he tumbles through the air.

sequence. Use 1/1000th of a second to freeze these tumbles.

> Vault – the sheer speed of these vaults is incredible (especially the small girls who twist and turn so quickly) and very hard for the photographer to capture. The aim is to pre-focus on a part of the apparatus mid-way through the routine and time it to release your shutter (1/2000th of a second) as the gymnast enters this plane of focus. It's almost impossible for an AI-servo autofocus system to keep up with something moving this fast through the air.

> Pommel – here the challenge is to convey the degree of difficulty of this element. 1/1000th of a second can often be too fast here, and takes the movement out of the picture. Drop the shutter speed down to 1/500th of a second. Look out for the peak of the flare (the moment at which a gymnast's feet are fully extended)

to make great pommel images.

> Trampolining – photographically similar to diving. The challenge is to capture the gymnast at the high point of his or her routine, which requires a fast shutter speed of 1/1000th of a second. Shoot a sequence and choose the best frame from that sequence if you have a fast motor drive.

Camera Set Up

Follow the pointers below to get the best results from your camera set up.

> Shutter speed – needs to be at least 1/1000th of a second to freeze the action. Manual exposure modes are a necessity in the arena because the backgrounds (usually pitch black) fool the camera metering system.

> Exposure – mixed-light rules apply, but at the Olympic and Paralympic Games all the lights will be the same

colour temperature (p.255). Because of the demands of television, expect lighting to be bright.

> **Aperture** – needs to be wide open to enable the exposure triangle. Ideally f/2.8 or f/4, which allows the maximum amount of light through the lens.

> **ISO** – 1600 and above. The latest cameras don't have any issues with noise in the high ISOs, so feel free to go higher.

Positioning

Professional photographers at ground level shoot low down, so you can see the competitors' faces looking up. Avoid shooting into any kind of lights; there will be a lot of television lights in the roof of the arena, which will cause problems with flare. Look out for the classic black

TECHNICAL WISH LIST

Your ultimate pro camera kit consists of two DSLRs and four lenses:
> **400mm f/2.8 long telephoto** for the rings, vaults and shooting from above
> **300mm f/2.8 or 200mm f/2 telephoto** for action shots at ground level, including asymmetric bars, floor routines and parallel bars
> **70–200mm f/2.8** for action shots of the pommel, beam and side-on shots of the vault
> **24–70mm f/2.8** for general views and low-down angles if you're lucky enough to be infield
> **monopod**
> **flashlight** for checking your equipment in the darkened arena

background – possibly seated spectators, if the lights are dimmed to leave a pool of light on the competitor. Another ground-level position is symmetrically straight on to the competitor. It's good for the beam and pommel enabling you to shoot a little looser (that is, leaving space for the action), but also construct a more graphic image.

Shooting from the back of the stands looking down on the competitors is similar to the spectators' angle, but further away. It provides interesting images and your success rate will increase, as at this distance with a long telephoto lens it's easier to keep the subject in the frame.

From above, exploit the colours of the mats to create intriguing symmetrical pictures.

At elite events such as the Olympic and Paralympic Games very few photographers are allowed to shoot infield. Apart from the main international agencies, everyone else has to shoot on the outside of the mats looking in.

Key Technique

As a general rule there are only two elements in sports-action photography: the subject and the background. The sports action takes place in the foreground and the stadium/crowd is the background. In more creative sports pictures, for instance golf, cycling and equestrian, there are three elements – foreground, subject and background. For example, you may have the golfer (the subject) teeing off surrounded by the crowd (the foreground) with a beautiful mountain range in the background.

Backgrounds/Foregrounds

To a professional photographer backgrounds and foregrounds are two key elements that should never be underestimated. I have mentioned many times how the background to your photograph can make or break your sports picture. I have seen amazing sports-action shots ruined by busy backgrounds with distracting elements: people walking, fluorescent jackets, empty stands, neon signs, cars, bits of buildings. Give as much attention to the background as to the subject; I spend my time watching the background trying to improve it.

A good background to me is one that places you, yet is so far out of focus and unobtrusive that your eye isn't drawn to it and so does not distract you from the action in the foreground. The main photographic technique to use here is known as shooting wide open; this restricts the depth of field to its minimum. In contrast to the out-of-focus background, the foreground should be sharply focused. A good foreground is the action taking place in the main area of the picture – football action on the pitch for instance. Undesirable foregrounds, such as officials, can be eliminated by moving in closer or by changing viewpoint and camera angle. Aim to clear the foreground of items that have no connection to the picture. If you're photographing your family or friends outside a stadium, for example, ensure you haven't left a bag or pushchair in the frame.

TIPS AND IDEAS

> Use pre-focus techniques for the vaulting as the gymnasts are too fast for the autofocus system to keep up.
> Keep noise to a minimum during the routines as the auditorium will be very quiet.
> Even at this elite level competitors do sometimes fall off; you should be be ready for anything, especially at the dismount stage.
> Look out for detailed shots and zoom in on competitors chalking their hands before they compete.

WINNING SHOT

This winning shot is on the asymmetric bars where a woman competitor is moving from one bar to the next. A fast shutter speed of 1/1000th of a second is required to stop the action, capturing the instant when both legs and hands are off the bars as she is poised to catch the next bar. Concentration is key here and so is the symmetry: the two bars divide the picture, so the image is the competitor and two parallel lines.

Most camera manufacturers' auto-focus systems are extremely quick, but they cannot keep up with the speed and quick changes of direction of a gymnast. This is especially true the nearer you stand to the competitor. Instead, you need to pre-focus on the top bar and wait for the action to happen. This will be on the same plane of focus as the bar and therefore will be sharp – keep your fingers crossed!

3.4 Power Sports

Weightlifting is a test of pure strength, one of the oldest and most basic forms of physical competition. At the Olympic Games there are 15 weight categories, eight for men and seven for women, and each competitor has three attempts. Paralympic Powerlifting is a bench-press competition and the ultimate test of upper-body strength. The aim of both sports is simple: to lift more weight, in the approved manner, than the other competitors. This sport works towards a crescendo as the medals are decided.

How to Photograph Power Sports

These sports are normally difficult for the sports photographer, but at the Olympic and Paralympic Games they produce fantastic images. This is largely due to the reaction of the competitors once they have won. It's not often that you see a man weighing 160kg leaping round the room in celebration!

Challenges
The challenge is to capture the sheer effort and exertion that the competitors are putting into the lift. In Paralympic Powerlifting the competitors are lying down with the heavy weights on either side of their faces, making it particularly difficult to capture facial expressions. Positioning here is essential, although options are limited at elite events.

Weightlifting and Powerlifting are among the least obviously photogenic sports you'll photograph, so you need to be creative with your shots. Be aware of the surroundings and backdrops, and consider how these can enhance your picture. Is the event taking place in front of the Olympic rings, for example? Or is it being held in a rundown gym with a gritty atmosphere that could bring strong character to your image?

Camera Set Up
Follow the pointers below to get the best results from your camera set up.
> **Shutter speed** – 1/640th of a second is fast enough to capture this sport. You won't need anything faster.
> **Exposure** – mixed-lighting conditions apply. Be careful as weightlifting takes place in dark arenas. Use manual exposure or shutter-speed priority.
> **Aperture** – needs to be wide open to get the exposure triangle. Ideally f/2.8 or f/4, which allows the maximum amount of light through the lens.
> **ISO** – 1000 and above.

Positioning
For Weightlifting the best position is exactly straight-on to the lifter. Don't shoot

too tight (that is, filling the frame with the individual lifter), but take care to leave space for the action, keeping the whole body, weights and background in the picture. If you are at an Olympic Games, for example, there are often Olympic rings behind the competitor which will place your picture beautifully.

You are looking both for action pictures as the competitor lifts, showing the effort as he or she strains to the limit, and reaction pictures after the result. Use a longer lens, 300mm or 400mm, to capture the facial expressions of competitors as they lift.

A great and unusual angle is directly above the competitor, looking straight down. This can produce really good images, but at elite level is only available to a few selected photographers. If you are shooting tight (filling the frame) with a long lens you can photograph from the side; focus on the face, which is framed by the weights themselves.

Key Technique

The action taking place at power sports is usually fairly static, although the tension builds towards a crescendo as the awards or medals are decided. The

▲ This close up of a competitor's face during the Paralympic Powerlifting shows the strain of lifting such great weights. The photographer has focused on the competitor's face for added impact.

SPECTATORS' ANGLE

As with the photographers' angle, the best seats are straight-on to the action. Be ready for the reaction shots at the end of the competition, as the tension really does mount here. The high angle from the back of the spectators' seats is the best place to shoot powerlifting as the face of the competitor is visible.

TECHNICAL WISH LIST

Your ultimate pro camera kit contains two DSLR cameras and two lenses:
> 400mm or 600mm f/4 long telephoto for close-ups of competitors' faces. This will get you strong images of athletes under pressure
> 70–200mm f/2.8 zoom lens for action shots and reaction (the general-purpose lens for this sport)
> monopod

▲ The photographer here has chosen not to fill the frame and to shoot a little loose allowing you to see the Paralympic Powerlifter celebrating.

greatest drama comes when the athlete reacts after his or her lift. Look for the big heavyweight lifters leaping in the air as they release the colossal weight behind them or fall to their knees in relief.

Reaction

Powerlifting is pure sporting theatre of the most compelling kind. While the actual lift is good for action pictures, especially if you concentrate on the face of the competitor, the sport really comes alive in the reaction of the athletes. Both elation and dejection make dramatic images as the winners and losers are decided. Remember that losers can often make more powerful pictures than winners as they realise that four years of hard work has not been enough.

Every sport has an element of reaction for you to capture with your camera, but the Olympic Games is the pinnacle. The celebration and reaction shots are the best you will see at any sporting event.

WINNING SHOT

The winning shot is a reaction shot – the split-second in which the competitor realises he or she has won. You need to keep the weights in the picture so people can identify the sport. Look out for the best facial expression of delight.

TIPS AND IDEAS
> Consider taking detail shots of hands on bars and chalking before the competition starts.
> Get your exposure right before the competition starts. Lights are often dimmed in the spectators' area during the event, making it difficult to do this later.
> Grainy black and white works well for a detailed study of this sport.
> Tell the story. If shooting in your local gym, try showing the sweat on people's faces as they lift these enormous weights.

3.5 Racket Sports

We all know that some sports are more challenging to photograph than others. Yet who would believe that badminton and table tennis are two of the hardest for the sports photographer to capture? This is because the idea with ball sports is to have the ball in the picture – nearly impossible with a darn shuttlecock, travelling faster than the Eurostar at 330km per hour.

How to Photograph Badminton and Table Tennis

It's easy to say timing's the secret to getting good pictures of these fast-moving sports; the speed of the shuttlecock in badminton is going to stump most people and table tennis is only a little easier. You really do have to practice, or else shoot incredibly wide to incorporate the full scene so that the shuttlecock or ping-pong ball stays in the frame longer.

Challenges

Only when you sit courtside trying to capture it do you realise how hard it is to photograph badminton well. It is such a wristy sport that it's impossible to anticipate, unlike tennis where you can read the shot. For the amateur the advice is to go against the grain: shoot a lot and

choose your best images out of the many you have taken. Ultimately, however, it is indeed a question of timing. Practise until you can capture the shuttlecock on the end of the racket.

The other great challenge with badminton occurs in the doubles event. In this instance two people are playing in each court, and the picture becomes weaker as a result. You are shooting on a shorter lens and the background can become very distracting. For doubles, shoot from above.

Table tennis poses similar problems, though capturing the table-tennis ball in the frame is a little easier than a shuttlecock. The challenge here is to get the best possible position from which to shoot (see below).

SPECTATORS' ANGLE

The professional photographers want to sit in the spectators' seating in both of these sports, so your view is going to be great. For badminton it is best to shoot action in the far court. At the London 2012 Olympic Games, don't shoot too tight (filling the frame with a player and racket) on match point. Instead shoot the whole court with both sides in and wait for the reaction shot, featuring winners and losers in the same image. The same applies to Table tennis.

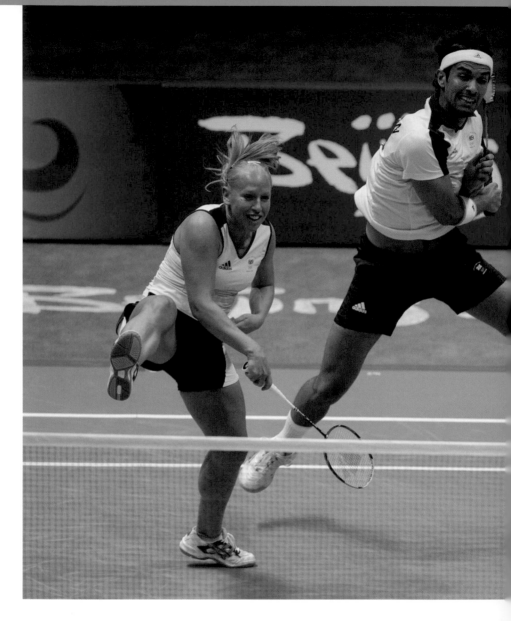

Camera Set Up

Follow the pointers below to get the best results from your camera set up.

> **Shutter speed** – needs to be at least 1/1000th of a second to freeze the action and capture the ball/shuttlecock. Manual or shutter-speed priority.

> **Exposure** – mixed-lighting conditions apply. Badminton and table tennis are always indoor, so once you have worked out the exposure don't change it.

> **Aperture** – needs to be wide open to throw the background out of focus and obtain the exposure triangle. Ideally f/2.8 or f/4, which allows the maximum amount of light through the lens (see advice in Chapter 5).

> **ISO** – 1600 and above. These two

Positioning

There are two positions for badminton photography. The first, used by professional photographers at elite events, is right up close by the net, looking back at the competitors. This is ideal for action shots and covering the sport. You can obviously only shoot one end at a time so choose which competitor you want to photograph. This position is best shot on a 70–200mm zoom; you will need the short end of the zoom for shots near the net and the longer end near the baseline. Use in the upright format (portrait) for the tightest action shots where you fill the frame with your subject.

The other position for badminton is actually from the spectators' stands at either end of the court. You shoot the competitors at the opposite end to you.

sports are usually played in dark arenas where no flash is allowed.

▲ Badminton is one of the hardest sports to photograph. Try to get both competitors in the same frame; here both seem to have played the same shot. Freeze the action with a shutter speed of at least 1/640th of a second. The shuttlecock is perfectly positioned in the corner of the frame.

Go high enough so the net doesn't come into play. This is the optimum angle as the competitors are looking towards your end and you can use a longer lens here – 300mm or 400mm. The resulting images are stronger with cleaner backgrounds. Similar positions apply for table tennis. Shoot down below near the net where you can cover both ends of the table, though not at the same time. Obviously you would like to use the longest lens you have here so don't get too close if you have a 300mm or 400mm. With table-tennis photography the serve is the peak of the action – the ball can be thrown really high. Look for an action portrait of the competitor's face with the ball in the picture. During the rallies competitors often have their heads down, so wait for a shot where you can see faces clearly.

TIPS AND IDEAS

> Shoot wide open. These backgrounds, for example in badminton doubles, are some of the messiest in sport, so try and look for a blank wall or netting as a background.
> Don't bother with a tripod or monopod. This action of this sport is far too fast to be restricted by the use of a lens support.
> Shoot the serve. With table tennis start by photographing the serve, as it is slightly easier than the fast-moving backhands and forehands.
> When shooting in the spectators' area, be considerate of people around you as these are two quiet sports.

A high angle for table tennis photography is straight above the table. From here you can use the shapes and colours of the table and the floor to make a picture with the server looking up to the camera's viewfinder. These are very creative shots although you will need to get permission to shoot from here. If you are lucky enough to get into this spot (and you should expect it to be reserved for professionals only at elite events), your images can't go far wrong.

Key Technique

The great advantage of black and white photography is that dull days can often produce the best black and white pictures. When the light looks average or uninteresting for colour photography, think about shooting black and white pictures. The creative techniques of black and white photography can really improve your sports photography.

Black and White Photography

Any picture you shoot in colour can be turned into black and white using

WINNING SHOT

The winning shot for badminton is a reaction shot. A photograph of the whole court on match point taken on a 70–200mm zoom from high-up at one end of the court. The picture is looking down as two competitors jump for joy and the other two competitors fall on their knees with anguish after losing. It's immediately obvious what has happened, creating a very emotional picture of a sport that is often very difficult to photograph.

computer software in the workflow process (p.255). Some cameras can do this for you. For the best black and white shots, follow these four tips.

1. Shoot in Raw format. This will help you in post-production, as the extra detail in the Raw file improves your final image. Shooting in JPEG doesn't stop you processing your pictures into black and white, of course, but there is less original information to play with. Any mistakes that you may have made, especially with exposure, are easier to correct in Raw.

2. Use contrast. Because you only have blacks, whites and greys to distinguish the elements in your photograph, look for tonal ranges – either sharp contrasts of black and white or subtle shades of grey, or both to create your picture. A great example is the gymnast lit by a spotlight standing out from the black background. The contrast here can be very strong and create a powerful image.

3. Consider symmetry and balance. Shapes and patterns can go unnoticed in a colour picture, but in a stark black and white picture patterns emerge and become a strong visual element. An example is shooting from above, looking down on the table-tennis table. The lack of colour in the table draws your eye to the competitors at either end; the shape of the table makes a rectangle with the net dividing the picture in half. The image becomes symmetrical with the competitors at each end.

4. **Texture.** This will bring an added dimension to your black and white photographs. Look for side-light which can add interesting shadows from the textures. An example would be

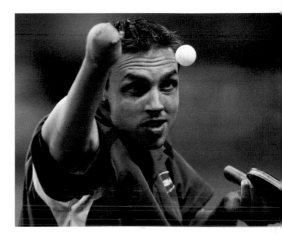

▲ This powerful Paralympic image was taken as the server studies the ball before he takes his shot. The athlete's eyes watching the ball are the focal point of this picture.

some grainy sand in a bunker shot at a golf tournament.

WINNING SHOT

For table tennis the winning shot is a serving image, shot in the upright format with the competitor serving in the bottom left. The rest of the image is black, except for a shiny white ball in the top right hand corner. How does the player serve when the ball is so high, maybe three metres up? This image is shot on a 70–200mm zoom and is all about the eye contact between the player and the ball up in the air. It should be a stark, dramatic picture.

3.6 Target Sports

Boccia is a game of skill – unique in that it can be played together by men and women of all ages with or without a disability (although at London 2012 it is purely a Paralympic sport). For the sports photographer the skill is in capturing the concentration and telling the story of the evolving game.

Three other target sports to be mentioned here are darts, snooker and shooting. These target sports are photographed in a similar way to Boccia even though snooker is a quiet game played in a near-silent arena and darts is a noisy game played in a boisterous setting. Shooting has the unique characteristic of being part indoors and part outdoors. Indoor consists of Rifle

▲ The Paralympic sport of Boccia is difficult to photograph. Here the photographer is trying to tell the story by showing the competitor and the balls in the same picture.

Shooting and Pistol while Trap and Skeet are outdoor and covered in Chapter 2.5. The techniques used to photograph them are similar.

How to Photograph Boccia, Shooting, Snooker and Darts

Indoor target sports are usually played in quiet arenas, which affect the opportunities available to a photographer. It can be frustrating when, desperate to take a picture, you see something happening but know that it is just too quiet – the sound of the shutter will put off the competitor. Conditions in other target sports vary: noise isn't an issue with darts but in shooting, which obviously has the potential to be very dangerous, sudden, unexpected sounds are a natural concern. You can still achieve good pictures, however, especially with creative techniques such as multiple exposure (see below).

At the Olympic and Paralympic Games, Shooting events will be held at the Royal Artillery Barracks in south-east London, with the Pistol and Rifle Shooting competitions being held indoors. This is an attractive venue and pictures of the famous façade will complement your sporting shots (p.227).

Challenges

Keeping yourself and your camera quiet are major challenges for photographers at any level in these sports. In snooker only professionals are allowed to take pictures; they use special photographers'

booths with perspex windows that cut down on the noise from the camera. This is great for taking pictures, but you are obviously limited as to where you can shoot from. For Boccia the arena is slightly busier – be aware of this as it can be tricky. Use a long lens to keep you away from the subject and don't release your shutter at inappropriate times. Wait instead for the competitor to release the ball before you take your shot.

The challenge in photographing darts lies in capturing the dart and competitor in one shot. This can be achieved by freezing the dart using a high shutter speed (1/2000th of a second). Alternatively, choose a relatively slow shutter speed to blur the dart creatively while keeping the competitor sharp (1/125th of a second).

Shooting isn't a particularly easy or

SPECTATORS' ANGLE

From the stands shoot a general view of the whole arena, then zoom in on the competitors. Look for reaction shots from winners and losers.

At elite snooker events you are not allowed to use cameras from spectators' areas as the noise would put the players off their game. Even at lower levels you should ask permission to photograph first.

At darts matches pay particular attention to competitors celebrating towards the crowd. A darts player uses the crowd for his or her motivation, which is great for the photographer. There are a lot of interesting shots that you can take on your point-and-shoot camera or camera phone.

photogenic sport to capture. There is very little point in trying to focus on the target, as whatever the level of competition it will be a long way away. One option is to zoom in to show the concentration on competitors' faces and the detail of their guns. Alternatively, you could shoot with a wide-angle lens to encompass the whole scene of target and shooter.

Camera Set Up

Follow the pointers below to get the best results from your camera set up.

> **Shutter speed** – needs to be 1/640th of a second for Boccia and snooker to keep everything sharp using a long telephoto lens. You can possibly reduce your shutter speed down to 1/400th of a second and still keep everything sharp if you need to under these dark lighting

TECHNICAL WISH LIST

Your ultimate pro camera kit contains two DSLR cameras and four lenses:
> 300mm or 400mm f/2.8 long telephoto for action shots of all the drama
> 200mm f/2 or f/1.8 extremely fast telephoto for indoor use
> 70–200mm f/2.8 for close-up reaction shots from within the crowd sections
> 24–70mm f/2.8 for general views
> camera soundproofing bag which fits around the camera and works like a baffle (a piece of soundproofing material) to silence the noise of the shutter
> monopod

conditions. For the best shutter speed in photographing darts, see Challenges on p.173.

> **Exposure** – mixed lighting plays an important part in the exposure of these sports. They are all usually played in darkly lit arenas, but the light at London 2012 has been fixed at 1/640th of a second f/2.8 at an ISO of 2000

> **Aperture** – needs to be wide open to throw the background out of focus and enable you to work with as low an ISO as possible.

> **ISO** – 1600 is really the minimum you'll be using here. At snooker you can easily be working with an ISO of 4000 to balance your exposure triangle (see Chapter 5).

Positioning

Select a low-down angle for Boccia as most competitors use a wheelchair – you want to be able to see competitors' faces as they concentrate and react. The head-on position is preferable as the athletes are throwing towards the camera. Professionals photographing snooker have to work in photo cabins at elite level, but in your local snooker hall you can use table-height level, shooting straight-on or to the side. With darts, a side-on angle is better to shoot from; remember to wait for the reaction shots. The competitor usually turns round and celebrates with the crowd.

Key Technique

Multiple exposure is a great technique for sports photography. It involves putting two or more exposures on top of each other to form a single image, which may add motion into a static shot or introduce a

particular atmosphere, such as a note of nostalgia. Use it to improve your creative images of indoor target sports.

Multiple Exposure

Multiple exposure works well when photographing fencing, diving and cycling, as well as snooker and darts. The single image it creates adds impact to a scene, indoor or out, which can change an ordinary picture into something dramatic. Creating multiple exposures is not difficult and can all be done in-camera, rather than in post-production.

SIX STEPS TO CREATING A MULTIPLE EXPOSURE

1. Support your camera with a tripod (at London 2012 you can use a bean bag or ensure your hand is utterly still) as you are going to take a series of pictures from a static location.

2. Choose your subject or sport. Multiple exposures are most successful when the subject is photographed against a black or clean background. In darts, for example, multiple exposure enables you to produce a sequence to show when the dart leaves the thrower's hand.

3. Select the multiple exposure button on your camera and decide how many frames you wish to take in your sequence.

4. Reduce your exposure by at least one stop. When adding multiple exposures on top of each other you can get 'burn' from too much exposure as you layer one upon another. Burn is a lightening of the image from too much exposure. The longer the sequence of multiple exposures the less exposure is required per image.

5. Release your shutter to take your

▲ Using a long telephoto lens behind the player the photographer has taken a detailed shot of the player's hands and snooker balls. This image doesn't need the competitor's face in it.

images at a key moment during the sport (this works well during fencing and darts as explained).

6. View your image and adjust your exposures accordingly. Be creative and experiment.

WINNING SHOT

The winning shot for these target sports is a great reaction shot. These sports can produce high-energy images of celebration or dejection, with the competitors feeding off the crowd's energy.

TIPS AND IDEAS

> Try some arty black and white detailed shots of the darts/dartboard.
> Choose a black background for darts as the dart shows up against a clean background.
> Be patient with target sports and wait for the picture to come to you.

3.7 Indoor Team Sports

Indoor team sports offer plenty of opportunities for dramatic photographs. Basketball, for example, will bring some of the biggest sports stars to London 2012 via the American Dream Team, with both photographers and spectators flocking to this indoor arena.
Handball is extremely fast: agile players throw a ball at up to 100km per hour, and it's not uncommon to see 50 goals in a 60-minute game. As a photographer you'll have your work cut out. Volleyball also has fast, furious and exhilarating action – perfect, like handball, for testing sports photographers' reflexes.

Wheelchair Rugby, once known as murderball, may not be as fast to capture, but it is a dramatic sport, which combines elements of basketball and handball. The ball used is identical in shape and size to volleyball.

The Paralympic sport of Goalball uses the volleyball court. It relies on silence in the arena so the visually impaired competitors can hear the bell inside the ball. Goalball is concerned less with fast-paced action and more with skill and tactics.

How to Photograph Indoor Team Sports

Capturing the action seems quite straightforward with these sports, and yet getting a truly great picture is difficult. Certainly team sports bring out the classic excuses of sports photographers: 'there was a player in my way'; 'I was blocked'; 'I couldn't see him'. You regularly hear these at the courtside, and we've all been there – but in reality people's arms and legs do get in the way of your killer shot. It's incredibly frustrating to see such a great image ruined by another player's body getting in the way. On such occasions, however, you have to be brutal with yourself and say it's not good enough. Move on and try again. Whether you are shooting basketball, handball and other indoor team sports at the Olympic Games or in your local

SPECTATORS' ANGLE
While the spectators' seating is higher up than the professionals, it's still possible to take good pictures. Zoom in on the action, trying to keep the image as minimal as possible. Focus on the action in front of you – this high angle lends itself to pan blurs. If you're right behind one of the baskets you've got a great seat, as all the action will be coming towards you. If you're sat on the side, concentrate on the one-on-ones. If you are photographing with camera phones or point-and-shoot cameras the shutter lag will be a problem, so anticipate your picture.

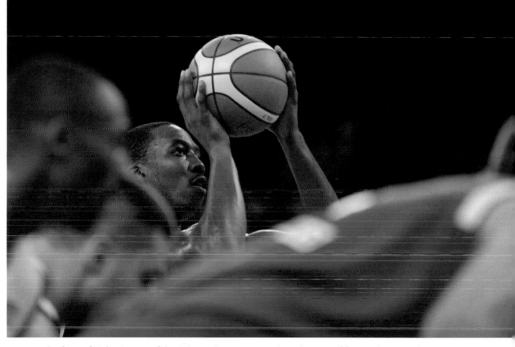

▲ Here the face of Kobe Bryant of the USA is clear amongst the other out of focus players as he is about to unleash his shot. Shot on a 300mm lens from courtside I used this lens wide open at f/2.8 to throw everything else out of focus.

school gym, the basic techniques you need are very much the same.

Challenges

The challenge for all three Olympic sports is getting a clean shot of the peak-of-the-action moment – be it the slam-dunk, spike or killer shot, where the athlete is usually hidden in among the other players. Anticipation and timing come to the fore, so you've got to be ready to seize the moment and nail your shot. Practise before a key game in order to quicken your reflexes. As well as knowing your stars, you also need to be very familiar with your sport. Who's an offensive player? Who's defensive? Who's considered controversial? In volleyball

you have the added challenge of players never actually taking possession of the ball, hence the name.

The challenges of both the Paralympic team sports are different. Goalball, with its need for silence, obviously brings problems for the sports photographer; all cameras are noisy to some degree. The best way to overcome this is to use a noise baffle (soundproofing material) or bag around your camera to reduce the noise. Alternatively, shoot on a long lens from as far away as possible. Motor drives are best turned off; use your camera on single shot. Time your shooting to take a single image in the moment when the goal is scored. After the goal is scored noise is acceptable,

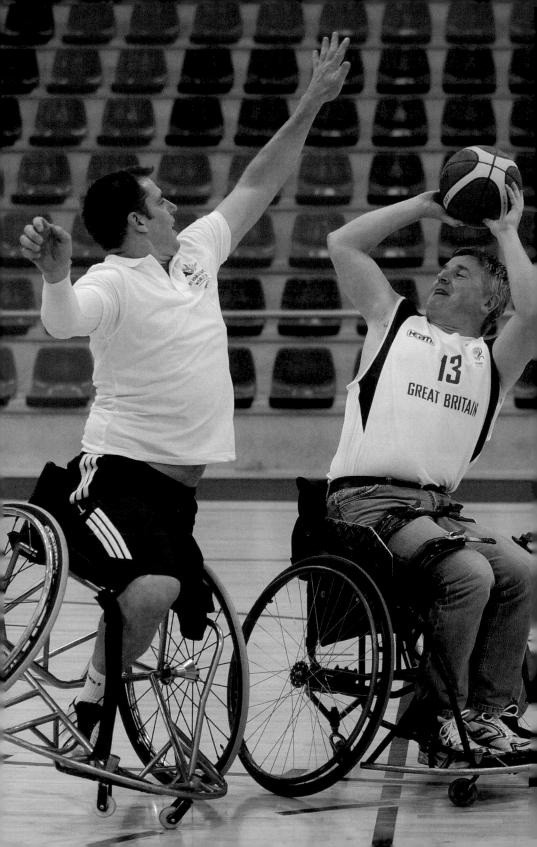

so capture the reaction. The dynamic game of Wheelchair Rugby brings the challenge of capturing the clashes when there can be a busy area full of competitors. You need to hone in on one or two individual one-on-ones.

The often-mentioned background issues of advertising boards and empty seats become acute here because the court is already busy. If you can't find a position that's clean, deliberately use the fact that there are subs and coaches encroaching on play in the background to add to your picture.

The arena's mixed lighting, like all indoor sports, will challenge your camera, but once you have this sorted out it doesn't change. Take the time before the event to prepare well and to set up your exposures and white balance (p.252).

Camera Set Up

Follow the pointers below to get the best results from your camera set up.

> **Shutter speed** – 1/1000th of a second is best, but this could go down to 1/640th of a second to freeze the action of these fast-paced sports.

> **Exposure** – Indoor mixed-lighting conditions with fast shutter speeds to freeze the action. Consider using slow shutter speeds for creative pan blur effects.

> **Aperture** – Despite needing depth of field to keep your fast-moving subject sharp, you need to shoot wide open at f/2.8 to throw the background out of focus.

> **ISO** – 1000 and above at elite level. Once you've adjusted for your optimum

ISO set it and leave it. At a local level use as high an ISO as your camera has. This is because elite-level sport is usually lit with extra lights for TV and therefore brighter than a non-elite sports venue.

Positioning

The best position for basketball photography is close to one of the baskets using a relatively wide lens (70–200mm or 24–70mm), though expect this to be reserved for professionals at elite events. From here you are able to get slam-dunks, one-on-ones and action around the baskets. You can cover the far basket as well if you want to, using a 300mm lens. It's difficult to juggle two cameras and lenses at this end-to-end sport. Professional photographers in America photographing the NBA are able, at some venues, to cable in to the strobe system which is fitted into the roof of the

▲ The unusual angle of this image was taken at a basketball game. I held my camera at floor level with the coach's feet in the foreground.
◄ This is a Paralympic Basketball practice session. Such sessions are a great time to hone your skills and your timing. This picture will be improved when the crowd fills the empty seats in the background. Shot on a 70mm-200mm lens.

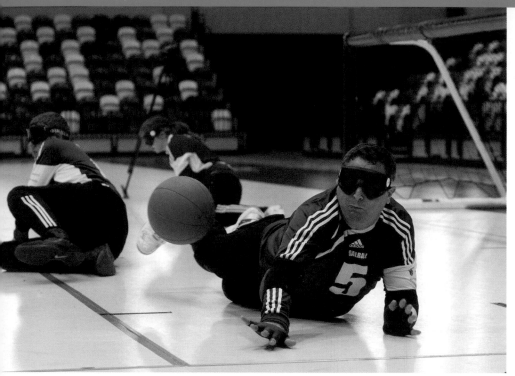

▲ Members of the Great Britain Paralympic Goalball team have their first opportunity to try out the newly completed Handball Arena in the Olympic Park. This shot was taken at a low angle and with a relatively wide angle lens.

TECHNICAL WISH LIST

Your ultimate pro camera kit contains two DSLR cameras and four lenses:
> 300mm or 400mm f/2.8 long telephoto for action shots at the other end of the court, action shots from the stands, detail shots and portraits
> 70–200mm f/2.8 for action shots from courtside, especially handball
> 50mm f/2 is a great start-off lens for action pictures of basketball and volleyball
> 24–70mm lens for basketball slam-dunks and volleyball digs
> remote camera kit to look directly down on the baskets at basketball

arena. By using this strobe system your exposure is constant (f/5.6 – f/8), your depth of field is greater and the quality of light is better. You need to time your pictures and not shoot a motor-driven sequence, but the results are far superior to ambient light. However, this option is not yet available in the UK.

Handball positioning is similar. Professional photographers will sit or stand as near the goal as possible so that the players will be shooting towards them with competitors' faces clearly visible. You may be able to take up this position at a lower level; if so keep as low as possible to exaggerate any height on players that are jumping.

One option with volleyball is to work at the net with a short lens. This

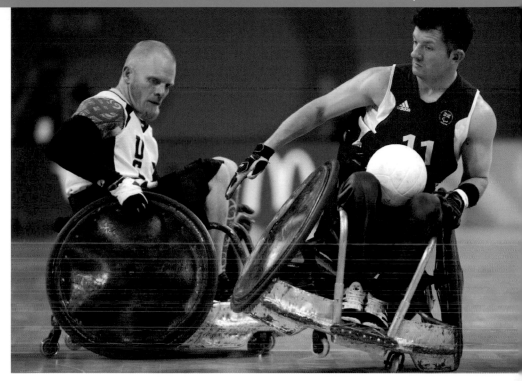

▲ Wheelchair Rugby is quite a fast-moving physical game with players bumping into each other. Always look out for duals and one on one action. The photographer here has used a 300mm lens to fill the frame from courtside.

does produce good pictures, but it's not a favourite position with professional photographers because you have to use a short lens (70–200mm). This type of lens brings the background into play, resulting in images that aren't as strong. Most professionals shoot from the back at one end, using a long telephoto (300mm or 400mm). They are looking for action shots, such as spikes where players jump up to knock the ball down. It's possible to get defensive players with their arms up on one side of the net blocking as the offensive player shoots towards you from the far end, which always makes for a strong image.

For Goalball you ideally want the low-down angle, ideally looking into the goal at the goalkeeper or the goal

WINNING SHOT

The winning shot in handball is the peak-of-the-action killer shot, with the offensive player off the ground trying to throw the winning goal. Time it right – these shots are over in a few hundredths of a second. As is often the case, a lower angle is most effective.

A goalball winning shot is a landscape-format picture of the goalie saving from an offensive shot, relying on his hearing to stop the ball. Look for the reaction shot when he saves.

Two or three players clashing for the ball makes a winning shot for wheelchair rugby. The picture is really of the competitors' faces. Keep it simple and not too cluttered, and rely on the faces to make a powerful image.

▲ The warm glow and long shadows caused by floodlights has produced an interesting image even though the basketball player is in silhouette. Silhouettes when done well can produce strong images.

WINNING SHOT

The basketball winning shot is the moment just before the slam-dunk, with the player poised at the height of his jump, just ready to slam the ball home. This image is best captured with a remote camera behind the basket, looking forward. The use of a wide-angle lens brings the viewer into the picture. This remote camera is triggered by your other camera and fires simultaneously. Not everyone, not even all professionals, is allowed to put a camera behind the basket, but this shot can be just as powerful when taken with a low angle from below as the height of the jump is accentuated.

scorer. Remember not to get too close as silence is essential here, and always ask permission to take pictures at Goalball before the event starts. The last thing a photographer wants to do is to put off competitors when they've been training for four years for a Paralympic Games. Wheelchair rugby needs a low angle as well to capture the extreme exertion on the competitors' faces. This is also best shot from either end. Pan blur works as a technique in wheelchair rugby as it can simplify the image and reduce a messy background.

Key Technique

The basic photographic technique of filling the frame, a phrase often mentioned within this book, is an

important technique for all sports photography. If you do it well, filling the frame will help to add a professional look to your photographs; it is worth mastering the art to give your pictures impact. Yet failing to fill the frame is one of the main faults I see in up-and-coming photographers' work.

Filling the Frame

Filling the frame with your subject can make for a bold and dramatic image. Try to get the athlete's face as large in the frame as possible, as this is where the emotion is, and emotion equals impact. To achieve this you have to use the longest lens you can. Fill the frame with the athlete or subject, which focuses your eye on the subject and drops the background out of focus. It's this lack of distraction to your eye that you're after, enabling the subject to stand out from everything else. An example is a basketball player running with the ball: you want to be looking at the player and not be distracted by the referee or fringe players in the background. Zooming in on him thus cuts the other players out, enabling you to focus on the player who has the ball.

When sizing up your shot on whatever lens you have, bear filling the frame in mind. If you are using a zoom lens, can you zoom in a little closer? If using a fixed lens, can you walk forward a few paces to fill the frame? A shot with an unfilled frame is weaker because the eye is drawn to the more intrusive background.

The wider lens you use, the more depth of field you have – and therefore the more intrusive the background. This is why professional photographers use fast, long telephoto lenses with small apertures that separate the subject from the background, and why they always shoot in a way that is known as wide open. If your lens has a minimum aperture of f/2.8 then you use this aperture. It has the smallest depth of field and throws the background out of focus for less distraction.

WINNING SHOT

Volleyball's winning shot is a spike photographed from the end of the court looking toward the net. You can get both the offensive and defensive players in the shot as they fight either to block or spike the ball. Pay attention to players' hands and the graphic shapes they make. Players' faces are also full of emotion, and make great shots.

TIPS AND IDEAS

> Despite the fast pace of these team sports there is a rhythm to the action, and once you've tuned into this the game becomes easier to shoot.
> Shooting from the left side of the basket enables you to avoid getting referees' backs from ruining your shots. This is because they generally stand to the right of the basket.
> Expect to use extremely high ISOs: 4000 and above in dimly-lit school gymnasiums.
> These are perfect sports for a budget 50mm lens. Most photographers will start out with one of these lenses.

3.8 Indoor Water Sports

This section covers Diving, Swimming, Synchronised Swimming and Water Polo. They are all challenging sports to photograph, not only fast-paced but also taking place in water where the light is bouncing around, which can fool your camera's metering system. If you can manage this, however, indoor water sports are among the most striking subjects for a sports photographer.

How to Photograph Diving

Diving, popularised in the UK in recent years by Tom Daley, must rank as one of the most challenging sports to photograph. Divers are not only travelling at high speed but also twisting and turning as they do so. I used to dread shooting diving, which I only covered once every four years at the Olympic Games: I'd be lucky to come back with

one usable image after a day's shoot. However, the advent of digital cameras has revolutionised diving photography. With the high ISOs now available I can freeze the divers at 1/2000th of a second, and get a great shot of every competitor. The techniques below will provide a springboard to improve your own diving photographs.

Challenges
Go to the practice sessions if you can, to familiarise yourself with the different diving techniques, especially in the Pairs Diving, so you can anticipate individual divers' moves. You need to be able to pan

SPECTATORS' ANGLE
During the Diving you will be able to use the same angle as the professionals. Spectators' seats have a great view of the event, so use this with your panning techniques to get some great shots. Work out the cleanest backdrop and then concentrate on the action.

WINNING SHOT
I took this picture of Chinese diver Liang Huo at the Beijing 2008 Olympic Games. It's the only time I've ever seen this effect of the water forming a perfect circle as the diver tumbles through the air. Liang still had the water from a previous dive in his hair, and as he attempted his second dive the water was ejected, producing this perfect circle. To accentuate this spray I needed a dark background, which was provided by the back of the seating area behind him, the darkest area in the arena. The very fast shutter speed of 1/2000th of a second freezes him and the spray perfectly.

▲ Tom Daley stands out from the lattice work on the ceiling of the Ponds Forge Aquatics Centre in Sheffield. This unusual image was created with only a 70-200mm lens from the spectator's area.

TECHNICAL WISH LIST

Your ultimate professional camera kit contains two fast motor-driven DSLRs and two lenses:

❭ 300mm f/2.8 hand-held for fast and smooth panning action. Not on a monopod. (In this case a monopod restricts your movements and your pans are not smooth enough, leading to totally blurred pictures.)
❭ 70–200mm f/2.8 for slow shutter-speed pan blur shots.
❭ remote camera with 24–70mm f/2.8 lens and transmitting/receiving device
❭ underwater camera and housing

steadily with your camera and have good coordination to follow the diver.

High-quality equipment does give you an advantage in this sport. Most diving halls are inside and dark, with some of the most difficult mixed-lighting conditions. Cameras with really good, workable high ISOs come to the fore, as do fast lenses that capture more light. My favourite lens for diving is a 200mm f/1.8 lens – incredibly hard to use as the depth of field is measured in centimetres! Used at f/1.8 it takes some nerve as a lot of pictures are outside this minute focus zone, but the resulting quality outweighs the risk.

Diving is just as challenging for compact cameras and camera phones, but a good pan blur should be possible with a steady hand. Use your camera

phone video-clip facility as you may be too far away for a stills image.

Camera Set Up

Follow the pointers below to get the best results from your camera set up.

> **Exposure** – use a high ISO to allow the fastest shutter speeds, 1/2000th of a second and above. Mixed-lighting conditions apply. Use manual or shutter-speed priority as the indoor light is generally even. Do watch out for large windows, however, which will affect the exposure.

> **Shutter speed** needs to be 1/2000th of a second or above to freeze the action. 1/250th of a second or below will work for pan blurs.

> **Aperture** – needs to be wide open to gain fast shutter speeds.

> **ISO** – should be 2000 and above.

Positioning

The best positions for photographing Diving are actually in the spectators' stands. These are exactly square-on to the 10m diving boards, so when you are following the action you are in the same plane of focus. One strategy is to pre-focus on the diving board and then not touch the focus ring again, just pan with the diver. Alternatively, follow focus by locking your central focusing point on the diver and following him or her through the dive. This technique helps to fill the frame. When shooting in the stands you should look for a clear background or use the crowd opposite with a slow shutter speed to blur them and create a colourful background.

Another possible angle, used by

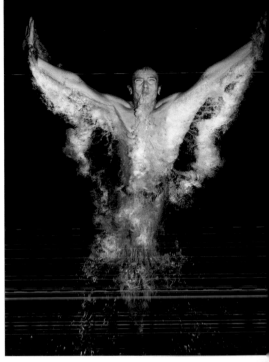

▲ This angelic shot shows Tom Daley captured underwater as he dives in from above. You can see the force of the water on his skin as he entered the water from above. The picture was taken with an exposure of 1/250th of a second at f/8, using ISO 400 and direct flash mounted on the top of the camera.

professionals at elite events, is at the deck level; here you can shoot the diver with the pool ceiling as the backdrop. Zoom out a little bit to get a creative shot of the roof – perhaps featuring a London 2012 logo to set against the diver. At the London 2012 Olympic Games I plan to place a remote camera to shoot the divers competing below with the pool as a background.

Remember to ask permission to photograph at your local pool because it's a public area (p.280). Take up a position in the spectators' area up near the 10m board and use a medium telephoto at the 200mm end.

Key Technique

If you want to photograph diving successfully you'll need to master the art of freezing the action. Freezing the action is a technique that applies to all sports photography (you either freeze them or blur them). However, it is particularly difficult with such a fast-moving sport, in which rapid action is compounded by twists and turns.

Freezing the Action

Fast shutter speeds freeze the action and slow shutter speeds blur (see p.245). On your camera you can control the shutter speed by either using shutter-speed priority or manual modes to dial in the shutter speed you require.

Sports photographers use 1/640th of a second as their default setting nine times out of ten. This setting enables you

not only to freeze most of the action, but also to get a decent exposure under most lighting conditions. Above and below this exposure are settings for sports at either end of the scale. For example, higher shutter speeds (such as 1/1000th, 1/2000th of a second) are useful for motor sport, diving, boxing, fencing, gymnastics, table tennis, water skiing and 100m sprint. Lower shutter speeds (such as 1/250th, 1/125th) are preferable for golf, rowing, sailing, boccia and snooker.

Other examples of shutter speeds that freeze the action are below:
> A shutter speed of 1/125th of a second freezes a person walking;
> 1/250th of a second will freeze someone jogging;
> 1/640th of a second will freeze someone running;
> 1/1000th of a second will freeze someone sprinting; and
> 1/2000th of a second will freeze someone diving.

Of all the sports, diving really does require an extremely fast shutter speed of 1/2000th of a second to freeze the action. This is because each competitor is twisting and turning as well as falling through the air at high speed. The diver is quite often tucked up in a little ball, only extending his or her body at the last moment before entering the pool.

If you don't want to freeze the action a pan blur works especially well with a slow shutter speed (1/60th of a second, see p.245). Remember to keep a smooth pan with the subject. Although it won't be a problem at the Olympic Games, try in other situations to avoid empty

TIPS AND IDEAS

> Try to photograph the divers in the first few seconds before they gain too much speed.
> You have to use a fast shutter speed – 1/2000th of a second or higher.
> If you want to practise photographing diving, use a trampoline and apply the same techniques. Think too about using fill-in flash or silhouette against the sky.
> When panning, try to capture the diver just as he enters the water. His or her hands and arms will be in the water, but the head and body remain above.

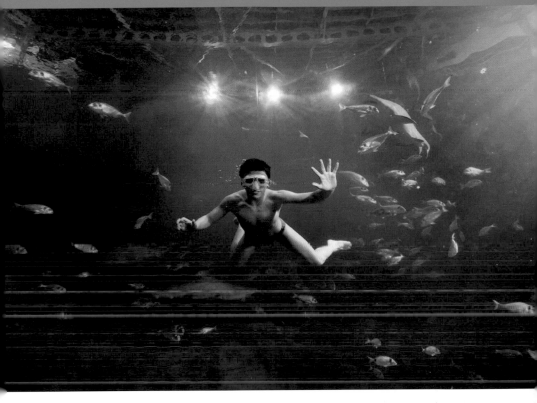

seats in the background. There is nothing worse than a great action shot with empty seats in the background: it really distracts the eye

SWIMMING WITH SHARKS

I have photographed Tom Daley since he was 11 years old. Most memorably I once asked him to get into a tank at Plymouth Aquarium with four 4.25m-long sand sharks! (Being Tom he agreed without fuss.) When we got to the tank and saw the fins just above the water, I did wonder if we were going bit far. All precautions were taken, including two scuba-divers and one free-diver in the tank, but I nonetheless opted to shoot through the viewing glass.

This proved a wise decision, as when Tom dived in and swam down one of the sharks went straight into attack mode and swam right at him. Tom was unaware of this unfolding behind him, but I looked at an ashen-faced Rob Daley (Tom's father) and froze, missing the shot in the drama. The shark missed Tom and I went on to take some lovely images of him swimming with the sharks and other fish. There was never any real danger as the sharks were sand sharks, although it certainly took courage on Tom's behalf to swim in a confined space with these intimidating fish. I was grateful to him, however, as we both enjoyed the chance to push the boundaries and create something really special.

How to Photograph Swimming

Swimming is a beautiful sport to photograph, but very challenging. The dramatic combination of fast-moving athletes, heads down and bodies under the water, with an excited atmosphere, spray, colour and lighting effects can produce stunning images.

I really look forward to photographing Olympic and Paralympic Swimming events; they are big occasions where you can be really creative. The digital camera has really come into its own at swimming, enabling good photographers to realise the sport's potential. We used to struggle with film to capture the images in the dark arena, but digital cameras have changed all that. Now the images are bright and clear, and you can get incredibly close to the subject. Some of the pictures are like action portraits, with the swimmer's face surrounded by water frozen in time.

Swimming is one of the most popular sports at the Paralympic Games: it has 600 competitors and 148 medals to be won. When photographing an event of this magnitude you need to be highly organised. Keeping track of your photographs is important when there are events in so many different disability categories. The techniques of photographing Paralympic Swimming are no different, so follow the advice below.

Challenges

Bear in mind that good swimmers usually have their heads down under the water for speed, only rising above the water to take a breath. You have to be alert and very quick to get the best shot. The real challenge is to capture such an instant of spray, water and the competitor's face – visible for just a split-second as he or she races up and down the pool.

Swimming indoors is usually in a dark, badly-lit pool, so mixed-lighting techniques have to be applied (p.255 and camera set up below).

Applying some of the sports photography techniques to public swimming pools is difficult because of the restrictions placed on photography there. (Always get permission before you attempt to photograph in public pools, see Chapter 6).

Each of the different strokes is photographed in the same way. The key to a good shot is patterns of breathing. You time your shot as the competitor breaks the surface to take a breath.

Camera Set Up

Follow the pointers below to get the best results from your camera set up.

> **Exposure** – the main challenge is that the light bouncing off the water can deceive your light meter, leading it to

SPECTATORS' ANGLE

Even though the action may seem a long way from your camera, the indoor lights will be bright from this high angle. You'll thus be able to pull up or zoom in on the action. Be aware of the problems that this environment can cause, however, especially the light reflecting off the water, which can confuse the metering system of your camera.

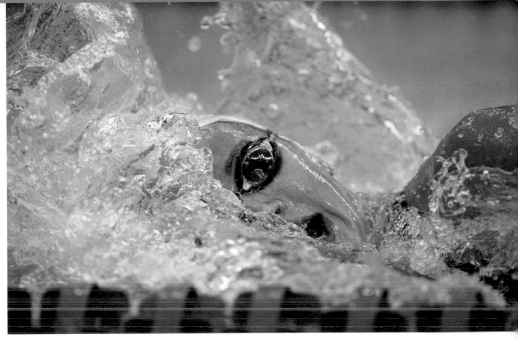

▲ This female competitor breathes to her left during a Freestyle event at the Beijing Olympic Games. I have frozen her with a shutter speed of 1/1250th of a second at f/4 ISO 1600 with a 600mm lens, and took the image lying on the floor of the pool deck. This gave me a very low angle looking straight into her face. If I could change one thing I would have the swimmer's goggles clear to give eye contact.

believe there is more light than there actually is. It's best to take an incident light reading for the pool area and use this (a tip is to slightly darken the image down a half or full stop to give detail in the highlights).

If you don't have an incident light meter, you have two choices. One is to shoot on shutter-speed priority and then use the camera's exposure compensation button to dial in more light, usually in third-stop increments. Dial in two-thirds of a stop, check the screen on the back of the camera and dial in more if needed. Alternatively you can take a

▶ Paralympic swimmer Louise Watkin powers through the water. To take an image like this you will need an underwater camera or housing. I also used an off-camera flash to light up Louise in the dark pool.

TECHNICAL WISH LIST

Your ultimate pro camera kit is two motor-driven DSLRs and two lenses:

> 400mm f/2.8 long telephoto for action pictures from the side or top of the deck. These telephotos need to be as fast as possible to work in the dark conditions unless you are lucky enough to shoot outdoors

> 1.4x converter changes a 400mm lens into 560mm f/4 to get even closer

> 70–200mm f/2.8 – this is ideal if you're standing next to the water

> monopod

> underwater camera and housing

> microfibre cloth to to wipe the front element and keep it clean

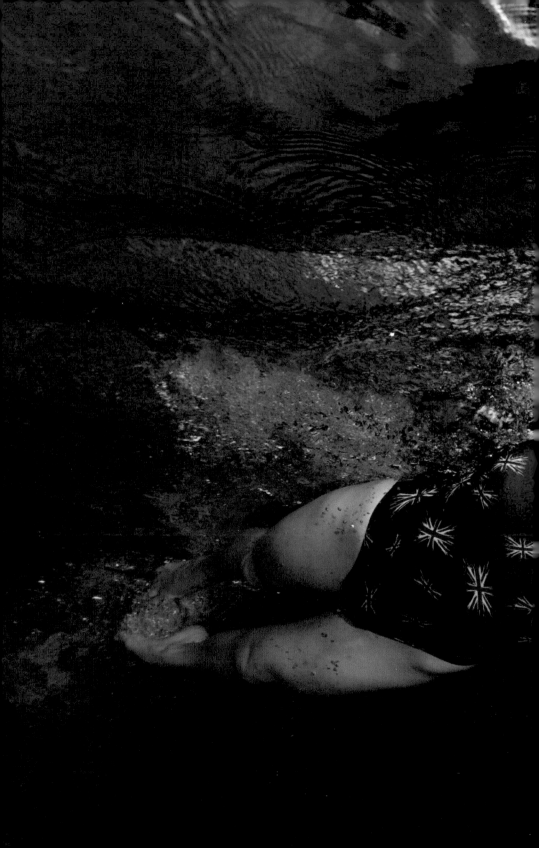

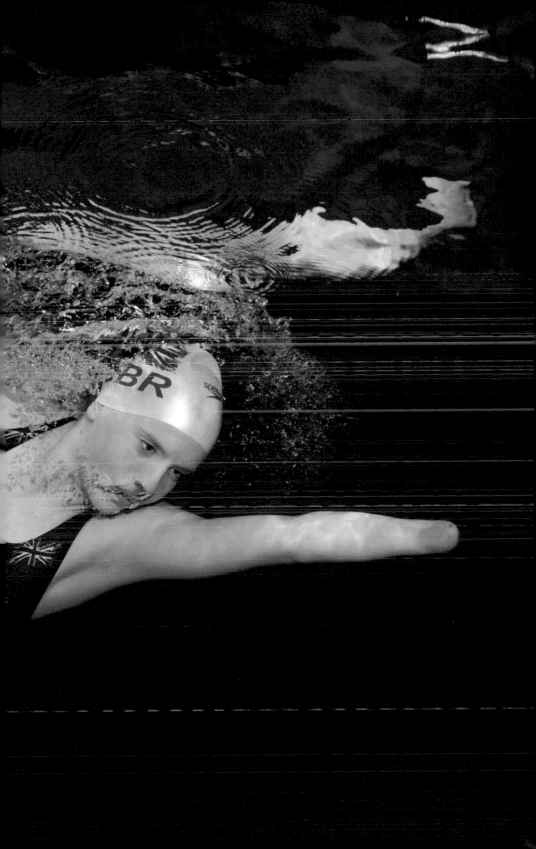

▲ This breaststroke image of Paralympian Liz Johnson has benefitted from the use of bokeh. Using a long telephoto lens wide open the warm lights from the pool ceiling reflected in the water have given this image a golden glow.

meter reading with your camera meter and set the readings manually. Check this reading on the back of the camera, you may need to open up accordingly.

› **Shutter Speed** – needs to be at least 1/1000th of a second or higher to freeze the movement of the swimmer; really high shutter speeds will help further. A speed of 1/8000th of a second will enable you to freeze the droplets of water – and stop people in their tracks with the resulting image. The trade-off is the light indoors may not let you go this fast, but still use the fastest shutter speed that you can.

› **Aperture** – needs to be wide open to collect as much light as possible in these dark indoor arenas. Shallow depth of field works well for swimming.

› **ISO** – 1600th of a second or more, depending on the lighting on the pool area.

Positioning

One of the best photographic positions for swimming is on the pool deck at the side of the pool. (At elite events this spot will be filled by professionals seeking that big and bold action picture.) A head-on position is best for butterfly and breaststroke and side-on for freestyle. I was able to capture the image shown here by using the 600mm lens's autofocus system to keep the swimmer sharp as she swam across my frame. I panned the lens at the same speed, then timed it to take the picture the second she looked my way to take a breath on her left-hand side. (She probably only did this three or four times each length of the pool.) You are drawn in so close that you feel as if you are swimming in the lane beside her.

Photographing swimming from above also works well, as water is photogenic

▲ Paralympian Rachael Latham performing the backstroke. I used back lighting to accentuate the droplets of water coming off her arm. I used a 400mm lens and timed my shot for when Rachel's arm was producing the most splash.

and the swimmers are all in lanes. Look for the symmetrical composition and leading lines from above when you have all the swimmers in a line below you. This applies at both elite level and amateur.

A compact camera or camera phone can produce a good picture. It reveals the beautiful colour of the water as swimmers power up the lanes, usually in a v-shape formation. The fastest qualifiers are always positioned in the middle lanes, so look out for the competitors there who will be the favourites to win.

Key Technique

Knowing the sport gives you the edge in sports photography, so it's well worth investing some time in research. Once you've familiarised yourself with the sport, photographing it will feel more natural. Background information on individual

TIPS AND IDEAS

> Don't fall in when you've got a camera to your eye and you're concentrating on what's happening through the lens. Do not slip or walk into anything, as you might end up in the water with an expensive camera.
> Be respectful of marshals. I remember an incident when a professional photographer overstepped the mark and a marshal pushed him into the pool with all his kit.
> Arrive early to allow your camera equipment to adapt to the temperature and humidity of the pool area.
> Microfibre or chamois leather will keep condensation off the lens front.
> Dress lightly as it's usually very humid by the pool.

stars is also important in any sport, but especially so in swimming as they are submerged for most of the time.

Know Your Sport – Know Your Swimmer

Details all help in planning your shot; learn in advance, for example, which side a particular swimmer breathes on. This is important as faces are only visible during the fraction of a second when swimmers come up for air. The rest of the time the swimmer spends head down in the water

for maximum speed. It's also helpful to know a certain competitor's routine at the end of the race. How does he or she celebrate? Which way does he or she look, and from which side exit the pool?

Swimming always has one or two key people who go for multiple gold medals, and some of these duels have been the high-points at previous Olympic and Paralympic Games. The fastest swimmers from the heats are always seeded in lanes four and five, so look to these lanes for the best swimmers.

Understanding the different disciplines – freestyle, backstroke, breaststroke and butterfly – will help you decide on your positioning for the best shooting angle.

THE WINNING SHOT

The winning shot is a breaststroke competitor, in this case Michael Phelps, gold-medallist in eight events in the 2008 Olympic Games. Taken the split-second before he broke the surface, the water is still smooth over his head; it looks as if he is encased in translucent jelly, with the reflection of the Aquatics Centre ceiling in the water. The high speed of the shutter has frozen the water – an effect that happens so quickly your eye never sees it. Only the camera is able to capture this instant.

This remarkable picture is enhanced by the use of colour, as Michael Phelps is framed by the yellow lane markings. The calm image belies the frenzy of the race.

How to Photograph Synchronised Swimming

Synchronised swimming is all about grace under pressure, and photographing these beautiful routines is a pleasure. It is a very photogenic sport, whether photographing the swimmers close-up in portraits or from their actual routines, wrists and legs snapping in unison. The patterns of the routines in the water make great symmetrical images.

The routine always starts pool-side with a short dance routine. The entry can be spectacular as the swimmers leap into the water in formation, producing some of the strongest images that you'll see. Use the techniques below to enhance your synchronised-swimming photography.

Challenges

What could be the challenge in photographing beautiful swimmers performing a gymnastics routine in water? Answer: the water itself. Underwater photography is a very

SPECTATORS' ANGLE

The spectators' seating area is ideal for taking Synchronised Swimming shots. Fill the frame with the swimmers and wait for them to perform their routine. If you can, zoom in on one or two individuals and wait for them to look up as they perform. Budget cameras, point-and-shoot or camera phones are all you need from these high up areas.

specialist skill and brings its own technical problems. Above water the problem is the light deceiving your camera's exposure meter. Once you've sorted this out, synchronised swimming is a relatively straightforward sport to photograph.

The swimmers will provide you with pattern after pattern. You have to decide which you want to record – don't be frugal with your images, shoot plenty and then select.

Camera Set Up

Follow the pointers below to get the best results from your camera set up.

> **Shutter speed** – needs to be at least 1/640th of a second, enough to freeze the action here. However, I would recommend using a faster shutter speed of at least 1/1000th of a second. This will freeze the water and improve your picture. Use manual or shutter speed priority.

> **Exposure** – the light for synchronised swimming is exactly the same as for swimming. See previous section.

> **Aperture** – needs to be wide open or mid-range apertures.

> **ISO** – will be 1600 or above in elite situations. At local swimming baths (after you've gained permission for photography) the light is generally very poor, and you'll need a very high ISO.

Positioning

With sports photography I'm generally an advocate of a low position, looking up at the sportsmen and women. However, the optimum angle for synchronised swimming is directly above, or as high as you can get looking down on your

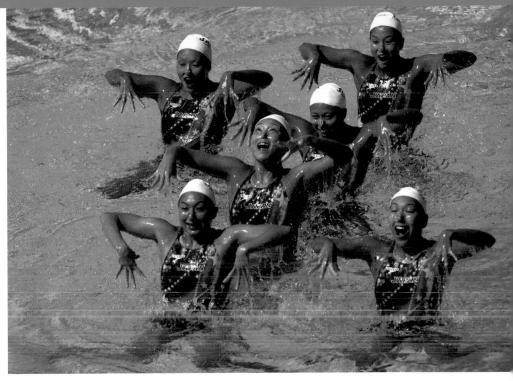

▲ A high angle looking down on the synchronised swimmers helps create this colourful image. The swimmers produce wonderfully symmetrical patterns as they break the surface. The shutter speed priority was set at 1/1000th of a second with aperture of f/4.5 at ISO 400.

WINNING SHOT

The winning shot is the view from above of a female team forming a flower-shaped pattern as they lie above the water. Symmetry and balance are an important element to this picture, which has the poise and elegance of a still from a black and white film of the 1950s. Everything should be as symmetrical as possible, with all the swimmers looking up at the camera.

TECHNICAL WISH LIST

Your ultimate pro camera kit contains two DSLR cameras and two lenses:
> 300mm or 400mm f/2.8 for images of individual swimmers from either in the stands or pool deck level
> 70–200mm f/2.8 for group shots from above
> underwater camera and housing for shots from in the pool of the swimmers performing. Obviously this is not possible during elite competition including the London 2012 Olympic and Paralympic Games, but it can be arranged during training and at a more local level. See underwater photography in swimming section.
> chamois cloth to clean your camera's front element

subject. The water makes a lovely blue backdrop for the patterns that the competitors produce. A low angle still produces good synchronised swimming images, but usually of only one or two swimmers. Competitors always perform their routine for the judges, so a position near to them is best.

Key Technique

Symmetry or formal balance in a photograph is achieved when elements on both sides of the picture or top and bottom are equal, similar to a mirror image. This technique lends itself perfectly to the sport of synchronised swimming, due to the stunning formations and patterns that the swimmers create.

Note that although our brains like to see order, rigidly composed pictures don't always hold our attention. So these guidelines are inevitably subjective: go ahead and experiment to see what works for you.

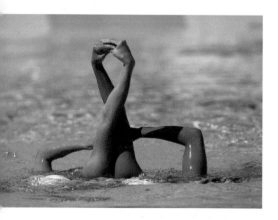

▲ This synchronised swimming shot of two women swimmers practicing in the outdoor pool in Athens 2004 is made more powerful by the shapes of their arms. It's difficult to tell one girl from another.

Symmetry and Balance

An example of formal balance in a photograph is found in the view directly above the pool. Here you are looking down on the synchronised swimmers as they perform beneath, and the symmetrical patterns that they make can, in turn produce beautiful images. While symmetry is found naturally in everyday life, it is rare in sport – so capture it when it presents itself.

Another example of symmetry's impact might occur in a team sport such as football. You would think it is difficult to find symmetry with so many competitors involved, but try zooming in on two men tackling for the ball. If they create the same shapes, you have a symmetrical picture. Patience is needed here: follow the action for a while, noting where the players are moving, and wait for your

TIPS AND IDEAS

> Acclimatise your equipment to the pool area an hour before the session starts, as this is an area of high humidity.
> Avoid reflections of overhead television lights in the water by moving position.
> Use the water spray from the swimmers as they are propelled from the water.
> It is possible to strobe-light synchronised swimming at an amateur level if you gain permission. Set up one or two off-camera flashes and place one of these flashguns behind the subject for added back-lighting effect.

picture. An asymmetrical balance to this picture would be two men to the left of this picture and one to the right, all tackling for the ball.

Reflections are an easy way of bringing symmetry to a sports picture. Think of water jumps at equestrian events, the water splash at the steeplechase, rowing, and swimming.

How to Photograph Water Polo

Water polo is a quick and exhilarating game – effectively an aquatic version of handball. Be aware that it's quite a physical game underwater and not for the faint-hearted. As with synchronised swimming, you will usually be photographing what's going on above, although I have included some advice on underwater photography below. Water polo action is fast-moving, so you will need to be alert: anticipation is important for good results.

Challenges

The main challenges in shooting water polo are associated with photographing near water. The rapid action is difficult to show because a lot goes on under water and, as in handball, the ball itself is moved around at breakneck speed. It's a question of being prepared for the peak-of-the-action moment – the match-defining throw when the goal is scored. Unusually water polo doesn't make dramatic underwater images as the ball itself remains above the water.

Clean backgrounds are usually very

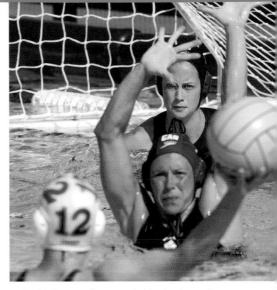

▲ In this image of water polo I had only a split second to decide on which of the three swimmers to focus on. Always try to photograph the competitor facing you.

important in most photographs, but not a major concern in capturing water polo. The pool and water are neutral to the eye and only help your pictures, so it's safe to concentrate just on the action.

Camera Set Up

Follow the pointers below to get the best results from your camera set up.

> **Shutter speed** – needs to be at least a 1/640th of a second (enough to freeze the action), but I would recommend using a faster shutter speed: at least 1/1000th of a second. This will freeze the water and significantly improve your picture. Use manual or shutter-speed priority.

> **Aperture** – needs to be wide open or mid-range.

> **Exposure** – the light for Water Polo is exactly the same as for swimming (p.190). Use manual or shutter-speed priority mode.

> **ISO** – needs to be 1600 or above. At your local swimming baths (remember to

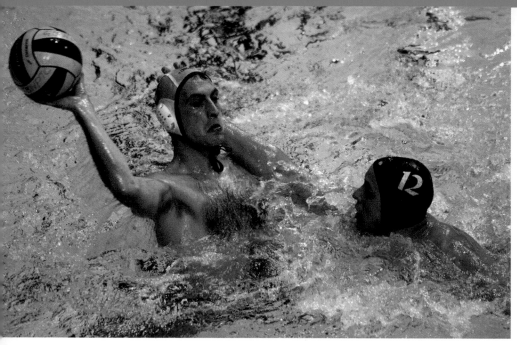

▲ From high in the spectator's area the photographer has used a 400mm lens to fill the frame with these two water polo players. In this situation shoot as many frames as you can.

ask permission before you photograph) the light is generally very poor, and you'll need a very high ISO.

Positioning

Get yourself down to the deck (which will be dominated by professionals at elite matches) and shoot as low as you can. It's really important to fill the frame and to shoot tight (that is, coming in close on the action). Because so much splashing water creates a messy situation, it's better to focus on one player as he or she throws the ball. The other option is to shoot from above where you have the blue water as the background. Fill the frame, but this time don't shoot as tight – keep two or three competitors in the picture.

Key Technique

Water polo is a dramatic and exciting game, with more goals scored than in, say, football. Action shots become the focus rather than the goals themselves, reflected in the skilful capturing of speed and light. All the techniques here for photographing water polo, such as fast shutter speeds, ISOs and mixed lighting, are equally applicable to elite levels or to photographing family and friends in your local swimming baths.

TECHNICAL WISH LIST

Your ultimate pro camera kit contains two DSLR cameras and two lenses:
> 300 or 400mm f/2.8 for images of individual players from either in the stands or pool deck level
> 70–200mm f/2.8 for group shots from above
> chamois cloth to clean your camera's front element

Capturing Speed and Light

To capture speed you can choose to take one frame in order to freeze the action or to let the motor drive work for you. If you have a very high-speed motor drive (ten frames a second and above) this technique works well. I still prefer to time it, however, and just let off a burst of three or four frames, starting with the image I want as the first frame.

Lock the camera's autofocus system on to the swimmer's eyes as this is the point of focus. Getting the correct focus is critical here, and you don't want it to move to the arm or the back of the head. Remember that the depth of field is incredibly small when working with long telephoto lenses wide open: we're talking about 10–20 cm.

If you are photographing underwater, bear in mind that water magnifies the image and makes the 35mm lens into a 50mm one. Water absorbs light much more quickly than air and sucks the colour out of the picture, so if you photograph more than a few feet below the surface you will need to use artificial light/flash to illuminate the subject. Even then you cannot work more than two metres away from the camera. Try photographing half-and-half, with the camera half-above and half-below the water, for creative shots.

WINNING SHOT

I think the winning shot for water polo is a very close-up image of a competitor's face. The player is in the middle of a cauldron of white water spray, with his hand throwing the ball and maybe another competitor's hand trying to block. In among the frenzy of action you need eye contact with the participant and a fast shutter speed to freeze the water droplets. Don't forget that the water polo competitors can raise themselves above the water when they want to throw the ball.

SPECTATORS' ANGLE

The spectators' seating area is ideal for taking water polo shots. Fill the frame with the players (p.84) and wait for them to swim-off at the start of each half. If you can zoom in on one or two individuals, remember the shutter lag and anticipate the action. Budget cameras, point-and-shoot or camera phones work well from these high-up areas.

TIPS AND IDEAS

> A major consideration when working poolside is keeping your camera kit dry. Remember that splash from the pool can travel a long way and easily damage equipment.

> The dimmer the lighting, the higher your ISO should be.

> When filling the frame as suggested, make sure that you don't cut players' hands and arms off.

> It's possible to strobe-light water polo at an amateur level if you gain permission. Set up one or two off-camera flashes. You could consider placing one of these flashguns behind the subject for added back-lighting effect.

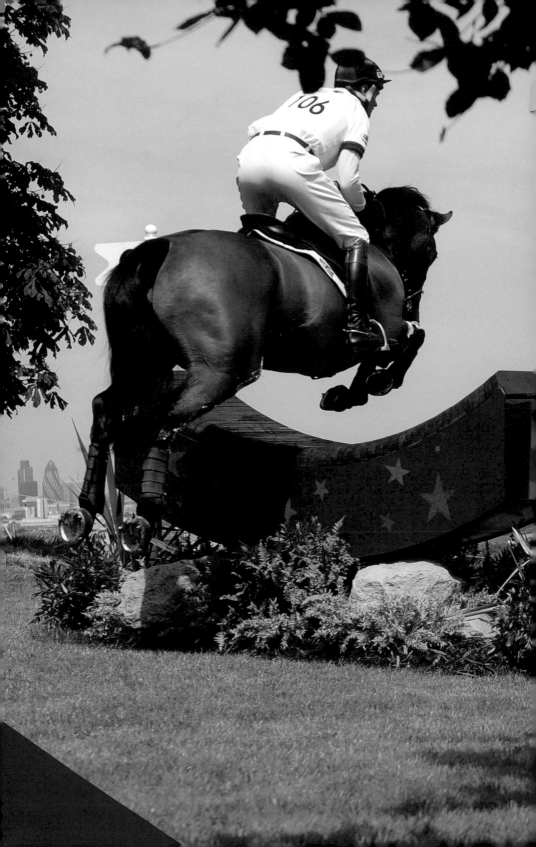

4

Taking Pictures
in and around London

London, even without the festivities of the Olympic and Paralympic Games, is one of the most photogenic cities in the world. Wherever you happen to point your camera, from historic old buildings to urban modernity, iconic landmarks to quirky street scenes, there is something for everyone.

It's great to be a tourist in London, but whether you've travelled here from afar specifically for London 2012 or whether you've arrived on the bus from just down the road, your visit may be short; you won't necessarily have time to schlep around looking for the best locations. This chapter will help you to find the best locations, taking into account background, skyline and composition.

A tourist's best friend is the compact camera, relatively light and easy to carry around. To get the most out of compact cameras, however, you need a certain amount of knowledge, especially about the correct use of light. The techniques described in the following chapter will explain how to get the best results from these cameras, which are particularly suited to landscape photography.

If you have a zoom lens, use this at its widest setting, with large apertures so that the buildings are sharp, and explore low camera angles looking sharply up at the buildings for dramatic results. In the Olympic Park itself, full-sized tripods and flash are prohibited, but outside the venues and in the city you can decide for yourself. Why not try combining a slow shutter speed with a tripod and using the flash to light up the people in and around the centre of London? The features of compact cameras are ideal for capturing the scenes of this wonderful city, so go out and have fun with them.

Photo Opportunities in the Capital

You may feel that the main landmarks have been photographed to death, but in fact every image is different. A lot depends on weather, light and the style of the photographer, to name but a few factors. And it is always fun to add your family and friends to the composition to show that you were there at the London 2012 Olympic and Paralympic Games. A snapshot and a grab shot are two

▲ This quintessentially English scene was taken during Wimbledon, with centre court visible in the background. I used a high angle to shoot this scene with a wide angle lens.

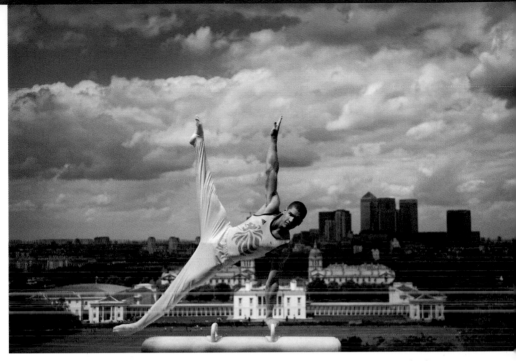

▲ Louis Smith performs on his pommel horse near the Greenwich Observatory. Canary Wharf and the National Maritime Museum provide a fantastic backdrop.

different things. A grab shot is when you take a shot without premeditation and just press the shutter whilst a snapshot is a casual shot, which doesn't follow the formal compositional rules.

When photographing your family and friends you want to create an emotional impact for the viewer – whether through a facial expression, interaction with the environment and other people, or juxtaposition with the background. Travel photography combines the techniques of landscape and people photography. Unlike sports photography, which is primarily fast-moving action and can be over very quickly, you generally have time with travel photography to be creative and think about your pictures. Some travel photography techniques such as rule of thirds, perspective,

light and composition can be used at events such as the Torch Relay, and some sports photography techniques like capturing key moments, telling the story and positioning can be applied to travel photography. If you are in the centre of London preparing to take a picture of your family and friends, you sometimes have only a moment to take your photograph before someone walks in front of you. Use your sports photographers' knowledge of anticipation and timing.

Resist the temptation to go for the obvious picture of Big Ben. Instead, zoom in on the detail or use a zoom burst effect (p.245) to create a colourful image of the face. Be imaginative – a creative approach often results in a dramatic and unique image. Think about placing

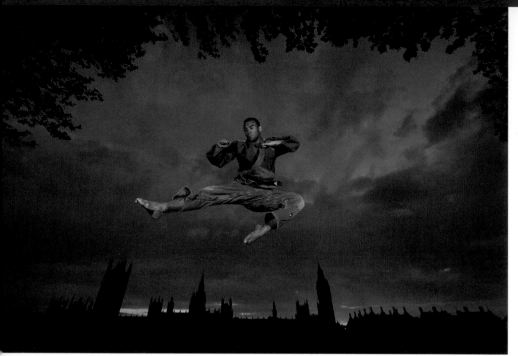

▲ Olympic Judo hopeful J R Badrick jumps across the dramatic sky in front of the Houses of Parliament. Luck played a part here; all the planning and assistants in the world can still not guarantee you a sky like this. I arranged for a trampoline to be located on the South Bank and shot this image on 1/250 at f/3, with an ISO of 100. Three off-camera flashes illuminate the subject.

London buses, taxis or their reflections in front of modern buildings such as the Shard, the Gherkin or Lloyds of London.

London's Landmarks

Particularly photogenic landmarks in and around the capital include the Houses of Parliament (and Big Ben, the clock tower), Buckingham Palace and the tree-lined Mall, Horse Guards Parade, Tower Bridge, London Eye, Hampton Court Palace, St Paul's Cathedral and the South Bank. There are also great vantage points such as Greenwich Park and Primrose Hill, which show off the city's dramatic skyline to good effect.

Houses of Parliament

The seat of the UK government, this is also known as the Palace of Westminster. The elegant clock tower is the most famous part of this gothic building; it was designed by Sir Charles Barry in 1856 and named Big Ben after the tower's largest bell. A light is illuminated at the top of the tower whenever Parliament is sitting at night.

For a good position try standing on Westminster Bridge at the Houses of Parliament end. If you turn through 180 degrees you can also photograph the London Eye and County Hall from this point. This stunningly intricate building photographs well at dusk when it's lit up, giving the stone a breathtaking warmth reflected in the Thames. If you're lucky

there will be a magnificent sunset as in the image of J R Badrick opposite.

Buckingham Palace

A fabulous building in its own right, this will be a pivotal point of the Olympic Marathon – runners streaming past and along The Mall will provide vivid action images from London 2012. My tip here is to choose either a high or low vantage point. From high you'll look down on the runners. If you get low to the ground you look up, but both create an image that gives the viewer a real feeling of being there in the bustling crowd. A fisheye lens (p.240) would be really effective here.

I think one of my defining images of the 2012 Games will be of cyclists passing in front of Buckingham Palace as they cycle round the Queen Victoria Memorial. I will then walk down The Mall to photograph the cyclists as they finish, with Buckingham Palace behind. I will use a long telephoto to compress the image and make the background of Buckingham Palace seem closer.

Horse Guards Parade

Horse Guards Parade is a traditional London landmark off Whitehall in central London. It takes its name from the soldiers who have provided protection for the monarch since the restoration in 1660 and is used for the annual Trooping of the Colour, which commemorates the Queen's official birthday.

The Changing of the Guard takes place here every morning at 11 on weekdays and 10 on Sundays. The ceremony, which involves the new guard taking over duties from the old,

is accompanied by lots of pomp and guards' bands. The Queen's guard in their bearskins and red jackets is a very colourful display, and it makes an iconic London photograph.

Tower Bridge

This iconic bridge over the Thames was opened on 30 June 1894 by the Prince of Wales (later Edward VII) and Princess Alexandra. Then the largest and most sophisticated bascule bridge in the world, its famous lifting section was designed to allow huge ships to pass beneath. The bascules are still operated by hydraulic power, but are now driven by electricity rather than steam. You can admire the technology in the Victorian engine rooms and capture some wonderful views of London and its riverside from the high-level walkways.

▲ Changing of the Guard at Horse Guards Parade. In their ornate uniforms the Queen's Guard make an iconic London image.

London Eye

The London Eye was conceived as a symbol of the new Millennium and opened in March 2000. It is the tallest cantilevered observation platform in the world and has become a hugely popular visitor attraction. The innovative design of its passenger pods or capsules (they turn within circular mounting wheels fixed to the outside of the main rim) provides a remarkable 360-degree panoramic view from the top of the wheel. If you can, try the circuit at different times of day to capture the views in changing light.

Hampton Court Palace

Hampton Court, originally a medieval manor house, was converted into a lavish palace by Cardinal Wolsey in the reign of Henry VIII. The King acquired the palace for himself and took over building work there in 1529; it became the setting for some of the most dramatic events of his reign. The famous architect Sir Christopher Wren developed the Tudor palace into a new building for monarchs William and Mary in the late 17th Century, and today it lies in beautiful gardens by the River Thames, to the south-west of London. The grounds are particularly famous for the challenging maze, and a popular ice-rink is located there in winter.

If you are outside Central London during the Olympic and Paralympic Games, try heading to Hampton Court Palace for the Cycling Time Trial. This starts in front of the historic Palace and will offer some great photo opportunities. I'll be shooting head-on to get the cyclists facing the camera with the Palace behind.

St Paul's Cathedral

St Paul's Cathedral, designed by Sir Christopher Wren, was built between 1675 and 1710 after its predecessor was destroyed in the Great Fire of London. It is built of Portland stone in a sober baroque style of architecture, and is one of the capital's most famous landmarks. The spectacular dome, 365 feet (108m) in height, features a famous Whispering Gallery running around the inside, which the public can visit. It gets its name from the fact that a whisper against the wall at any point in the gallery can be heard by someone else with an ear to the wall at any other point in the gallery: try it and see. The elaborate bell towers, rising in tiers to a bell-shaped miniature dome, are topped by a gilded pine cone and make a powerful silhouette to photograph against the sky.

St Paul's, one of several London landmarks to feature on the Olympic and Paralympic Marathon courses, will make a dramatic backdrop to the events.

▲ The London Eye from a bridge in St James's Park, using a long lens to bring the distant Eye closer.

South Bank

This is a busy, bustling area with lots going on and a large programme of events are planned during the London 2012 Olympic and Paralympic Games. With the Thames as a backdrop there are hundreds of photo opportunities – and no two pictures will look the same. Buskers make interesting subjects, especially if you have children with you as they love to stand next to the London street performers who congregate here. Contrasting styles of architecture provide interest and startling juxtapositions. The stark 1960s construction of the South Bank itself, made of solid concrete, is set against the historic buildings on the north side of the river.

Views of London's Skyline

London has a unique skyline and I have used my favourite vantage points around the capital over and over again as backdrops for my pictures.

For me, the best view is from the Royal Observatory in Greenwich Park.

In London 2012 this will be a venue for the Equestrian events – a great location from which you can see Canary Wharf, the Millennium Dome and the City of London. Using only a wide-angle lens, you can get a fabulous image of London. Shoot in the morning or the evening when the light is best. A panoramic technique (p.61) is ideal here for a treasured image.

Another justly famous London location is Primrose Hill. Situated on the edge of Regents Park, it affords views looking south towards St Paul's, the Gherkin and the BT Tower. A wide-angle lens or 70–200mm f/2.8 are all you need. Bear in mind that you will be shooting into the sun on a cloudless day. This position is best for morning or evening photography.

Parliament Hill on Hampstead Heath is also worth a visit for its views of the City, Gherkin and the London skyline. Remember the aspect is south facing and looking towards the sun, so you will need to shoot early or late in the day.

▲ A wide angle lens and low angle gives an unusual perspective on St Paul's Cathedral.

▲ The busy book market of London's South Bank, with the River Thames and historic buildings behind.

▲ The special effect of a rainbow is created by using a zoom lens (70mm-200mm) with the highlight reflecting off the London Eye causing this circular shape. I underexposed the picture to make it more saturated with colour.

Whatever your location you will need to keep some key photographic techniques in mind for best results. The advice below will help you do justice to your camera skills and the settings.

Keep it Simple

By this I mean concentrate on the main part of the image. Be big and bold, and don't let your eye get too distracted. If you are photographing the London Eye, for example, cut out all the clutter around the bottom, such as the crowds of people milling around, and either close in on the pods or zoom right out to show the Eye against the London skyline.

You can take a great shot of the London Eye from directly opposite, standing on the north side of the Thames. Put your camera on a tripod and use a slow shutter speed to blend the water

with the evening light, the pod and the reflection of the Eye in the river.

Work with the Light

Photography can be defined as 'the recording of light', and any photographer needs to choose the light carefully. There are many different forms of light – dramatic, soft, shadows, hard, hazy etc – but overall the quality is what is important. The larger the light source, the softer the light will be, and it is well worth making the effort to get up early.

The photographer's friend is the golden hour at first light and the last hour in the evening before the sun goes down. This is because dawn and sunset light is horizontal, investing the subject with a strong, three-dimensional quality. At dawn and dusk the sun is low and sunlight has to go through all the layers

TIPS AND HINTS

> **Sunrise:** if you intend to photograph at sunrise make the effort to check out the location the day before. It will be very difficult to find a good spot while still dark, and you don't want to miss the best light looking for a suitable composition.

> **Sunset:** spend some time exploring the location during the afternoon to find a good composition. Wait for the best moment of the sunset. As the sun gets lower in the sky you can watch the light progressively changing.

> **Pre-dawn and past dusk:** up to about 30 minutes before dawn and past sunset the landscape basks in soft, colourful light. There are no shadows and colours are widely saturated. Try black and white photography at this time of day.

> **Overcast light:** cloudy days are good for the photographer. The light is soft and bluish in colour, shadows are soft or nonexistent and contrast is low.

> **Open shade:** open shade gives a soft diffused light. This light has a slightly blue tint, which is good for portraiture. A subject is placed in shade on a sunny day, ideally with a directly lit area behind him or her. Use the technique of fill-flash to soften the contrast between shadows and highlight.

> **Backlight:** a subject is 'backlit' when the sun is positioned behind them and the camera is pointed towards the sun. You can either hide the sun behind the subject or have it visible as a bright spot in the photograph.

> **Direct light:** this light is direct, intense and very unforgiving, casting strong shadows. It is far from ideal for photographing your family and friends, so avoid where possible. Neither is it the ideal choice for landscape photography although sometimes you don't have the luxury of choice.

of dust and pollution before it reaches the subject; it is thus softened, warm and tinted pink, red or orange. This combination of diffused light and warm tint is pleasing to the eye and creates the ideal photographic light. Many of the best landscape pictures are taken at this time.

The overhead sun at midday is hostile to photography. It creates harsh shadows and bright highlights that can be really unflattering and contrast too much. This is especially important in portrait photography, as the light will place those unsightly shadows beneath

▲ On the right the subject is backlit as I shot into the sun. On the left a reflector casts the light back, and brightens the shadows; fill in flash offers the same result.

the subject's eyes and nose. One solution is to move the subject into the shade, where the light is more diffuse. Where that is not possible professionals use diffusers and reflectors, but you need an assistant for this. The assistant holds up a diffuser, an enormous plastic-framed white sheet between the subject and the sun. A reflector is silver, gold or white; it is placed underneath the subject to push the sunlight back up onto the subject's face. If you don't have a photographic reflector use a large piece of white card or polystyrene – A3-size, or bigger.

Use a Tripod

Most photographers talk about their tripod as though it's their best friend. But not many friends, or even paid assistants, are always on hand or able to stay out all night to hold your camera steady and help get the perfect shot. Tripods, once set up give you the time to get the image right and then offer a steady platform from which to take that shot. Extremely slow shutter speeds are possible whilst the camera is being held so still.

There are many tripods on the market, so go for something sturdy and well made. No matter what type you buy, as long as you use one, your photography will improve. Remember that a light, cheaper tripod that you carry with you is far more helpful than an expensive heavy one you leave at home!

There are two common types of tripod head fitting – the conventional pan-and-tilt or the ball-and-socket, although there are others including quick-release and pistol-grip.

Pan and tilt has one or two levers to help you pan (move the head from side to side) and tilt (move it up and down). A ball and socket is good for quick work, as it allows you to move the head in a single movement.

A tripod's main function, of course, is to hold the camera steady and avoid camera shake (which results in a blurred image). Tripods are obviously the most sturdy support you can have, but they are cumbersome and slow for the sports photographer. You are also unable to take them into any London 2012 venue,

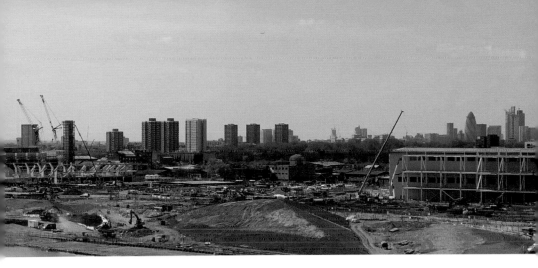

▲ This panoramic shot was taken from the roof of the Velodrome. The Olympic Stadium is visible on the left with Canary Wharf behind.

or those of most other major sporting events except cricket, because bags over a certain size are prohibited by security regulations. Spectators may bring in one soft-sided bag per person that should be no larger than 30cm x 20cm x 20cm and so small enough to fit under the seat. At cricket they are a must because they support the heavy super-telephoto lenses all day from the photographers' fixed position. They are occasionally used at other sporting events as a platform for remote cameras.

Venues

I have been incredibly lucky to have been able to see the Olympic Park and stadia take shape over the last four or five years. I have watched them evolve from drawings on paper to the immensely impressive architectural buildings they have become, and have had the opportunity to take some unforgettable images. One I remember well features the BMX rider Shanaze Reade cycling on the half-finished roof of the Velodrome. She had to weave in and out of builders as they were nailing the finishing touches to this beautiful venue.

I also photographed Tom Daley on the 5-metre diving platform; at that stage of the building work it was completely covered in miles of scaffolding except for one small hole through which I could look to photograph Tom. That day we also glued tiles to the swimming pool floor being prepared at the time. It's nice to think that when Tom takes his Olympic dive he'll be diving into a pool that he helped to tile!

As the buildings are completed the final vision of the Olympic Park and other venues is starting to emerge. They will provide a magnificent backdrop to the events of the Olympic and Paralympic Games, and are cleverly interwoven with iconic vistas of the city itself, an active part of the London 2012 Games. Some

planning and practice will enable you to take some really memorable shots of this highly photogenic venue.

Olympic Park

The Olympic Park, the UK's largest-ever urban river and wetland planting, has transformed the derelict urban wasteland of the Lea Valley. More than 300,000 wetland plants and 2,000 semi-mature, British-grown trees (including ash, alder, willow, birch, hazel, cherry, poplar, London plane and lime) will create a colourful riverside setting for the Olympic and Paralympic Games. Stretching for half a mile between the Aquatics Centre and Olympic Stadium is an area of parklands, celebrating Britain's enduring passion for gardens and plants.

Positioning

The low gradient paths that make the Park so accessible, allow views of London, with sudden, unexpected sightlines opening towards the city. There will be

▲ Tom Daley stands on the 5m diving board in the Aquatics Centre. The leading lines draw your eye into him positioned in the centre.

a festival atmosphere at Games time, so take your family, friends and camera along for a great day out. Those not lucky enough to get a ticket can watch live action on the large screens erected around the Park, and photo opportunities will be almost limitless.

Olympic Stadium

The Olympic Stadium will host the Athletics and Paralympic Athletics. It's located in the south of the Olympic Park on an island site with waterways on three sides. Five bridges allow spectators access from the surrounding area and control the flow of people on to the site. The Stadium will be one of the most popular venues for visitors.

Your main challenge is going to be the crowds, which will be everywhere. If you want a view of the at least partially empty Stadium the only answer is to get there early. Otherwise use the crowd to show the atmosphere. Photograph painted faces, flags, laughter and record the global cultures being brought together through their love of sport. You might like to create your own project to see how many different nationalities you can photograph, and capture the spirit of the Games through the images of the fans you have photographed.

Planning is important and will help you to work around restrictions about where you can, and cannot, photograph in the Stadium. You should also make yourself familiar with the terms and conditions of ticketing (p.278).

Remember that the Stadium is basically a round bowl. If you find yourself trying to take a picture of family

▲ I grabbed this shot of the Olympic Stadium as I walked past on my way to a shoot. By shooting directly into the sun it has turned an average picture into something a little bit more exciting.

TIPS AND IDEAS

> Each night after your hard day's shoot, take time to jot down a few notes about the images you've taken that day in a diary. This will help when it comes to captioning and archiving. Some cameras allow for voice recording, which is another way of referencing your images.

> Be discreet with expensive camera equipment, especially in large crowds. The vast majority of spectators will be there purely for this spectacular event, but some opportunistic individuals will be on the lookout for easy targets.

Always have the camera strap around your neck or shoulders.

> Don't burden yourself by bringing too much equipment – it'll slow you down and tire you out.

> If you don't have a tripod with you and you want to use long shutter speeds use your camera bag as support or roll your jacket up. Think laterally: there's always something you can adapt. Remember, you can take in one soft-sided bag per person (for example, a backpack or handbag) no larger than 30cm x 20cm x 20cm.

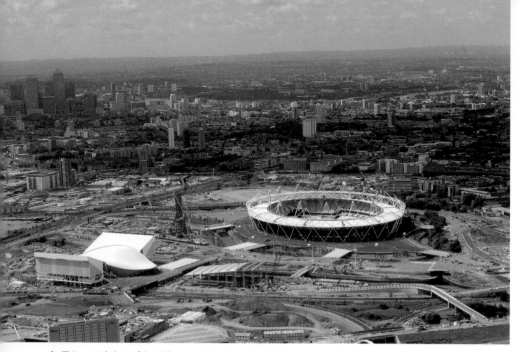

▲ This aerial shot of the Olympic Park shows the building progress being made in the summer of 2011. I shot this from a helicopter on a 24mm-70mm zoom and used a fast shutter speed as the vibrations from the helicopter can cause camera shake.

or friends from the shade, simply walk around the outside to the other side and try the shot again.

Positioning

Really you have limitless positioning options, but I'll describe four basics to start you off.

Firstly, try capturing this landmark of East London from a distance to position it in the London skyline. At dusk when the floodlights are on (during the Athletics Finals, for example) you'll be able to see this landmark from miles away. The display of urban lights from buildings, street lights and neon signs add to the atmosphere. Try to get a high vantage point with a medium telephoto lens to compress the perspective.

If you're lucky enough to coincide

with a sunset, expose for the sky. If the floodlights are on they will illuminate the stadium. If you use automatic exposure try aperture priority – you have no action to freeze and you need control over the depth of field. Small apertures (f/8 or f/11) are best as these give you a large depth of field. Alternatively position the building between yourself and the setting sun (a lower angle is best here) to photograph the Stadium in silhouette. You should deactivate the flash and expose for the sky.

A common mistake in my second suggestion, shooting close up to a building, is to use a wide-angle lens looking up at it. The wide-angle lens will distort the building, in this case the Stadium, making it appear to get narrower at the top. Sometimes you

can't move far enough back, in which case you have to use a wide-angle lens. (An architectural photographer would use a very expensive, specialist 'tilt and shift' lens to overcome these perspective problems.)

Perspective problems can also be adjusted digitally on the computer as you process the image, though it's always better to sort problems out in-camera. I'm always asked the best way of photographing a group of people standing in front of a scene. You should try to frame the venue, filling the area with the building without omitting any obvious bits. Then place your family and friends into that picture. It's always best to keep everyone as close together as possible (leave no gaps) and ideally you want the photographer/passer-by/camera-on-timer to get everyone's attention. I always crouch down to show the building behind towering in the background. The key is for the photographer to take charge of the situation and ensure everyone knows that on the count of three they need to be looking towards the camera with their eyes open – then take the picture on the count of two! Try putting the camera on the ground if you are very close to the venue for a more dramatic picture. The little travel tripods are really handy to carry, take up very little space and are great for this low angle. Spectators may bring in one soft-sided bag per person (for example, a backpack or handbag). This should be small enough to fit under the seat – it should be no larger than 30cm x 20cm x 20cm.

My suggestion number three involves having an eye for interesting detail, such as an intriguing sign, shape or shadows. A small depth of field (f/2.8 or f/4) will accentuate this detail. The 2012 graphics pattern is incorporated into the steel frame supporting the Stadium roof, for example. Use this design feature in a creative, detailed image.

Don't restrict yourself to photographing

▲ The basketball arena is a square box shape so when shooting it zoom in or use a wide angle lens to accentuate the shape as I did here.

▲ The basketball arena also has an interesting texture. I contrasted this with the sky by shooting up from a low angle.

the fascia; if you are lucky enough to have a ticket, my last suggestion is to pay proper attention to the inside. The Stadium design is a sunken bowl, so use a wide-angle lens to accentuate this. Before you take your seat, if you are able, go to the top of the Stadium to take a general view or panoramic, if possible capturing the whole of the stadium in the picture. A high angle is best for this view.

Aquatics Centre

The Aquatics Centre, providing a 'gateway' to the Olympic Park for visitors at the southern entrance, will be one of the busiest sites. Its spectacular design (by acclaimed international architect Zaha Hadid) features a wave-like roof which some have compared to a dolphin's back. During the Games two temporary seating stands, plugged into either side like battery packs, to boost spectator numbers. Afterwards these stands will be

▲ The Velodrome is the easiest venue to shoot on the Olympic Park. It's interesting shape needs no explanation. I have kept the picture simple and silhouetted it against a summer's sky.

removed and the side walls entirely filled in with glass, revealing the building's sleek and streamlined shape.

Positioning

Choose your moment to take a group picture in front of the venue. Be patient: wait for a gap in the crowd and then grab your shot. Either end of the Aquatics Centre is a good place to stand to capture the best angle of this beautiful building.

During the London 2012 Games the Diving, Swimming, Synchronised Swimming, Paralympic Swimming and swimming element of the Modern Pentathlon will take place in the Centre. With a 50m competition pool, 25m competition diving pool and 50m warm-up pool, those lucky enough to have tickets may well be pretty close to the action. But if you're a bit further away, don't be disappointed. Once inside just remember that if you can't get close, get creative. Use some of the techniques I talked about in Chapter 3 such as symmetry and balance, silhouettes and black and white photography. Check the tips in the Spectators' Angle boxes.

Velodrome

Hosting the Track Cycling and Paralympic Track Cycling, the gracious Velodrome, perched proudly on its hill, was the first venue to be finished at the Olympic Park. Together with the Aquatics Centre, it is one of the most architecturally interesting venues for photography.

Clad in Red Cedar, it makes the best possible use of natural light, while the innovative low cable-net roof system will

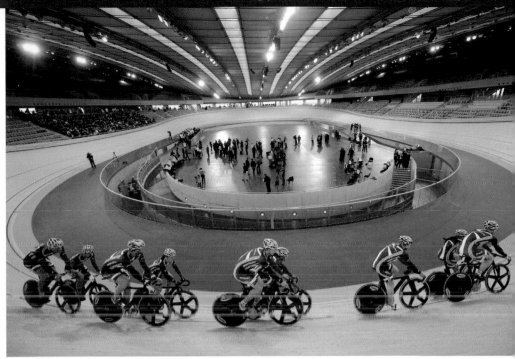

▲ The British Cycling team test out the Velodrome at the Olympic Park during early 2011.
The best general view can be taken at one end with a wide angle lens. Shot on a 14mm-24mm
lens at 1/250th of a second f/2.8 ISO 800.

produce a fantastic atmosphere for both
competitors and spectators There are
seats around the track in the concrete
lower tier, with further seating suspended
in the two upper tiers, within the curves of
the Velodrome roof.

Positioning

The views from inside looking out give
you a 360-degree view across the
Olympic Park – possibly one of the best
places from which to look over the Park.
Looking south across the Park you can
see the Aquatics Centre and the Olympic
Stadium with the London skyline in the
distance. From the outside this Pringle-
shaped building will give you a lot of
scope to be creative with its strong and
elegant curves.

Eton Dorney

The Rowing, Paralympic Rowing and
Canoe Sprint competitions are set to
take place at the beautiful Eton Dorney
near Windsor. This is a world-class venue
featuring an eight-lane rowing course
set in a 400-acre park with a nature
conservation area. You should be able
to get close to the action here and really
feel involved as you look through the
lens. Use some of the techniques I talked
about in Chapter 2 such as fill the frame,
freeze the action, timing and anticipation.
The challenge is to capture the effort, the
drama and excitement of the event – be
ready and react.

Positioning

Choose the start or the finish – you can't
cover both as the course is a minimum

TECHNICAL WISH LIST

Your ultimate pro camera equipment is two DSLRs and four lenses:

> 300mm f/4 long telephoto for compressing perspective and candid shots. It can be used with 1.4x converter to give you a 420mm lens This f/4 lens is compact, doesn't weigh much and is easy to carry around.

> 70–200mm f/2.8 lens is ideal for candid street/people photography; one of the two prime travel photography lenses

> 24–70mm f/2.8 is the other optimal travel photography lens, perfect for landscapes, grab shots and architectural images

> Super wide-angle 14–24mm or semi-fisheye. This is suitable for interior travel shots and when working in confined spaces

> Tilt and shift lenses are the professional's solution to photographing architecture and buildings close up, as they correct the distortion that make buildings appear to topple backwards

> Camera bag for stowing all equipment and smaller gadget bag

> Tripod/mini-tripod/GorillaPod

> Off-camera electronic shutter release

> Flashgun

> Incident light meter

> Filters

> Portable external hard drive for daily backing up of images

> Laptop

> Notebook and pen

of 2,000m long. As an alternative to shooting the racing, you could consider photographing their practice as the crews warm up although spectators will be allowed into the venue no more than two-and-a-half hours before the first competition. A tip here is to change the colour temperature of your camera (see Chapter 5) and warm the image up to give your picture a golden glow. To do this manually, change the white balance from daylight (roughly 5,500) up to 7,000 plus. Play around with it to get the effect you want (only possible on DSLRs).

Greenwich Park

In and around Greenwich Park (a World Heritage Site where the Dressage, Jumping, Eventing, Paralympic Equestrian and riding element of the Modern Pentathlon take place) is the National Maritime Museum and Old Royal Navy College. Here you will find some of the best views of London. From the top of the Observatory you look down on the National Maritime Museum with Canary Wharf in front of you, the Millennium Dome to the right and the Gherkin and City of London to the left. This park is a great place to take candid shots of friends and family. Use a low angle by lying down on the grass near to your subject. Children are always amused by standing astride the Meridian Line, where longitude is defined as zero and which divides the Earth into the Eastern and Western Hemisphere.

I have also taken one of my favourite shots of gymnast Louis Smith here, performing his vaulting routine with the spectacular London skyline in the background.

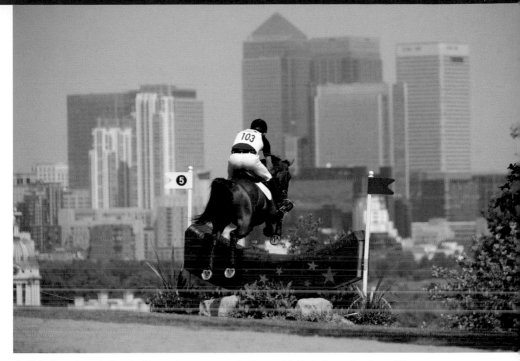

▲ This shot taken during the Equestrian test event in Greenwich Park shows the view of Canary Wharf looming in the distance. By using a 300mm telephoto lens the backdrop looms larger than it would using a shorter lens.

Positioning

On the climb up to the Observatory there are some fantastic vistas with views of the River Thames, Canary Wharf, Isle of Dogs and City of London. From this high vantage point you can look down on The Queen's House, built in the 17th Century by Inigo Jones, and contrast it with the ultra-modern Canary Wharf behind it.

You only need a wide-angle lens to take a great picture here. You're also working with the light, not against it, as the sun is behind you. Simply choose your moment when the sky is best to capture your image.

If photographing your family here, as well as the view, you might consider using not just a wide-angle lens but a telephoto (70–200mm) if you have one. If you do, stand further back from your subject for best effect. The telephoto lens will compress the image, making the background of Canary Wharf appear more dramatic and much closer, as if it is towering above.

The Queen's House will provide a magnificent backdrop for the Equestrian events at the London 2012 Olympic and Paralympic Games. The sight lines of the historic vista down to the River Thames have also been preserved – a real bonus for photographers at the event.

▶ A birds eye view of London. The Greenwich Park venue can be clearly seen with London in the background. The Equestrian arena is set up for a test event in the summer of 2011. I was lucky enough to take this picture from a helicopter using a 24mm lens and 1/1000 at F5.6.

▲ This is the Beach Volleyball test event at Horse Guards Parade in the summer of 2011. By shooting from the far corner of the spectator's area I was able to get this London skyline as a backdrop.

Horse Guards Parade

For the London 2012 Games the Beach Volleyball will take place on Horse Guards Parade right in the centre of London. Sand is being brought in to create the capital's very own beach, which will guarantee a unique photo opportunity here.

The volleyball court has been orientated so that it's possible from the back of the main stand to get the most incredible view across London. With the Beach Volleyball in the foreground below it's possible, with a wide-angle lens, to get the vista of Admiralty Arch and the London Eye above William Kent's Horse Guards Building.

The dramatic London skyline frames the view (see advice on panoramic technique p.61).

Lord's Cricket Ground

The world famous Lord's Cricket Ground is in St John's Wood near Regents Park. I feel very at home here, and it will provide a stunning backdrop to the Archery taking place here at the London 2012 Games. Plans show an archery range on the outfield of the Main Ground and the Nursery Ground, with temporary extra seating for spectators.

The orientation of the archery field of play has been switched to east–west at Lord's, enabling the action to be sandwiched between the modern Media Centre and the historic Pavilion.

Positioning

There are two places in front of which you'll want to capture your family or friends – the Pavilion, with its famous Long Room, built in 1889, is a thoroughly traditional English backdrop. It makes

a powerful contrast to the futuristic Media Centre, with its spaceship shaped architecture. The best place for a general view of the Ground is the upper section of the Grandstand.

Royal Artillery Barracks

The Royal Artillery Barracks, which dates from 1776, is located on the edge of Woolwich Common in south-east London and close to Greenwich Park. At London 2012 it will be hosting the Shooting, Paralympic Shooting and Paralympic Archery – a perfect location for the blend of indoor and outdoor events. The Trap, Skeet and Paralympic Archery events will be held outdoors, while the Pistol and Rifle Shooting will be indoors. Temporary grandstands will be constructed at each shooting range.

Positioning

The Royal Artillery Barracks façade is famous for being the longest in the country and makes a great photo opportunity. Use your rule of thirds technique to compose this picture, balancing the façade's perfect symmetrical lines with sky above and green grass below. The temporary seating makes an ideal position to shoot from.

Hyde Park

This is the largest of London's famous Royal Parks. You can photograph swimming all year round here, even in winter. During the Olympic Games Hyde

TIPS AND IDEAS

> Just as I recommend with sports photography, take your 'safe' shots, that is establishing shots. Once you have these captured move on to something more creative – don't be afraid to be original. Change your angle – shoot from ground level looking up or use a tripod with really slow shutter speed, change lenses or use bridges to look down on your subject.

> Visualize the image you want to take in your mind like a painter would. Think about light and composition, then try to create the image in your head.

> Use some distinctive features such as statues, fountains, Big Ben, bridges or building features as silhouettes against a rising or setting sun, or a dramatic sky.

> Don't forget to keep a look out for humour. This is often overlooked, but if you get it right it is a great asset to your photography.

> If stuck for inspiration have a look at the postcard stand or calendars for some creative ideas.

▶ Rollerblading in Hyde Park, a great place to practice action photography at the heart of the city.

▲ Open water swimmer Keri-Anne Payne was the first British athlete to qualify for London 2012. Here she practices in the Serpentine in Hyde Park. This picture was taken from a pedalo using a 24mm lens as she swam past .

Park hosts the Swimming 10km Marathon and the swimming element of the Triathlon – a photographer's dream, as 55 women on 4th August and 55 men a few days later on the 7th, thrash through the water of this tranquil lake in the heart of London.

The Park is also expected to be home to much of the music, theatre, film and cultural events that will take place throughout the summer of 2012. All of these will present countless opportunities for imaginative photography.

Positioning

Candid shots of people asleep in deckchairs, walking down tree-lined avenues, feeding the ducks and relaxing are plentiful here. Remember to be polite and ask permission before photographing up close to members of the public.

Use Hyde Park to practise your sports photography techniques as tennis, rowing, Frisbee-throwing, cycling, football, jogging, horse riding all take place here.

Weymouth and Portland

Down on the stunning south coast is the Weymouth and Portland National Sailing Academy where the Sailing and Paralympic Sailing takes place. This exposed spot jutting out into the English Channel has some of the best natural sailing waters in the UK. It is the largest single venue of the London 2012 Olympic and Paralympic Games, as spectators will be viewing from Weymouth and round to Osmington and Ringstead.

Positioning

There are a wide range of photo opportunities around Weymouth. You may choose to be quayside and up

▲ Ben Ainslie is one of the participants of this Finn class race. I was positioned on a boat some distance away to avoid the racing. So with a 500mm lens I was able to get this cluster of boats approaching the start line.

close to the crowds and action at the live site on Weymouth beach. The ticketed onshore spectator area in Nothe Gardens is a good location for reaction shots as people watch the lead changes on the giant video screens.

Camera Set Up

> Shutter speed – you are not trying to freeze the action, so your shutter speeds can be lower. Always use a shutter speed that is higher than the focal length of the lens (for instance 1/250th of a second when using a 200mm lens). Shutter speeds lower than 1/60th of a second result in camera blur unless using a tripod so stick between 1/250th and 1/60th.

> Aperture – in travel photography as a general rule you are using mid-range to small apertures to give you a larger depth of field (in contrast to sports photography, where you are using your lens wide open

to throw the background out of focus). Obviously this can change if you are shooting portraits or seeking a specific shot of a building or place.

> Exposure – you usually have more control over your exposure and more time to adjust it than in the sports arena. Apertures become more important than shutter speeds as you are not freezing the action.

> ISO – low ISOs are desirable unless shooting at night or in dark conditions. 100–200 is optimal on sunny days, rising to 400 and above on cloudy days.

▲ Giles Scott sails his boat down the river Thames for a specially commissioned picture.
I wanted him sailing in front of the Houses of Parliament and the London Eye.

TIPS AND IDEAS

> Check the weather forecast so that you can plan your photography around rainy/sunny days.

> If using a wide-angle lens watch for lens flare – use your hand to shield the lens from the sun and don't forget to keep your hand out of shot.

> This is a once-in-a-lifetime event so sleep when it's over – get up early, stay out late and get the best from the light. In England it's usually cloudy, so if the sun is out make sure you are.

> One of the biggest challenges to overcome with travel photography is confidence. A characterful face or cultural scene is often better shot close up, so pluck up the courage to ask permission – the worst that can happen is they say no. Be polite whether they agree or not.

Iconic Images

Just as at the Olympic and Paralympic Games in Beijing, Athens, Sydney and elsewhere, London 2012 will present some iconic images for the sports photographer to capture. The pressure is on, as you'll be freeze-framing history. Some iconic images can be anticipated and professional photographers are already planning where these will take place. There are the pictures that are going to become iconic – unique to London because of their compelling backdrop. Many of these locations are quintessential London views, and the locations of Olympic and Paralympic venues have been picked to showcase the best that London has to offer.

Several have been mentioned already in this chapter, such as Beach Volleyball on Horse Guards Parade and Greenwich

Park where the Equestrian events take place. As the riders jump over the fences it's possible, with the use of a wide-angle lens and a remote camera, to capture the rider jumping over the London skyline of Canary Wharf. The Road Cycling course, 240 kilometres in length, is going to produce more iconic images than any other event. The list of backdrops at this event should make any photographer very happy. They include The Mall, Buckingham Palace, Natural History Museum, Putney Bridge, Richmond Park, Bushy Park, Hampton Court Palace, Box Hill, Dorking Cockerell and Kingston upon Thames.

The Marathon course winds its 26.2-mile way through central London, passing iconic places such as The Mall, Buckingham Palace, Trafalgar Square, Blackfriars Underpass, St Paul's Cathedral, Guildhall, Tower of London, Monument and Big Ben.

The streets of London will be crammed with people, so arrive early having done your research and decided on your own viewpoint. My tip is to aim for one big scenic shot and then move around to try and get a bit of variety as the runners pound the streets of London. I will be trying to shoot the runners as they pass Big Ben using a low angle and shooting up. My aim is to try and include as many runners as I possibly can in the image, with Big Ben behind.

The Olympic Games will also produce iconic images that couldn't possibly be anticipated and really happen by chance. If you happen to be there when they take place, you are incredibly lucky. Examples of previous iconic images are Usain

Bolt beating the 100m world record in Beijing, Ellie Simmonds' triumph at the Paralympic Games that same year and Matthew Pinsent's congratulating of Sir Steve Redgrave at Sydney 2004. Having said that you can't anticipate these types of images, you can increase the chances of being in the right place at the right time by some strategic research. Iconic images tend to happen around the breaking of records. Looking forward to London 2012 we might consider Britain's Ben Ainslie, hoping to win a remarkable fourth gold and fifth Olympic medal in the Finn class sailing, or diver Tom Daley winning his first gold and a place in Olympic history as potential iconic images.

Who knows how many there will be? The Olympic and Paralympic Games always deliver moments of great drama, whether elation or dejection, and I really hope you are there with your camera to capture them.

▲ A woman triathlete runs past the Sydney Harbour Bridge backdrop during the Sydney 2000 Games. I used my flash gun to illuminate her and create an arresting image.

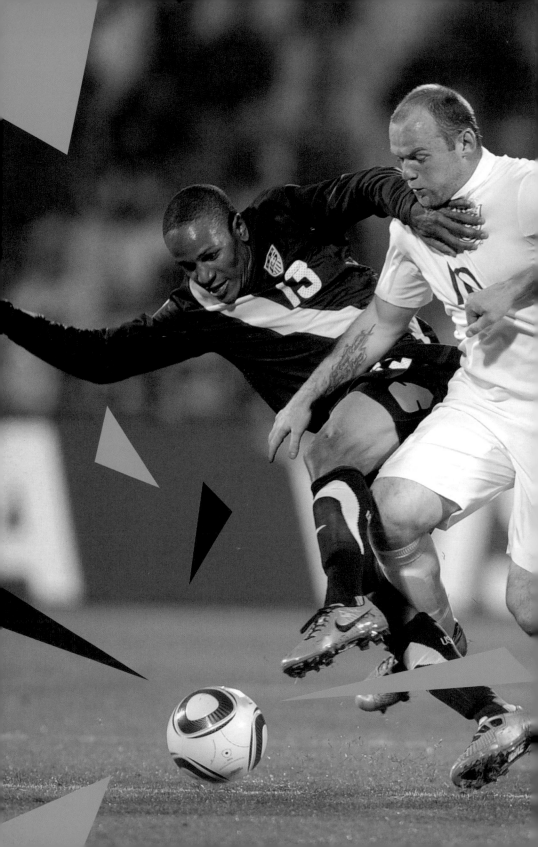

Techniques
and Equipment

5

Equipment Overview

There are plenty of cameras to choose from on the market. The choice between different megapixels, lenses, motor drives, high ISOs, optical zooms versus electronic etc can be overwhelming, so it's important to keep practical considerations in mind.

First ask yourself what you need the camera for and why. If it is to record family and friends around sporting venues (even in or outside the Olympic Stadium) and to record a few moments of your day at an Olympic or Paralympic event, a camera phone may do the job.

Camera Phones

Camera phones will not get close to the results achieved by high-quality professional or semi-professional cameras, but they are certainly good enough for most people during the day. They are very small and light so won't be a burden in a pocket or bag and the two-for-one benefit means you don't have to carry your phone and camera. Also there's less equipment to worry about getting lost or stolen.

The main disadvantage with camera phones is that they were not designed with the sports photographer in mind: they lack control for freezing the action. They also only have a fixed lens, usually a 28mm, which is perfect for family groups and scenes but not so good for distant sport action. Camera phones struggle under dark or floodlit conditions. Most tend not to have flashguns attached, and even if they do these are small and ineffective.

However, some of the latest camera phones are 8 to 12 megapixels giving very sharp and clear image quality. If you can, go for one that has autofocus. Camera phones now come with lots of exciting new apps, such as those for the iPhone or Android phone, for example, and other technology including 3D, panoramic and a host of special effects.

Compact Cameras

Point-and-shoot or compact cameras are a good compromise. They combine the ease of a camera phone with the benefit of a slightly better lens with more functions (designed for a purpose-built

TIPS AND IDEAS

> Always clean the camera phone lens before taking a picture as grease from your fingers and pockets finds its way all over the lens, resulting in smeary photographs. Cleaning is best done with a clean, non-abrasive cloth.

> Always fully charge your camera phone before setting out as using the rear screen display, or LCD, for playing back pictures uses a lot of battery power.

> If you are planning to take a lot of pictures, carry a spare memory card.

▲ During the women's relay I used a slower than normal shutter speed (1/200th of a second) to add movement to the woman's arms to give a sense of her speed. I panned with her as she sprinted past.

camera). When buying a compact camera go for one with the highest megapixels you can afford (generally the higher the megapixel count the better the actual photograph will come out). A megapixel is equivalent to a million pixels, and more pixels will improve colour depth, producing superior images for enlarging and printing. You should also look for a good quality zoom lens and a good-sized viewing screen, as well as considering weight, size and style. Many of the latest compact cameras pack in lots of impressive features. These include 3D, High Definition (HD), video, face recognition, autofocusing, manual controls and GPS for geo-tagging (geographically noting where and when you took a picture). They may also offer in-camera editing, panoramic software, waterproof and dustproof fixtures to protect the camera and more.

TIPS AND IDEAS

❯ Wait for your camera to process its data. When you have pressed the shutter button, don't check the image on the camera's rear screen straight away – this can kill your shot especially at night. Instead practice keeping your camera still for a few seconds afterwards. This allows the camera time to focus, take the picture and close the shutter.

❯ To get good images ensure you keep the lens free from dirt. Clean the lens on a regular basis.

❯ Try to use natural light. Often with compact cameras the flash is turned on automatically too early by the camera. Flash light can take the life out of a picture, so if you think there is enough natural light, go with it.

▲ Michael Phelps held up so many gold medals to the photographers in Beijing that I decided to focus in on the medal itself. You can easily recognize who the medal belongs to.

For sports photography shutter lag is the biggest problem to overcome. This is the time between pressing the shutter button and the photo actually being taken. Most of the time delay is taken up by the camera's autofocus system searching for the focal point, and it is the main reason for missed photo opportunities. You can take a good sports picture with these cameras, however – you just have to work a little harder than the owner of a DSLR. Remember, it's all about anticipating the action.

Lenses aren't normally interchangeable on compact cameras. They are usually mid-range zooms trying to cover both wide angle and telephoto, and they can struggle at the telephoto end of the range. Despite this they remain great all-rounders, at their best when seizing the moment and taking pictures on the go. Compact cameras are the most popular cameras in the world.

Digital Single Lens Reflex (DSLR)

Compact cameras are fine for casual photography, but the next level up, the DSLR (digital single lens reflex), is for a more serious photographer. With interchangeable lenses, through-the-lens viewfinder, metering, fully manual settings, larger megapixel size, fast motor drive, external flash, Raw (untouched, "raw" pixel information) and JPEG format options and less shutter lag you have far more control over capturing your images. Initially they appear complicated, but DSLR cameras have automatic modes for the less experienced and manual modes for the more advanced. Budget or entry-level DSLRs are only a small step up

from a compact camera.

Obvious disadvantages are the weight and size. They can be slower for that spontaneous picture on the move as you may have to change lenses, and you do need to invest some time learning what you can and can't do. For the keen amateur upwards they are a necessity, offering results far superior to a compact camera or camera phone.

Ten points about using a DSLR

> Digital SLR cameras are defined by their reflex viewfinder. This means that your eye sees the same light that is falling on the image sensor. To make a split-second decision to record a very fast moving subject you need to see the subject as the camera sees it. Even though the viewfinder goes black for a fraction of a second as you press the shutter release, you can still see the ball being kicked or the try being scored.

> Having the choice of lenses to attach to your camera adds to your creativity and increases your options. Each camera manufacturer has its own exclusive camera/lens mount, which cannot be swapped, but independent manufacturers also make lenses that will fit most camera bodies. These are often cheaper than the brand-dedicated options as well.

> Larger megapixel size and better sensors combine to give you colour depth and clarity, enabling you to take better quality photographs that you are able to crop into and blow up. When putting a lens on and off a camera dust can settle on the CCD (charge coupled device) or image sensor and give you those classic dark spots on the image. This is a problem unique to DSLRs and can be infuriating at times, especially when you get a black spot across your subject's face. Sensors are best cleaned sparingly every two or three months.

TIPS AND IDEAS

> Always keep the lens mount on the camera covered with either a cap or lens. This stops dust reaching the camera's sensor and creating black spots on your images.

> Don't just rely on what you see on the rear screen. This is only a rough guide, especially for exposure. If you have the time, check your exposures by looking at your images on a laptop. If you don't, use the camera's metering system manually.

> Try and limit your use of built-in flashes, which are really only there for emergencies. They point directly at your subject and give you a harsh shadow.

> Choose your equipment with care and background research. If you are serious about being a photographer, you'll have your kit for the long-run.

> Studying other photographers at work and watching how they operate is an economic way of learning about photography in practice. The Internet can also be a great source for information, but be selective what you use – the uncensored nature of the web means that the information isn't always up-to-date or correct.

> Multiple digital file formats give the user the choice of shooting raw, JPEG, TIFF, NEFF etc (see p.258).

> ISO ranges (p.247) are far superior to those in compact cameras and being able to work in low light levels is a massive advantage, especially when photographing sport. This is one area that has really developed in the last few years: being able to shoot at 3000 or 4000 ISO was unheard of only five years ago. This is a ground-breaking area that is really being exploited at the moment.

> Fast motor drives have been around for a long time, but now really long bursts or sequences are commonplace (not least because shooting on digital is effectively free; you don't have the cost of buying film or processing). It's now possible to shoot very long sequences of pictures.

> Accurate autofocus has played a big part in the explosion of sports photography. Previously you had to be extremely talented to manually follow-focus a large telephoto lens when photographing fast-moving subjects, but this is now taken care of by the autofocus system. This technology has really improved the quality of achievable sports photos.

> External flash and primary flashguns are more advanced and easier to use on these cameras.

> All controls on DSLRs are both manual and automatic, so regardless of your experience or capabilities these cameras can be set up for you; most are programmable to give you your own customised settings. DSLRs are extremely advanced computers that can do everything for you if you wish.

> Technology is continually advancing and improving DSLRs, so keep in touch with new developments.

Three-dimensional (3D) cameras

3D cameras are still very new to the market, but they will come into their own during London 2012 and beyond. There are now 3D camera phones, compact cameras and DSLRs.

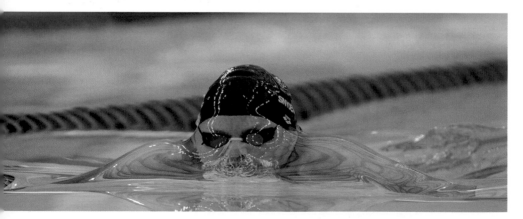

▲ I like this image because the ceiling of the Beijing Aquatics Centre is reflected in the water and on the cap of the swimmer. I shot this image on a 600mm f/4 lens from the pool deck.

They all rely on capturing two 2D images simultaneously on the camera's CCD, then overlaying them to produce one 3D image. This can then be viewed as a 3D image on the camera's LCD display and then transferred as normal on to a computer for viewing on a 3D television. It is also possible to print these 3D images on to colour photographic paper, but at the moment this is very expensive and not easily available.

3D images are best viewed on the largest television screen you have. The technology works best when viewed as big as possible.

These new 3D cameras produce fantastic images, especially for photographing family scenes and portraits around the London 2012 venues. The effect gives the viewer the sense of actually being there, and you are able to move around the image as you view it to see the depth. This new technology offers lots of new picture opportunities, and even the opportunity to retake old pictures in 3D. It's an exciting technique that I am sure will produce some new, stunning and original images.

To capture the two simultaneous 2D images you can either bolt two normal cameras next to each other, with the same lenses on each camera both focused on the same point of the subject. The cameras are fired simultaneously and the two images joined in the computer to produce a 3D image. Or some manufacturers produce a camera with two lenses side by side that capture the two 2D images onto different sensors, and then join them up in the camera to be viewed on the back of the LCD display.

These lenses are mid-range zoom lenses, but work best at the wide-angle end of the range.

Alternatively Panasonic produce a DSLR with interchangeable lenses, one of which allows you to take a 3D photograph using a single lens. The camera's CCD or image sensor is split in half, with one image recorded on the left-hand side of the sensor and the other image on the right-hand side. The two images are then joined in the camera for viewing on the back of the screen. The advantage of this system is that you have interchangeable lenses, which give you more options for your photography. Because 3D works best with the subject near the camera you can use this camera to take great pictures of children's games in the garden, school sports days, goalmouth action at football matches, golf tournaments, cycling races and swimming galas.

Interchangeable Lenses

The camera lenses that you choose now will almost certainly dominate your camera choice in the future. Cameras are constantly being updated (for a professional they last about three or four years) whereas a good lens can last a lifetime, so it's worth buying the best quality you can afford. The look of a lens doesn't matter: it's the all-important glass inside that really counts. So does the speed of the autofocus system, as the motors that drive these autofocus systems are usually built into the lens and not into the camera.

It used to be that prime lenses gave you the best quality and pros always

used them. However zoom lenses have now become so good, both in terms of sharpness and the speed of their apertures, that most professional photographers have at least two zoom lenses in their kit bag. If cameras and lenses were perfect, you would only need one. In an ideal world you could then shoot all your pictures on a wide-angle lens and blow the image up. But if you want to get a portrait photo out of your wide-angle landscape picture and crop closely into it you run out of pixels; it just becomes a grainy mess. To get round this you usually have to change the lens every time you think about taking a different kind of picture. (Obviously if you only have a fixed lens the answer is to walk closer to, or further away from the subject.) Interchangeable lenses enable you to stay where you are; if you want to get closer to the subject, for instance, you can add bigger and bigger telephoto lenses.

What Lenses do I Need?
Normal/Standard Lens

A 50mm lens is normally called the standard lens, and this gives you the same view/magnification that you see with your eye. These lenses are relatively cheap to manufacture and everyone starts off with one as their first lens. A do-all lens, you are able to take portraits and yet if you stand at a distance you can also take landscapes. Standard lenses also include any lens from 35–80mm; anything below 35mm is a wide-angle lens.

Wide-Angles
Wide-angle lenses on 35mm format are generally considered to have a focal length of 35mm or less. These lenses are mainly used for landscape, candid family group shots or when you can get extremely close to your subject. One of the disadvantages of these lenses is they can distort the image, for example if you shoot a portrait of a person the nose and head become larger. This is called lens distortion.

Ultra Wide-Angle and Fisheye Lenses
Wide-angle lenses wider than a 20mm are often called ultra wide-angle. Some

are corrected for distortion while others distort. An example of the latter is the fisheye or semi-fisheye lens. This is a non-corrected or distorting ultra wide-angle; it bends all straight lines and is often used to make something interesting out of a mundane picture of a stadium, for example. It will exaggerate the bowl shape of the Olympic Stadium, making it look even more impressive than in reality

You can also buy ultra-wide lenses that have been corrected for distortion. These are very expensive and usually have a large piece of spherical glass in the front. They are used when space is at a premium and you need to get a picture in a confined space. Ultra-wide lenses are especially useful on remote cameras in confined spaces such as at a horse-racing jump or close up to a goal mouth.

▲ Giles Scott sails his Finn class boat in Weymouth Bay. I attached a remote camera and lens to the top of the mast, which I triggered by radio from a nearby boat, using a 16mm lens, manual exposure of 1/800th of a second, f/8 and an ISO of 400.

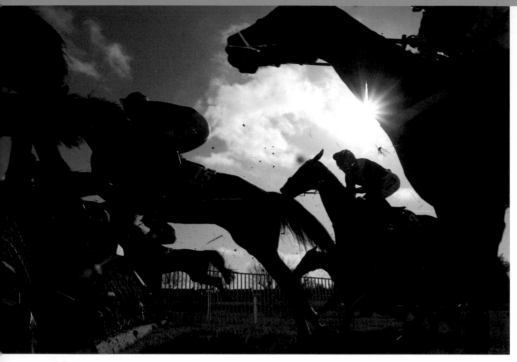

▲ This superb silhouette, taken at the Cheltenham festival by shooting into the sun, really gives you an idea of how the horses jump. I really like the sun peeping round the neck of the horse in the foreground.

Telephoto Lenses

Telephoto lenses start at 70mm and are used for high magnification when the subject is far away and you want to photograph it without moving forward. Alternatively you can use it to flatten perspective and make two objects that are far apart look close together. These lenses are difficult and expensive to produce; only in the past 20 to 30 years have camera manufacturers been able to design really high-quality long lenses.

Telephoto lenses in the 80–200mm range are perfect for portraits and sports where you are relatively close to the action, that is football goalmouths, tennis, fencing, boxing etc. The really expensive telephoto lenses are 200mm and above. The 400mm lens is the professional sports photographer's standard lens,

the one I use every day. This enables me to get close to the action without having to stand too close, and is perfect for the majority of outdoor sports.

The really big lenses that I will use at the London 2012 Games, for example, are in this range. They look so large because they are extremely fast. These lenses have a large aperture, usually F2.8, to collect the light when you are working indoors, or outdoors under floodlights on dark days.

If the 400mm lens is the professionals' standard for sports photography, the 600mm and 800mm are the extreme long lenses (used for sports such as cricket, motor-racing and sailing). They happen so far away from the photographer that you need super-telephotos to bring you close to the action.

Teleconverters are a small, lightweight, intermediate optic that increases the magnification of your telephoto lens. A 2x teleconverter turns a 400mm f/2.8 into a 800mm f/5.6, and a 1.4x converter turns a 400mm f/2.8 into a 560mm f/4 lens. This is a cost-effective way of increasing the focal length of your telephoto, and converters are great for saving weight and space as well. A small disadvantage is the quality loss to the image on some converters. A few are good; most are a compromise.

Zoom Lenses

Zoom lenses are a great compromise, enabling you to carry round a huge focal-length range in just one or two lenses. There are even some zoom lenses on the market that range from wide angle to long telephoto. These tend to be very slow, however, and the quality can be relatively poor. The two main zooms for sports photography are the very popular 70–200mm and the 24–70mm ranges. If you have these two lenses in your kit bag, you are covered when photographing numerous sports. Add the sports photographers' 400mm lens and these three lenses make up your main kit.

Filters

Sports photographers, like most photographers, use skylight filters on the front of their wide-angle and mid-range zooms to protect the expensive front elements. Special-effect filters are used sparingly. Grey grad, neutral-density filters and polarising filters are occasionally used to improve skies in wide-angle shots as they darken down the sky. As digital capture grows in popularity and quality, certain filters (such as graduating filters, warming filters, diffusing filters and star effect) have become less essential to the photographer as a lot of these effects can now be applied in post-production work. However, I always think it's better to create the image you want in-camera.

Flashguns

A separate flashgun is a brilliant way to extend your photographic range and bring extra quality to your sports images. (Personally I use them sparingly as I prefer to work with ambient light if possible.) Flashguns can be used attached to the camera via the camera's hot shoe, which gives a sometimes harsh, direct light. It is very portable and convenient, however, especially when used as fill-in light during the day. This technique can be effective for shooting road cycling and marathon running.

Alternatively you can now use flashguns off-camera, radio controlled or fired by infrared remotely. The positions in which you can locate a flash are now almost limitless. This type of flash photography has become extremely popular and photographers are pushing new areas with this technique, using the flashes to backlight or sidelight the subject. This technique is again ideal for road cycling, marathon running and most indoor sports, but always check whether you can use them at indoor sports events. They are not allowed at the London 2012 Olympic and Paralympic Games, for example.

The exposures for these flashguns can either be controlled by the camera on

automatic or, preferably, used in manual mode by the photographer (p.249).

Monopod

Monopods are a sports photographer's best friend. Lightweight yet stable, they enable you to be very mobile while keeping your telephoto still. Always choose a sturdy monopod that will not bend or buckle under the weight of the camera, lens and photographer leaning on it. Telescopic carbon-fibre models are the best, and you don't need any kind of ball head or adjustable top to them: just screw the monopod to your lens.

Gadget bag

Photographers spend more time talking about their gadget bags than almost anything else. Options include shoulder bags, hard cases, rucksacks, roll-along cases and trolleys. Spectators may bring in one soft-sided bag per person (for example, a backpack or handbag). This should be small enough to fit under the seat – it should be no larger than 30cmx 20cm x 20cm I have a range of all of them for different events and times.

My everyday choice is a lightweight roll-along case or padded box, which keeps all the cameras safe and well padded while being easy to pull along. This bag weighs about 20kg fully loaded, so you would not want it on your back, and at London 2012 a bag of this size would be allowed only for a professional photographer. This box is my office, studio, seat and base camp, so it's worth spending time to get just the right one for you and your needs.

If you are flying with camera equipment, a hard plastic case to protect your gear is worth investing in. These cases can take a pounding.

Digital Camera Set Up

Setting up a DSLR can be extremely complex. You need to spend time getting to know your camera's settings: it's a programmable computer and getting even one setting wrong can ruin your picture. First let me explain what each of the main settings control.

Some of these set-up steps also apply to more advanced compact cameras, especially exposure settings and modes.

Exposure Settings

Exposure is the basis of all photography. Controlling light coming through the lens into the camera is the art of creating an image. There are three controls you need to master to balance the light and create the perfect image. These three controls – shutter speed, aperture and ISO – are all interlinked and are known as the exposure triangle. When you adjust one, it has an effect on the other two.

The camera can balance these three settings for you to create the correct exposure. Eight times out of ten this is correct. To correct the two times out of ten and to give you more control over the other eight, use manual exposures. Most professional photographers use manual exposures in the majority of situations. You should take time to master and learn all you can about the exposure triangle. The initial exposure setting for the sports photographer is the shutter speed.

SHUTTER SPEED TECHNIQUES

	Shutter speed	**How to do it**	**Result**
Pan Blur	Slow shutter speed with daylight exposure: 1/125th of a second	Select a slow shutter speed and follow the subject as it moves, pressing the shutter down as you pan	If you get this right the subject will appear sharp but the background will blur giving the subject motion. Good for cycling, running, motor sport
Streak (long blur)	Long shutter speed set at night with a moving subject, such as a car: 30-second exposure	Position camera on a tripod if possible. Fire the shutter speed between one and 15 seconds, depending on the streak you require	Lights will streak effectively. Try on night events
Freeze action	Fast shutter speed in daylight: 1/1000th of a second	Use a shutter speed faster than the subject is moving	Try this out if you want to stop a goal-scoring footballer or freeze an athlete in mid-air
Zoom burst	Slow shutter speed with zoom lens: half a second exposure	Set the zoom ring on the lens to either end of the zoom range. Then set the camera to a slow shutter speed and fire the shutter release as you quickly rotate the zoom barrel from one end of the focal length to the other	Gives a great zoom burst effect. Try this out at Opening and Closing Ceremonies, Synchronized Swimming or generally around the Olympic Park.
Slow-sync flash	Slow shutter speed with flash: 1/250th of a second	Flash freezes the action, but the slow shutter speed continues to record the conditions. This results in further subject movement	A staple of the sports photographer. Try this out at cycling events or motorsport. Ensure flash photography is permitted beforehand

Shutter Speed

The shutter speed refers to how fast the camera will take the picture you're shooting. Think of it as blinking your eye. If you blink quickly while watching a football match most of the players will be in roughly the same position, but if you blink slowly they will have moved. All cameras from a basic compact camera to a professional-level DSLR have shutter speeds, although extremely basic compacts will often have a fixed speed over which you have no control. More advanced compacts have adjustable shutter speeds where the speed is controlled by the camera and can't be overriden.

With more sophisticated digital cameras and DSLRs you still have the automated control, but you can manually override for more creative use of the shutter speed. Camera shutter speeds can go from long exposures of 30 seconds or more to fast speeds of anything as short as 1/8000th of a second, depending on your camera. The sports photographers' norm is 1/640th of a second to freeze the action. This speed will freeze most sports and is used every day by professionals, with higher shutter speeds being required for motorsports, diving, skiing, gymnastics etc.

By adjusting the shutter speed, you can control the movement of the subject. A fast shutter speed will freeze the subject and a slow shutter speed will make it look more blurred as the subject moves. You can combine a slow shutter speed with flash to get both movement and blur indoors or outdoors even if the lighting is very good.

Aperture

Aperture (known to photographers as the f stop) refers to the lens diaphragm opening inside a photographic lens which controls the amount of light the camera lets in. When you press the shutter button (release), light passes through the aperture diaphragm and hits the sensor forming an exposure. Aperture also determines an important photographic element known as depth of field.

Depth of field is a technical term for the sharp part of your picture (the area of the picture that is in focus.) A narrow depth of field means that only a small area of the picture is in focus and whatever is behind or in front of this area is blurred. A large depth of field means that all, or nearly all, of the photograph you are taking is in focus.

As the lens opens wider (creating

DEPTH OF FIELD – CONTROLLING THE ELEMENTS AND OUTCOMES

> **Lens opening:** the wider the aperture, the shallower the depth of field. A narrower aperture extends the depth of field.

> **Focal length of the lens:** wide-angle lenses extend the field of sharpness more than a longer focal-length telephoto lens or the longest reach of your zoom lens.

> **Distance from lens to subject:** the nearer the subject is the shallower the depth of field. The farther the subject, the deeper the depth of field.

▲ This image was taken during the Opening Ceremony at Beijing 2008 using a panning technique and a slow shutter speed to capture these fluorescent wheels during the ceremony.

a big aperture) the numbers or f stops become lower, for example f/1.4, f/2, f/2.8, f/4 etc. A small aperture (as the aperture closes) results in bigger numbers or f stops, for example f/22, f/16, f/11, f/8 etc. See glossary (p.282) for more explanation of f stops.

The shutter speed and aperture relate closely to each other – the faster the shutter speed the more light it requires. This is because the camera has less time to allow the light in, as it's taking the picture faster.

ISO

In digital photography the ISO (International Organisation for Standardisation) measures the sensitivity of the camera's sensor. The lower the ISO number the less sensitive your camera is to light and the less noise (an unwanted dark speckling or grain effect on your image due to lack of light) there will be in your picture.

Higher ISO settings are generally used in darker situations to get faster shutter speeds, for example indoor sports events where you want to freeze the action. The disadvantage is the higher the ISO the more noise there will be in your shots; your images might also have a colour cast. However, the most recent cameras are really starting to overcome these problems, letting you shoot up to incredibly high ISOs of 6400 without any noise. In the future this will not be a major problem.

One of the main differences between a compact camera and a DSLR is that the former produces images with more noise

▲ Sergio Garcia tees off from the fifth hole at the Open Championships in Sandwich, Kent. The dark forbidding sky really adds atmosphere to this silhouette – I had to lie on the ground behind the tee to get the angle for this shot.

when using high ISOs and long exposure times. Not all compact cameras allow you to adjust the ISO. The DSLR handles noise better, but it is still a problem for most above ISO 2000.

Basic Camera Set-up

All the exposure priority modes are usually on one of the main control rings, depending on your camera. Exposure modes determine how your camera records what you see. They are your main tools to alter and control the exposure.

Fully automatic (P)

Most people start off using this mode where the camera is totally in charge of the shutter speed, aperture and ISO. It will produce a good exposure most of the time. This mode is used on most camera phones and compact cameras. The downside is that it can get the exposure wrong and you have no control; you might want to freeze the action and the camera decides to use a shutter speed that won't do this.

Shutter-speed priority – semi-automatic (often called TV mode)

This is the optimum semi-automatic mode for shooting sports. You set the shutter speed and ISO – the camera does the rest.

Aperture priority – semi-automatic (often called AV mode)

This is the optimum mode for shooting landscapes and people where you set the aperture and the ISO and the camera controls the shutter speed.

Other automatic modes

The three modes above are the three most important automatic modes and you will use them most of the time. Your camera may have other modes, such as landscape, portrait, night, macro, sports, movie, panoramic, snow etc.

Manual Mode

This gives the photographer total control over the exposure: you set the shutter speed, aperture and ISO. It is widely used by professional photographers, mainly on DSLRs; if you want to achieve a professional look, this is the mode you need to master. The camera's in-built exposure meter helps the photographer choose which shutter speeds, apertures and ISOs to use. This mode is worth persevering with as it improves the quality of your exposure and therefore your image. It works best when the light is stable, that is a bright sunny day or a cloudy day. Manual mode becomes more of a challenge when the light readings change rapidly, for example on days when the sun is constantly appearing and disappearing behind clouds.

Using manual exposure may make only a slight difference to your picture, but such small differences make your work stand out from other photographers'.

Metering Modes

The metering system in all digital cameras measures the amount of light in the picture and calculates the best exposure values: shutter speed, aperture and ISO.

There are three metering modes to look out for on your camera's in-built metering system. This metering system is the foundation for your exposures and can be controlled or guided by these three modes. Be aware they make a lot of difference to the resulting exposures. They are:

> **Centre weighted:** here the camera chooses the exposure area around the centre of your viewfinder or picture. As in most cases your subject will be in the centre, this metering system is the obvious choice.

THREE STEPS TO USING MANUAL EXPOSURES IN SPORTS PHOTOGRAPHY

1. Decide on what shutter speed you wish to use (1/640th is a good starting point) and then set it on your camera using the shutter speed control.

2. Roughly choose your ISO: around 100–200 on a sunny day, 400 on a cloudy day and 1000–2000 indoors using your ISO input dial.

3. On your camera adjust the aperture control until the camera's exposure meter shows you have the correct exposure. From this exposure it is then possible to adjust upwards or downwards for different effects. You might want to darken or underexpose your picture, for example, for silhouettes or dark effects. To overexpose or lighten your image, open up the aperture; this will let more light in to give your picture a brighter look.

> **Matrix metering:** I prefer Matrix metering, a system that has come to the fore in the last few years. It's probably the most complex metering mode, offering the best exposure in most circumstances. The image is split up into a matrix of different modes which are all evaluated individually to create the perfect exposure.

> **Spot metering:** this, as the name implies, is where the exposure is taken from the very centre of the scene. It's optimum for tricky light conditions where you have a lot of contrast, for instance a dark horse in front of a bright Buckingham Palace.

Focus

Focus is as important as the exposure triangle. The focal point of your picture is the central area of sharpness to which you want to draw the viewers' eye. It's where you pick the distance to focus your camera on. This can be done automatically (AF) by your camera's autofocus system, or manually (MF) where the photographer twists the lens barrel him or herself (note that manual focus is not achievable on every camera). Focus can enhance a subject by making it stand out or blend into its surroundings. It can draw you in and create an emotional connection with the viewer.

Autofocus Set-Up

Control and knowledge of your autofocus (AF) system is extremely important in all cameras. Because sport is so fast-moving, programming your DSLR's focusing system to work best for each individual sport is an art.

As each camera manufacturer's system is slightly different, it's best to familiarise yourself with the individual camera instructions. The main modes are Continuous Autofocus (AI servo) versus Single Shot (AFS). I prefer Continuous Autofocus for all my photography. With AI Servo mode the camera is continually focusing, which speeds up the time between pressing the shutter and image capture (shutter lag). Even though this has a slight disadvantage (the camera will take a picture when the image is slightly out of focus), it's worth persevering as the gain in speed outweighs the mistakes. Single shot AF is only activated after you've pressed the shutter and stops as soon as the focus is locked on to the subject. The disadvantage is that a fast-moving subject will have moved between lock-on and capture.

With both of these modes it's possible on DSLRs to use expanding focus points, which I recommend. Every camera has a focus point in the centre of the frame. It also has any number of extra points built around this. Most cameras are weighted to using the centre point because the subject is usually in the centre. This is, of course, true, but you should also add extra expanding points so that when your subject moves off-centre the focal point moves with it. This customisation is down to the individual camera and photographer.

Tips on using AF

Firstly, it's not always how you have the AF set up that matters most. It is also

▶ This picture of Paula Radcliffe during the Bejing 2008 Marathon really does say a thousand words. The pain on her face as she finishes is plain to see.

A GENERAL GUIDE TO FOCUS

Portraits	› Focus on the eyes › Use a large aperture (f/2.8 or lower if possible) › Focal length 50mm and above › Get as close to the subject as you can
Landscape and architecture	› Aim to capture as much of the view as sharply as possible › Use as small an aperture as possible (f/11 or higher) › Focus on something in the middle distance › If it is possible use a tripod
Macros (For close-up photography	› Attach a macro lens or use the macro mode on your camera, depending on your camera › Get as close as you can › Use the smallest aperture you can (f/8, f/11 or higher) › Use a high ISO setting › You may need an extra light when using a small aperture and working at close distances
Travel photography	› Blend of portraiture and landscape photography › Ideal for photographing family and friends at London 2012 venues › As a general rule always focus on the subject › Use a medium aperture (f/4, f/5.6, f/8) › Focal length should be medium to wide to include some background › Shutter speed should be fast enough to freeze the subject
Sports photography	› Focus on the main competitor and keep the autofocus locked on in continuous servo mode › Use a large aperture (f/2.8 or f/4) to collect as much light for the camera as possible in the usually dark conditions. Or use the same apertures outdoors under bright light by adjusting your exposure triangle accordingly.

about how you follow the subject with the AF points. Always follow the action with the AF points, anticipating when you are going to release the shutter.

Secondly, set your DSLR up so that the autofocus system is activated by the back button rather than the shutter button. This will give you more control as you can use your thumb to control the AF and your index finger to control shutter release.

White Balance

Digital cameras often have difficulty in judging true white under different sources of light (p.254). 'White balance' describes the process of removing colour casts so that the subject appears as white in the final photograph as it does to the photographer's eyes. All cameras contain an Automatic White Balance setting, but this isn't always right because the camera

PROS AND CONS OF USING AF MODE

	Pros	Cons
Continuous Autofocus mode (AI Servo)	› Minimises focusing time because the camera will focus continually. Reduces the time lag between pressing the shutter-release button and recording the image.	› You can take photographs even though the camera is not in focus. If you have time in the Continuous mode, check the AF indicator to make sure the camera is focused before taking a photograph.
Single Autofocus modes (AFS)	› Since the camera is not continually adjusting focus, the focus motor is not in operation until the shutter release button is pressed. This saves batteries. Under the single mode, photographs can only be taken when the camera is focused, a more secure way of photo taking.	› Because the camera starts its focusing activity only when the shutter-release button is pressed halfway down, there will be a time lag between pressing the button and the camera being focused. As a result your camera may not react fast enough.
Manual Focus mode (MF)	› Photographer manually focuses the lens. Especially for busy sports, such as the football goalmouth.	› Requires a high skill level.

is trying to balance all the colours in the picture to create an average. This is sometimes slightly off. Manufacturers also include a range of white balance presets on most DSLRs using the standard icons shown below.

Using these presets will stop your images looking unusually yellow or orange (follow the guide below). Understanding and managing digital white balance can help you avoid distorting colour casts, although in some sports, such as swimming, it's extremely difficult to remove the cast completely.

There are two answers to the problem.

The first is shooting in raw format (p.258) which allows you to modify the image during processing and change the colour temperature to produce a perfect white balance. Please check if your camera can shoot in raw format. If you don't have this facility you have two choices: use the presets or take a manual white balance reading. Begin by switching the camera to manual white balance mode (K colour temp.) and take a photo of a white object – a white sheet of paper or white-balance card, for example – under the lighting conditions in which you'll be photographing.

Auto Daylight Shade Cloudy Tungsten Fluorescent Flash Custom Colour temp

Adjust your degrees Kelvin (see table below) until you get a true white, then use this manual white balance for all your pictures. This can be done roughly on the back of the camera, but really needs to be done properly by viewing the test picture on a laptop with a corrected screen. Start at the daylight setting 5600 and work up the scale. It should become obvious fairly quickly as the pictures become yellower or bluer, hotter or colder (see Colour Temperature). When you get nearer to a true white, fine-tune in the processing (see workflow below).

Once you have made a decision on your white balance for a particular venue it's best to write it down, or save it in the camera as a custom preset. It can then be used the next time you come back to that venue.

This sounds fiddly, but such fine-tuning can really make the quality of your images better than the photographer next to you. Concentration on detail like this will make you a better photographer.

WHITE BALANCE PRESETS

	Location	Sport
Auto White Balance (AWB)	Indoor and outdoor (works better outdoors)	Equestrian, Rowing, Sailing, Paralympic Sailing; Cycling (outdoor); Athletics (during the day)
Daylight	Outdoors	Equestrian, Beach Volleyball, Archery, Rowing, Sailing, Road Cycling, Triathlon
Shade	Outdoors (indoors by a window)	Athletics, Golf, Football, Tennis
Cloudy	Outdoors	Tennis, Football, Cricket, Golf, Sailing
Tungsten	Indoors	Sports halls, Badminton, Gymnastics, Judo, Goalball, Boccia, Wheelchair Fencing
Fluorescent	Indoors	Sports halls, some local gymnasiums
Flash	Indoor or outdoor at night	Cycling, running, portraits, rally
Custom manual setting	Indoor or outdoor	Any sport
Colour temp. manual setting	Indoor or outdoor	Gives you the degrees of colour temperature

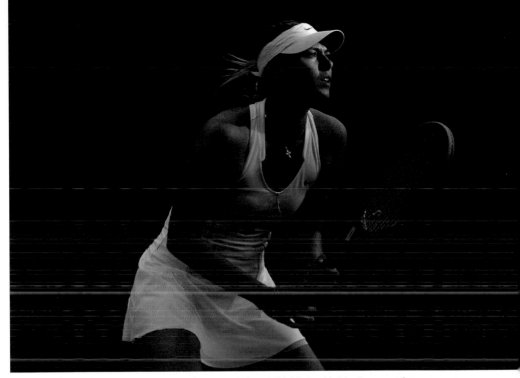

▲ On Wimbledon Centre Court Maria Sharapova's face is highlighted by the last rays of golden light. Expose for the light on her face and let the shadows disappear.

Colour Temperature

All light sources have a different colour temperature. Natural light, for example, is very different from sodium lights. In photography colour temperature of light is measured in degrees Kelvin and can vary from cool to warm (see table).

If there is one main indoor light, such as tungsten light, it is easy to set the camera at 3,200 or let the camera's Automatic White Balance do the work. Where there is mixed lighting it is better to do a test if you have time and to manually adjust the white balance in the degrees Kelvin. So if you are taking pictures with your camera on auto white balance and the images are coming out with a colour cast, change to the manual settings or process in raw and adjust the colour later.

It may help to think of different indoor lights in the same way that sunlight changes colour throughout the day. A tungsten light, for example, is the equivalent of the yellow light at dusk or dawn, while fluorescent light is green and flash is blue.

Digital Photography Workflow

Workflow is a term that professional sports photographers use to describe the process of preparing for, shooting, producing and managing the image over its lifetime. It describes a very important part of digital photography, as developed photographs are no longer physically

▲ The two shadows of Tiger Woods. Tiger always practices very, very early in the morning, and as he swings his club in the bunker the shadow of a player to his right enters the frame to give the illusion of two suns.

filed in cabinets or albums where you know where they are. With digital photography you have a lot more images to store and they are all hidden away on a computer, so it's easy to delete or lose them. Modern equipment is also a lot more complex, expensive and electronic than cameras once were – so there's more to go wrong.

Workflow is as important to amateur photographers as professionals, and well worth taking time and trouble over. I think sports photographers' digital workflow, for example, is generally poor. This is due in part to the speed in which we have to work; we're always working on location and move quickly from one job to the next. The nature of the job allows little time for organising in the office, and corners are sometimes cut in trying to

process images as quickly as possible. The following steps will help you to maintain a clear and efficient workflow.

Preparing for a Digital Sports Shoot

Having spent the past 30 years of my life carrying mountains of equipment all around the world I have learned to keep it simple – take what you need. But it's a real problem deciding which pieces of kit to leave at home, which pieces to take with you, what might stay in the boot of the car and which bits to carry on the shoot with you (the essentials).

As you know sports photographers carry – and need – all the big telephoto lenses. The massive 400mm f/2.8 lens can weigh 5kg, and the new digital cameras with all their heavy batteries are

COLOUR TEMPERATURE

Colour temperature (Kelvin)	Light source	Colour
1,000–2,000K	Candlelight	Strong yellow
2,500–3,500K	Tungsten bulb (household variety)	Yellow
3,000–4,000K	Sunrise/sunset	Golden
3,275–3,380K	Tungsten lamp	Warm
4,000–5,000K	Fluorescent lamps	Green
5,000–5,500K	Flash	Neutral to blue
5,000–6,500K	Daylight with clear sky (sun overhead)	Neutral
6,500–8,000K	Moderately overcast sky	Slight blue
9,000–10,000K	Shade or heavily overcast sky	Cold blue

still bulky and weigh 1.5kg. The basic kit that I take on every job consists of the following:

> two SLR cameras
> 400mm f/2.8 lens
> 70–200mm f/2.8 lens
> 24–80mm f/2.8 lens
> 14–24mm f/2.8 lens
> teleconverter 1.4x and 2x
> two flashguns
> 10 flash cards
> monopod
> folding stool
> spare batteries for flashgun and camera
> cleaning kit
> waterproof equipment for camera
> rocket blower for getting rid of dust

I can then add to it with specialist lenses and accessories, but this basic kit will cover me for indoor and outdoor sports;

up close and far away. It all fits into a roll-along bag. Add to this my laptop computer (with sun visor), card reader and portable hard drive.

The above list is my basic kit, but yours should reflect your own needs and priorities. It may well be just your camera and lens. Do not burden yourself with more than you need.

One of the challenges of sports photography is that if you are photographing golf, for instance, and walk out on to the golf course at the British Open Golf Championships at seven in the morning, you will then be out for six hours. It can be pouring with rain when you start off and sunny and hot when you finish, so you have to be prepared to add clothes or pack them away. Many a time have I entered the press room steaming after being out in all my rain gear in the middle of summer. Make a checklist for your day's shoot.

Is it indoors or outdoors? Do you need to hire any specialist equipment?

Further preparation work involves organising my camera cards (compact flash cards) and keeping them in a pouch or storage unit in my camera bag. I always make sure I have enough cards for the job (usually 10 or more) and take care that all the cards are formatted and cleared of data before starting the job, to avoid being caught out having full camera cards. Remember, it's very easy to leave your camera cards at home.

Camera set-up (p.258) is the next important step in my workflow. Before any sports shoot I double-check exposure priority modes and autofocus set-up for every venue and every shoot.

Digital File Formats

Digital cameras offer more than one image format. The two main ones are JPEG (pronounced jay-peg and standing for Joint Photographic Experts Group), which is the default format used by most digital cameras. This format lets you specify image size and compression. When you capture the analogue image it is then processed in the camera based on your camera settings and compressed to a smaller file (the JPEG). These changes cannot be undone as it now becomes the original file and during this process information is lost. This isn't a problem for the majority of photographers, however, and JPEGs can be blown up to large-size prints. They have become really popular as they are manageable files that can be easily uploaded, emailed, printed from, manipulated – in short, a perfect file for everyday use.

Raw is a format that is available mainly on DSLR cameras and is a favourite with professionals. If you want the best quality, you want to start with a raw image file. These files contain all the image data captured by the camera, without it being changed in any way. If you want total control over exposure, white balance and other settings this is the file to use because only four camera settings permanently affect a raw image – the aperture, the shutter speed, the ISO and the focus. Other camera settings are saved as metadata and affect the appearance of the thumbnail or preview images, but not the raw image itself.

Raw images are not always noticeably better, but if you have any problems with the file, such as under/overexposure or colour-correction problems, the raw file has so much more information to work with and manipulate. It is thus easier than working on a JPEG to retrieve the information and work with it. A good example would be if your flash was too powerful and the subject is overexposed. If you are using a raw image file you can bring back a lot of the lost detail with the capture software.

There are other file formats and most camera manufacturers operate their own format. These are constantly changing, but the most common one is DNG, which stands for digital negative.

Another format is a TIFF (tagged image file format), which is usually larger than JPEG or raw and can be saved using either 8-bit or 16-bit colour processing.

Importing images into your digital studio
Technical Wish List

Given that the vast majority of your sports photography shots will be taken on location, your digital studio has to be portable. The primary role of your digital studio is managing, editing, producing and archiving your photos. You need a laptop with a decent processing capacity and plenty of digital storage space along with editing and transmitting software.

A professional photographer's ultimate digital studio consists of:

> Laptop computer (powerful yet portable)
> Spare battery for laptop
> Sun visor for laptop screen
> Rainproof cover for laptop
> Card reader attached to back of laptop using Velcro
> 3G dongle – this gives you wireless connectivity
> Ethernet cable
> Laptop bag
> External hard drive

Transferring your images from the camera to your computer is the first step you'll take after capturing them. There are several ways to do this. Most camera manufacturers provide you with software with which to do this. I find the best way is to remove the camera's image storage card (CF card, SD card or PCMCICA card), and to insert it into an external card reader, which connects to your computer usually by USB or Firewire. Once the computer can read the card, download all the images to your computer. It's here that you can decide to back up your images for the first time to an external hard drive for safe keeping.

Another way of downloading your images is to connect your camera to the computer directly using the cables provided by your manufacturer.

CHECKLIST
> Charge all batteries
> Camera cards (they are so small and easily forgotten or lost)
> Camera equipment and lenses
> Chamois leather to clean the lens
> Notepad for captions
> Permanent marker for writing on camera cards
> Spare batteries for camera and flashgun
> Waterproof clothes for outside
> Appropriate footwear
> Photographer's jacket or vest with lots of pockets to keep things in

Digital workflow equipment
> Laptop (fully charged)
> Camera card reader
> Laptop protector screen
> Laptop charger and spare battery
> Transmission device, such as a 3G dongle
> Portable hard drive

Non-essentials
> Duck tape (for marking your position)
> USB hard drive
> Spare cables (in case of loss/ damage)

Browsing and Editing

There are many pieces of browsing software on the market for viewing your images; some come free with the camera or laptop. The best have a film strip where you can see 10 or 20 small images and one large; you can then click through going forwards and back to choose your picture once you have tagged this image. If you think it's particularly important you can give it a rating, usually 5 stars. I usually work to edit my first selection out from the original files. If I have time I then re-edit these to choose my best, but time can be critical.

Editing (that is, making a change or correction to an existing image) has become one of the most important steps in a photographer's digital workflow. Before you edit the images, however, you have to choose which image out of your shoot to edit. It's the initial keep-or-delete stage, and you have to be ruthless – with cameras that shoot 10 frames a second you end up with a sequence of images that are all roughly similar. Choose the peak-of-the-action image and possibly the frame either side, then delete the rest. Once you have made your edit you import them from your editing browser to Photoshop or other software. Here you can carry out your more advanced editing of cropping, sharpening, enhancing colour, brightness and contrast, re-sizing and finally saving.

Always remember that if you have the most fantastic sequence people are only going to remember the picture you show them. If you can't decide which is the best one, just take the plunge and pick one. Resist the temptation to show all of them.

Photoshop has become such a huge tool and help for the professional photographer that it could fill several books alone. There are alternative software packages on the market, however, so shop around to find one that suits your needs and budget. Bear in mind that sports photography shouldn't require much work in Photoshop, especially for editorial use. A lot of special-effect filters can be replicated in Photoshop, but most of these don't apply to sports photography: the drama of the sport is interesting enough without being added to.

How much retouching is too much? There is a debate at the moment about what can and can't be done to an image. A general rule for editorial use is that you can only use old-fashioned dark room techniques to improve a picture – that is, dodging and burning (p.282) to the exposure. The last thing you want to do is to mislead people by changing a background or altering the image to show something that didn't happen. Always be honest about the image.

BASIC EDITING STEPS

> Import your photo from the folder into the browsing software
> Keep or delete
> Import into Photoshop
> Crop
> Enhance: sharpen, correct exposure, adjust colour balance, dodge or burn
> Caption
> Resize and save

▲ This shot shows a horse on the early morning gallops before a race, the cameras data records a capture time 06:56am after a 2hr drive to the gallops at Cheltenham. The horse is silhouetted against the sky by using a 1/6400 of a second shutter speed and an aperture of F8 on ISO 400. 24mm lens.

Storing and Organising your Digital Studio

One of the big changes brought about by digital photography is the sheer volume of pictures that everyone takes. This has rocketed, from the roll of 36 images on a film to the hundreds or thousands that you are now able to store on one camera card.

Such volume means that the storing of these images has become more important than ever. The last thing you want is for them to be scattered randomly on your computer's hard drive or desktop; they need to be in an organised library. The following are some simple ways to organise your digital photographs for easy viewing and sharing.

File Naming

File naming is an important first step in the cataloguing of your new library. Who would remember that their favourite picture is called IMG007.JPG or Chelseagoal1.JPG? The file name is the easiest way for initially organizing your photos. For example, if you are taking a picture at the swimming in the Aquatics Centre at the Olympic Park, use some letters which relate to the event, such as OLY-SWIM-12.JPG. This will tell you that it was taken at the OLYmpic Games at the SWIMming in 2012.

These newly named images can now be stored in folders and filed away on your hard drive. The folders can be categorised in a number of ways, but I find chronological date format is best. You can also organise by subject, for example events, projects, shoots, people, family etc. It is possible to combine both of these to form one folder, but the more images you have the more folders you need.

There are a number of ways to organise your folders. An efficient system I like to use is to organise by the year the images were taken, and then create subfolders for each month, such as 2012 then August. As I have thousands of images I would then subdivide with further folders, such as the Olympic or Paralympic Games, followed by Athletics and so on.

Alternatively you could try organising by season, and then use important events as subfolders, such as Summer12 followed by Olympic or Paralympic Games.

Captioning

Adding a caption with keywords is one of the most important things you can do to your picture. It will save you many hours in the future when you are trying to retrieve an image from your personal library. In Photoshop the caption is located in the 'file info'. Apart from who, why, what, when and where, include the photographer's name and contact details along with the copyright notice (Chapter 6) and the ever-important keywords. Every image should have some keywords that will help you and others locate this image above others. In Photoshop the camera data, including camera make, camera lens, shutter speed, aperture, ISO, exposure and flash settings, is all stored in the file info.

Archiving

After you finish editing your photographs they should be archived along with their metadata. There are several ways to archive them including DVD, CD, back-up external hard drives and server space (online photo storage). It's always an idea on hard drives to back up everything twice on to different hard drives in case of theft or damage to an individual hard drive. This is called mirror archiving. Digital photographs require specific care to make sure they aren't damaged or lost. If your photographs aren't backed up properly a single failure of your computer can wipe out your whole photo collection. The following information will help prevent such disasters.

Online photo storage acts as a useful backup to the images stored on your hard drives. There are now really good options available for storing your pictures online. By having your photographs stored both online and away from your office/home, you are adding another layer of security to your library. Some online photo labs or printing sites offer online storage as well. These are easy to use, normally with a drag and drop facility.

Portable hard drives are worth mentioning. I carry two portable hard drives myself and always transfer my shoots as I download the images onto my computer. They are easy to carry and again provide an extra layer of security for your valuable photographs.

Server Space

This is your own library archived on to a server housed in a building away from your home studio. The advantages for this are automatic backup, plus you can share your files and they are instantly available. You have instant access to your files from any computer anywhere, and there is no worry about hard drives failing or being stolen or dropped.

The disadvantages are that you need a fast internet connection and the company you choose has to be totally reliable. I'm not sure myself if this type of storage should completely replace your own archiving, but it can enhance your backup procedure.

Backup Hard Drives

Backing up means you make a copy of your original tile to prevent a problem if there is a computer failing. Archiving is permanent, safe storage for your images and should be divided between an on-site copy and an off-site copy.

I have two hard drives that mirror each other. One copy is in my house and the other copy is off site in case of fire or something as simple as the hard drive being dropped. This mirroring of two hard drives is an industry standard; it is relatively inexpensive and remains the safest way to store your images.

There are no disadvantages if you back up to two mirrored hard drives stored in different locations: if one drive fails, you are left with an exact copy.

DVD

Saving photos to DVD is an easy, inexpensive and reliable way to store your images for approximately a hundred years. It allows you to store thousands of images on a single disc, makes space on your computer's hard drive and allows you to easily share numerous images with family and friends rather than email them.

The disadvantages are that DVDs are fragile and can be scratched or lost.

Printing and Display

After a successful sports shoot, whether at London 2012 Olympic Games, Paralympic Games or at other events, you'll want to share your images with as many people as possible. You may well want to upload them to Facebook, print and frame them or even make photo books. Remember you will need to add your own copyright to any images taken at London 2012 and other major events. Below I have outlined the choices for printing and display.

Colour Printing

There are many on-line or walk-in labs to choose from. Stick with an established company and take either your camera card or memory stick with you to the walk-in print lab. Always remember to back up your images at home. Some offer while-you-wait printing and are the best option if you don't have a computer or decent printer yourself.

Online Labs

You can upload your images as long as you have a reasonably fast broadband from your computer to an online store. The advantage is that many of these companies offer next-day delivery. They are convenient, offer great value for money and produce professional archive-quality prints using a silver-halide printing process. You should check out the type of printing they offer, but generally the prints will last a lifetime. Most offer an incredible variety of printing options such as mugs, calendars, books, notepads, cushions, bags, canvas, acrylic, keyrings and many

▲ A lone cyclist speeds round the track. Try to use as slow a shutter speed as possible to get more interesting images. Here I used 1/15th of a second to blur as much of the image as I could whilst keeping the cyclist sharp.

more. Online labs are hugely popular for good reason: quality, convenience, price and choice.

Photo Books

These have taken over from the albums of yesterday. They come in all shapes, sizes and colours, allowing you to create a truly unique portfolio in which to display your photographs. Most pro photographers now have several photo books as their portfolio, tailoring different books to particular clients. Whereas an old-fashioned portfolio used to be A2 prints in an enormous plastic case, the new photo books look incredibly professional and are truly bespoke.

Digital Photo Frames

These offer a great way of showcasing images, for example those of London 2012. In the last couple of years these frames have become an ideal replacement of the old album. The photographs continually rotate, telling your own experience of the Games, or of any other sports event. People often complain that they never see digital pictures because they are stored away on a computer and it can take time to hunt them down and boot the computer up. Having a photo frame full of your images avoids this problem.

Home Printing

There are many excellent printers on the market so, rather like choosing a camera, selecting the model or make best suited to you may seem overwhelming. There are three main printer types: Laser, Thermal and Inkjet.

Inkjet is the most important category for the photographer. They are extremely popular and produce magnificent

looking prints. The photograph is created by millions of tiny droplets of ink being fired at specially coated paper. Each droplet is so small it cannot be seen by the naked eye, but collectively they give the appearance of a smooth continuous tone. Basic inkjet printers are used for printing documents, but can now also print photographs.

These basic printers usually have one multicolour cartridge. The advantage is that all the inks can be installed at once; the disadvantage is that if one colour runs out then all the other colours are wasted and the cartridge needs replacing. The next level of inkjet printers (photo quality) have three or more colours: cyan, magenta, yellow and a black. The advantage is that you only have to replace the finished single inks one at a time, which is far more cost-effective. These inkjet printers got off to a bad start when they were first introduced, as they often faded or changed colour. Technology has improved over the last few years, and now these inkjet printers can rival wet chemistry prints – making them perfect for the amateur photographer printing up to A4 in size.

Top-of-the-range inkjet printers tend to use six or more colours – cyan, magenta, yellow, black, light cyan and light magenta. Some manufacturers even add other colours into this ink set including green, blue or orange. Some of the more advanced printers may incorporate more variations to the black inks used for black and white printing. These printers are capable of printing to sizes A4, A3, A2 and A1.

Thermal printers use three coloured ribbons – cyan, magenta and yellow – and special media to produce a true photographic print. These three colours are used together to create a black, which sometimes gives the appearance of a flat looking print. They are able to print quickly, however, and are portable. The print size is usually small, 15 x 10cm to 25 x 20cm.

Colour laser printers are generally better suited to office use. They have four colour tone cartridges – cyan, magenta, yellow and black – and each colour is applied as the paper moves past the drum head. Generally laser printers are not suitable for producing high-quality photographic prints.

Sharing and Transmitting Images

As well as all the options available for printing your images there are a plethora of social networking sites, websites, image-sharing and online libraries in which to showcase and share your images.

Social networking websites such as Facebook, Myspace and Twitter are hugely popular platforms for sharing images. One reason for the great appeal of these sites is the fact that all your friends and family can add their comments to your photographs once you have published them on your wall. Pictures can be uploaded straight from your camera phone, from some point-and-shoot cameras and from your computer. It's almost instantaneous: you could be sitting in the spectator seats in the Olympic Stadium having just watched

an Athletics final, and within minutes be sharing your experience with family and friends via Twitter. Compare this to using a film camera just a few years ago. You had to wait for the chemist to open on Monday morning to have your film sent away for developing, getting them back a week or so later before inviting friends over to see your snaps.

Online libraries such as Shutterstock, iStockphoto and Alamy etc., offer a professional, commercial library for selling images. It must be stated again that all images taken at London 2012

Olympic or Paralympic venues cannot be sold commercially by amateur photographers (see Chapter 6). When photographing at major sporting events always check that you are able to sell your images without getting permission from the sports body concerned.

Once you have confirmed that your sporting images can be submitted to these libraries, go online to read their terms and conditions. The standard is high, and technically the images have to be of a high standard to be accepted. This can be a way of earning some

◀ There's a lot of movement and shape to this shot of Tottenham v Fulham one Saturday. Here I have focused on Peter Crouch the tallest player and hoped he'd head the ball.

enable you to build your own inexpensive website to showcase and create an online gallery of your work. All professional photographers have a website; it's the best way to market yourself and is extremely convenient for future employers to peruse your work. Your website should be as good as you can make it. Keep it simple and uncluttered, allowing the pictures to do the talking. Try and show a variety of images, but be coherent: you need to show an individual style or 'look' to your work.

Transmitting photographs

Professional photographers transmit their photos all round the world using software called File Transfer Protocol (FTP). This enables large images to be transferred in real-time quickly and safely. Unlike email, notoriously unreliable for sending pictures, FTP is a must for the serious professional sports photographer.

Another piece of very useful free software for sending pictures securely from one place to another is WeTransfer. com. This is more reliable than email as you get a follow up email telling you that your images have been received and viewed. It's straightforward to upload your images to WeTansfer follow the instructions on the web page. It's a useful tool for sending pictures to clients as well as family and friends.

money out of your hobby, however, and perhaps paying for that next lens. Don't forget that if you are in the right place at the right time, you might take a picture that could earn you a lot of money, but remember to make it clear that you own the copyright to the image. For advice on protecting your rights and taking on responsibility for sports photography pictures, especially if you are selling them commercially, see Chapter 6.

Making your own website has become much easier and affordable. Sites such as Vistaprint and webs.com

Troubleshooting

> **Autofocus Sensor:** autofocus sensor was not on subject at the time you took the picture. Use your DSLR's software to show you the active focus points. More practice will help you keep the sensor on the subject.

> **Camera shake:** if your photographs are not pin sharp but your subject is in focus, it's probably camera shake. Use a monopod or tripod to help with this.

> **AI Focus:** your AI Focus may not have engaged properly. Always give your camera a couple of seconds to lock on to the subject before taking a photo. Ensure your shutter is pressed in halfway and that you are tracking the subject with one of your autofocus sensors.

> **Low shutter speed:** if you're shooting in low light you may not have a fast enough shutter speed to freeze the action and to prevent camera shake. Increase your ISO to 400 or more if this is the case. Also ensure you are using a fast enough lens with a wide aperture, such as f/2.8.

> **Inadequate equipment:** if your pictures are still out of focus and you have tried all the above techniques, you may need to upgrade your equipment.

> **Motion blur:** a faster shutter speed is the only solution to this problem. Some sports require speeds as fast as 1/1000th or more.

> **Too much contrast:** the sensor is not able to pick up the whole spectrum of light and expose it correctly in some situation. Either select the part of the scene that is most important and expose correctly or use a graduated ND filter to get the whole scene exposed correctly.

> **Add more contrast:** low contrast can result from photographing in bad lighting conditions or conditions such as snowy landscapes. Try using a lens hood.

> **Lens flare:** when the lens picks up stray light it creates lens flare, especially when it's sunny. Use a lens hood to minimise the risk.

> **Underexposure:** if not enough light reaches the sensor your photo will be underexposed. Change the exposure settings – meaning a slower shutter speed, a larger aperture or higher ISO – or all of them combined.

> **Overexposure:** too much light has reached the sensor. Change the exposure settings to get a correctly exposed photo – meaning a faster shutter speed, a smaller aperture or lower ISO – or all of them combined.

> **Red eye:** a common problem with compact cameras, this is caused when the flash is located close to the lens. Use an external flash that you can bounce on a wall or ceiling rather than the internal flash. Some cameras have a red-eye reduction mode.

> **Noise in photograph:** usually due to a high ISO setting, but can also be caused by long exposures. To prevent noise use a low ISO setting.

> **Grey or black spots on photo:** these grey or black spots are usually caused by sensor dust. Try to keep your gear clean and dust free.

◀ Sailor Giles Scott trains by running up a hill in Portland, Dorset. The main focus of the image is Giles but the scene in the background leads the eye out. I shot this with a 70mm-200mm zoom.

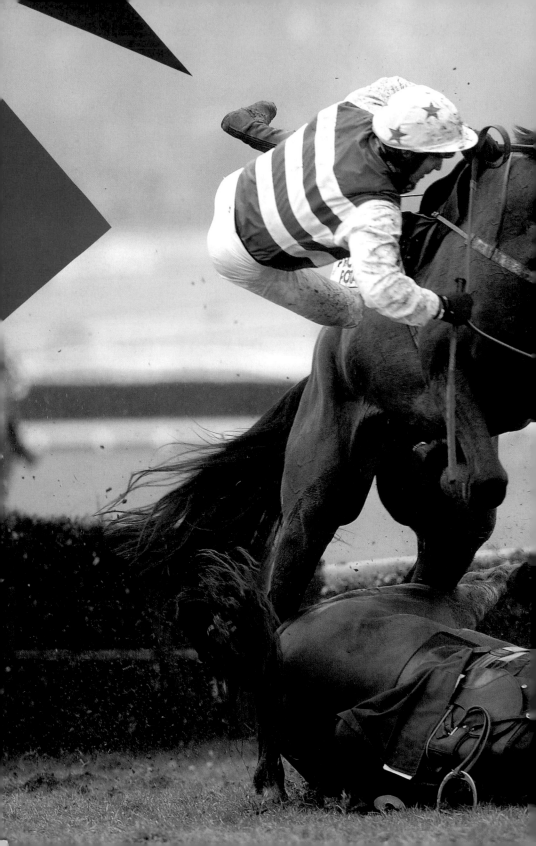

6 Legal Issues

E very photographer should have a basic understanding of the legal issues surrounding photography. Whether it's the control of the image you've taken or issues of child protection, gaining permission, third-party insurance, model release forms, rights to privacy or rules of ticketing, you need to understand your rights and responsibilities. The law changes depending on where the images were taken, school, stadium, public or private property, so if in doubt always seek permission to photograph and take legal advice. It is your responsibility to do so.

Every image you capture is a unique creative expression of what you see. Even if you are standing next to another photographer photographing the same sports, your image will be slightly different and original. You need to protect this originality. This is obviously vital if you are operating commercially as a professional photographer: it is how you make your living. It is important for amateurs too, however; it only takes a couple of seconds to add a copyright notice to your photograph and this should be an integral part of your workflow (p.255). You and those in the photograph are then protected, especially in the modern world where pictures are passed around the Internet. Many people forget that the Internet is a worldwide public forum, quite different from a family album, which is only shown to a select audience.

From the spectators' angle you can take pictures at most sporting events, but you must always check beforehand. There are obvious examples, such as snooker where you cannot – it would be too distracting for the players. The ticketing information provides useful details of what equipment you are allowed to take into the London 2012 venues. Remember that the pictures you take from the public spectators' angle are for your own private use only. You can share them on the Internet, but they must not be sold commercially. If these images are submitted to a public site such as Flickr they must have a notice on them saying 'not for commercial usage' and no video footage can be uploaded to social network sites from any London 2012 event. See the Terms of Ticketing for the London 2012 Olympic and Paralympic Games (p.278).

This is not to disregard online photo-sharing sites, of which Flickr, PhotoBucket and SmugMug are some of the largest. They are a great showcase, as you can upload your photos for free and share them in groups with as many people as you want. Among the best features of such sites is their ability to reference pictures by adding the location they were taken, along with the time and date. There is also a lot of flexibility in how you choose to use these sites. You can join groups to find people with similar interests to you, add security features to control access to your photos or link your photos to popular blogging systems. Sites such as those named above, allow you

▲ This picture of gymnast Louis Smith in his gym in Huntingdon tries to capture the ups, downs and frustrations that go into the many, many hours of training for big competitions. Here Louis is having some quiet time after a difficult session.

to specify a user license to protect your copyright. One minor inconvenience is that you have to join the site before you can really start viewing all the pictures, but basic membership is free.

All images taken at the London 2012 Olympic and Paralympic Games have to feature a notice to prevent them from being used commercially. Spectators who have taken pictures at the London 2012 Games are not allowed to put up their images for sale.

Major sports bodies now control all the commercial rights to their sports, whether for television, Internet or stills photography. If you are working at a sports venue as a professional photographer you will be asked to sign a commercial form. These forms usually give you permission to sell the pictures for editorial purposes only. For any other commercial usage you have to seek permission from the governing body. This applies to football (Premier League, FA Cup, England international games), rugby internationals, The Championships at Wimbledon, international cricket matches and many more.

Copyright

Copyright is extremely important as it gives the creator of an image (or the author of a work) the power to control how it is used. The owner of the copyright has the exclusive right to decide if, when, how and how often his or her work can be used or copied. Copyright is shown by the use of the symbol © and the copyright holder's name.

An image that does not have copyright

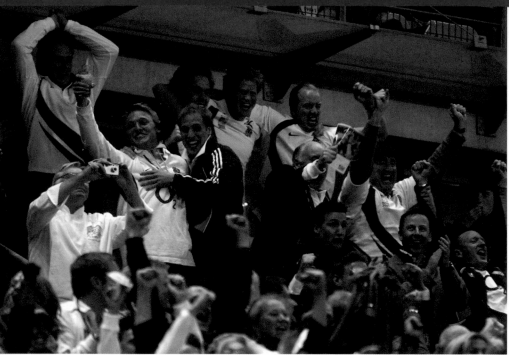

▲ At first glance this looks like any group of England Rugby fans celebrating during a match. On closer inspection Princes William and Harry can be clearly seen enjoying themselves with their friends. Sports events are full of celebrities and VIPs.

assigned leaves the photographer (and his or her subjects) potentially exposed. For example, a member of the public can upload images taken at sporting events such as the London 2012 Games on to a social networking site/public website within seconds of the image being photographed. If they are not properly protected, these images can then be lifted by a third party and sold or distributed round the world again within minutes. The photographer has lost control of his images before he or she has even left the stadium or other venue. If the images had been copyrighted, this would have deterred people from using them – and if they had still done so, the photographer would have had legal redress.

Legally the photographer owns copyright on any photos he or she has taken other than in the following instances:

> If there is an agreement that assigns copyright to another party; or
> If the photographer is an employee of the company for which the photos were taken, or an employee of a company instructed to take the photos, the photographer will then be acting on behalf of their employer. In such a case the copyright is owned by the company for which the photographer works.

In all other cases the photographer retains the copyright. When professionals are paid for their work, they normally retain copyright, depending on the individual agreement. In such cases any reproduction without the photographer's permission is an infringement of copyright.

MODEL RELEASE FORM

Photographer: _____

Model: _____

Address: _____

I hereby assign full copyright of these photographs to the photographer together with the right of reproduction.

I agree that the Photographer or licensees can use the photographs in any way and in any medium.

The Photographer and licensees may have unrestricted use of these for whatever purpose, including advertising, with any reasonable retouching or alteration.

I agree that the above mentioned photographs and any reproductions shall be deemed to represent an imaginary person, and further agree that the Photographer or any person authorised by or acting on his or her behalf may use the photographs or any reproductions of them for any advertising purposes or for the purpose of illustrating any wording, and agree that no such wording shall be considered to be attributed to me personally unless my name is used.

Provided my name is not mentioned in connection with any other statement or wording which may be attributed to me personally, I undertake not to prosecute or to institute proceedings, claims or demands against either the Photographer or his or her agents in respect of any usage of the above mentioned photographs. I have read this model release form carefully and fully understand its meanings and implications.

Signed: _____ date: _____

Important!
If the Model is under 18 year of age, a parent or legal guardian must also sign:

Parent/Guardian: _____date: _____

Model Release Forms

A model release form, example above, signed by the subject, including amateur competitors and professional athletes, acknowledges that you have permission to use the image and confirms that the subject has willingly handed over the usage rights to you as photographer.

If you are wishing to sell your sports pictures editorially you don't strictly need a model release, but you will probably have signed an agreement with the sports body to be able to photograph at that event. If you want to sell these images commercially outside of the editorial environment, for instance to photographic libraries or agencies, you will need model release. The organising

body of a sporting event often includes a clause in participants' agreements stating that the latter agree to images of themselves being used by the event organisers. Acceptance of such usage forms part of the participants' agreement to enter the event. However, it is always worth checking the situation at a particular event in advance.

An individual has certain rights to control the use of their image. The specific details vary from one country to another depending on national legislation. However, the general intention seems to be to protect a person against any defamatory or offensive use of his or her image.

If you intend to sell or distribute images that include people, then it is worth getting your subjects to sign a model release form as this will protect you against any comeback. Remember that it is far easier and more efficient to arrange this at the time than to try and track individuals down later, so build this into your photographic practice.

Accreditation

All major and most semi-professional sporting events (and even some amateur ones) require photographers to be accredited. You will need to wear this credential prominently while you are working.

Accreditation effectively involves presentation of a certification of competency, authority or credibility to a photographer. These credentials are issued by sports governing bodies and sports-event organisers to verify that you are a professional or semi-professional photographer (whether freelance or employed). It is important as it means that you are authorised to work at that event. Accredited photographers are usually given a bib, badge or pass on arrival to make you identifiable by the event's volunteers and marshals, and to differentiate you from the spectators (who

GOOD PRACTICE

Every professional and amateur photographer should have their own set of guidelines which they seek to follow at all events. This will help you to become known as a professional operator with a good reputation. It is much better to be a welcome sight at a sporting event rather than simply tolerated.

Such guidelines might include a commitment to:

> never obscure a spectator's view
> never obscure a judge's view
> always be respectful to volunteers and helpers
> never interfere with the field of play
> never infringe the field of play
> always be polite and courteous to people associated with the event
> always gain permission to photograph
> use model releases when required
> introduce yourself where necessary to ensure people are comfortable with your presence
> wear muted colours that do not distract participants
> be conscious of your own and others' safety

▲ As one of the faces of London 2012, diver Tom Daley is always the centre of attention. This humorous picture shows that even photographers and camermen sometimes have to work from the 10m platform.

may also be taking photographs). The accreditation usually comes with a set of rules and regulations detailing where and when you can work, as well as where the resulting images can be distributed.

The best way of applying for accreditation is to have the backing of a magazine, newspaper or website. If you have a guaranteed outlet for your pictures, however small, your chances of successfully applying for accreditation certainly improve. There are more and more photographers applying to go to sports events and the numbers for photographers are often limited, but don't let that deter you. Patience is the answer. Start off in the lower levels of sport; by improving your photography and gaining experience you can progress relatively easily up to the elite levels. Another helpful tip is to join a professional organisation or body of

photographers, such as the British Press Photographers Association, to give your application more substance.

Some events, especially those of international interest, are heavily oversubscribed. Accreditation for the London 2012 Olympic and Paralympic Games, for example, is extremely hard to come by, and only professional photographers from large news organisations are accredited. The selection process for accreditation is very complex but fair, with all the competing countries being given a chance to send media representatives.

If you are not accredited you can still take pictures, but you must always be aware of the rules for photography at the relevant event. Your seating will be different from the accredited photographers and your view of the action may well be more restricted and

▲ A Cheltenham race favourite on the early morning gallops. The light can be beautiful at this time in the morning. I positioned myself lying on the ground looking up with a wide angle lens to get the horse silhouetted with the sun behind.

further away. This is not necessarily a disadvantage, however. You will be taking different shots from the pros, but they can still be good and quite possibly more interesting. Use your creativity and some of the techniques described in this book to produce your own imaginative interpretation of the day's events.

Terms and Conditions of Ticketing at London 2012

You are allowed to take camera phones, compact cameras and DSLRs into Olympic and Paralympic venues as long as the equipment fits into a bag no bigger than 30 x 20 x 20cm. Anything above this may be confiscated and not necessarily returned to you, so do follow the rules and check your equipment before to ensure its size. This rule has been created to ensure that everyone watching the Olympic sports has a clear view and can watch the events in a comfortable and safe environment.

Tripods and flash photography are not permitted within the venues. This need not be a problem, as I have shown you the techniques in Chapters two and three to freeze the action without the use of a tripod. Nor is flash photography required

use but as noted above may not exploit images for commercial use.

Below are sections from the Rules of Ticketing that specifically apply to photographers. Please see www.london2012.com for the full list of terms of ticketing.

19.3 Forbidden behaviour

19.3.2 The following is an illustrative list of prohibited and restricted behaviour within any Venue: ... unauthorised transmissions and/or recording through mobile telephones or other instruments (video cameras, tape recorders, etc), entry of unauthorised journalists/reporters with taping or recording equipment and/or video cameras, flash photography, attempting to access restricted areas ... standing on Ticketed seats, interfering with the operation of a Session (including, for certain Sessions, the use of mobile telephones) ... disrupting the comfort or safety of other Ticket Holders and any other activity that LOCOG deems dangerous or inappropriate.

19.4 Security inspections

19.4.1 LOCOG may conduct security searches to ensure safety at a Session. 19.4.2 A Ticket Holder who rejects a security search or refuses to comply with rules and security notices published by LOCOG will be required immediately to leave the Venue without refund to the Ticket Holder or Purchaser.

19.6 Filming, photography and taping

19.6.1 Ticket Holders consent to being photographed, filmed or taped, by LOCOG, by the IOC, by the IPC or by third parties appointed and/or authorised by them.

19.6.2 LOCOG, the IOC, the IPC or third parties appointed and/or authorised by them shall, without requirement of the payment of money or other form of consideration, have the right to broadcast, publish, license and use any such photographs, films, recordings or

KEY POINTS FOR PHOTOGRAPHERS

> You cannot bring large photographic equipment, including tripods, into an Olympic or Paralympic venue. The IOC's definition of 'large' is any photographic equipment longer than 30cm – that would generally be any lens bigger than a 300mm f/4 lens.

> No flash photography is permitted inside Olympic or Paralympic venues.

> Images, video and sound recordings of the Games taken by a Ticket Holder cannot be used for any purpose other than for private and domestic purposes. A Ticket Holder may not license, broadcast or publish video and/or sound recordings, including on social networking websites and the internet more generally, and may not exploit images, video and/or sound recordings for commercial purposes under any circumstances, whether on the internet or otherwise, or make them available to third parties for commercial purposes.

images of a Ticket Holder in perpetuity. 19.6.3 Images, video and sound recordings of the Games taken by a Ticket Holder cannot be used for any purpose other than for private and domestic purposes and a Ticket Holder may not license, broadcast or publish video and/ or sound recordings, including on social networking websites and the internet more generally, and may not exploit images, video and/or sound recordings for commercial purposes under any circumstances, whether on the internet or otherwise, or make them available to third parties for commercial purposes.

CRB Checks

The (UK) Children Act 2004 made it clear that safeguarding children is the responsibility of all. The Child's welfare is, and must always be, paramount.

If you are photographing children, other than your own, whether you are paid or working as a volunteer, you should apply to be CRB checked. The

A 'No Photography' sign, commonly placed in properties where the owner objects to or it is illegal to take photographs. Note that this is not a legal requirement in some jurisdictions.

Criminal Records Bureau searches your details against criminal records and other sources including the Police National Computer. The checks are designed to reveal convictions, cautions, reprimands and warnings; for further details go to the www.direct.gov.uk site.

CRB checks cannot be applied for by the individual photographer, so you will need to contact either the registered body (your employer) or an umbrella body such as local sports clubs' governing bodies or local councils.

Insurance

There are a number of insurance solutions for photographers including public liability cover, professional indemnity and photographic equipment cover. Some really only apply to professionals, but others should be considered at all levels. Each insurer will offer varying policies, but the following is a rough guide.

> **Public Liability Insurance** – this covers photographers against third-party claims, for example those from members of the public. Such claims may be for damage or injury that you as a photographer may have caused, directly or indirectly, to either a third party or their property. An example of this might be if you were to leave your camera bag by the side of the swimming pool and a swimmer tripped over it on leaving the pool.

> **Professional Indemnity Insurance** – this covers the photographer in the event that he/she was in a dispute with a client. It pays the cost of defending any allegations made against him or her, or

▲ Photographer's positions at the London 2012 Olympic Games are tightly controlled. Benches like these are for the professional only. It's a special privilege to be able to sit in these courtside areas seen here at the basketball.

the compensation if any is awarded to the client. If you accidently delete or lose all your images from a commissioned shoot, for example, the client would most likely require a significant amount of compensation.

> Photographic Equipment Insurance
– sports photography is really tough on equipment, so it goes without saying that your photographic equipment should all be covered by insurance against theft and accidental damage. They are busy, crowded events at all levels, and you simply cannot watch everything all the time. When you are working on-the-go covering multiple events simultaneously, for example, it's not uncommon to leave a camera out of sight for a few moments, and it can then be stolen very easily.

Camera phones, compact cameras and DSLRs used for personal use should always be covered on your household contents insurance. This will cover you in the event of accidental damage and theft.

Glossary

Aperture – The hole in the lens through which light travels to reach the camera's sensor or film. Aperture size is expressed in f-stops. The lower the aperture f-stop the larger the hole is and the more light is let in. The larger the f-stop the smaller the hole and the less light enters.

Autofocus – A facility in which the camera automatically selects a part of the image (usually in the middle of the frame) and keeps this area sharp.

Bokeh – The English form of boke, which means blur in Japanese. Bokeh refers to how out-of-focus parts of a photo look. Different lenses produce different looking out-of-focus backgrounds, depending on (for example) the number and shape of their aperture blades.

Chamois cloth – A porous leather with a gentle, non-abrasive composition and exceptional absorption properties. Perfect for cleaning lenses.

Colour cast – An overall bias of the image towards one colour.

Colour temperature – The colour of the light source measured in Kelvin (K). Most colour films are balanced for 5,500°K, the colour temperature for average daylight conditions. Lower values produce a yellow/orange cast, higher colour temperatures produce a blue cast.

Cropping – The procees of trimming edges off an image, removing unwanted areas to improve composition.

Depth of field – The distance between the nearest and furthest objects in your photograph that are acceptably sharp.

Exposure – The amount of light reaching the camera's image sensor. Exposure is controlled by the shutter speed (time), aperture (intensity) and ISO.

F-stop (f/number) – Dividing the lens focal length by the effective diameter of the aperture gives the f/number, used to indicate the aperture value. Each full f/number, also called a stop or f-stop, halves or doubles image brightness. The most common f/numbers are 1.4, 2, 2.8, 4, 5.6, 8, 11, 16 and 22. They are usually preceded by an 'f'. The larger the f/number, the smaller the lens opening. In the series of numbers above, f/1.4 is the largest opening and f/22 the smallest. The smaller stops (larger f/numbers) give the greater depth of field in a photograph, and vice versa.

Filter – An optical accessory to enhance certain ranges of light.

Fish-eye lens – An uncorrected ultra wide angle lens that gives a circular image.

Flare – Unwanted light reflecting within a lens or camera. It reduces contrast to create bright streaks or patterns on the image.

Focal length – An indication of the magnification and angle-of-view of a lens. The human eye sees objects roughly the same as a 43mm focal length of a lens for a 35mm camera. Anything shorter is classed as a wide-angle, while longer focal lengths are telephoto.

Focal plane – The area behind the lens where light is gathered to form a sharply focused image; the point where the film or sensor is placed.

Full frame – An imaging sensor with the same size as film used for the respective format of camera.

Image sensor – A type of transducer (an electronic device that converts one type of energy to another). This particular type of transducer converts light (visual images) to electronic signals, capturing images electronically as pixels. Image sensors are used in digital cameras and usually consist of an arrangement of charge-coupled devices (CCD).

ISO (International Organisation of Standardisation) – A measure of the sensitivity of the image sensor.

JPEG – (Joint Photographic Experts Group) Standard method of image data compression used to reduce the file size of digital images. It's known as lossy compression because some data is permanently lost during the process.

Megapixel – One million pixels; a term for measuring the image size of your picture.

Metadata – Information written into the digital photo usually exposure values and descriptive information.

Metering – A term used for measuring light.

Monopod – An extendable pole used to support a camera or lens.

Motor drive/continuous shooting mode – A burst or series of pictures taken as quickly as possible.

Noise – Random coloured pixels that appear in dark or shadow areas when the light levels are below the camera's sensor sensitivity range.

Panning – A technique in which you follow the subject through the camera lens along a horizontal path.

Prime lens – A fixed focal length lens, usually of good quality.

RAW – A picture file format for most DSLRs. In this mode the photograph is captured in a 'raw' state direct from the camera's CCD, with no automated processing done by the camera. You then use RAW processing software such as Capture One to view and process the file on your computer, giving you complete control of properties such as exposure, colour and sharpness. It is the best quality for shooting with.

Rule of thirds – A compositional rule of thumb in visual arts such as painting, photography and design. The rule states that an image should be imagined as divided into nine equal parts by two equally-spaced horizontal lines and two equally spaced vertical lines. Important compositional elements should be placed along these lines or their intersections.

Shutter release – A button, usually found on the right-hand side of the camera, that you press to take a picture. Most cameras have a two-stage release. The first pressure activates the camera's autofocus and metering modes and the second fires the shutter.

Shutter speed – The setting on your camera that controls the length of time for which the shutter is open (allowing light through the lens to the sensor inside your camera). Shutter speeds vary from very small fractions of a second to several seconds on most cameras.

Teleconvertor – An accessory that fits between the camera lens and body to increase the focal length of a lens by 1.4x, 1.7x, 2x or 3x. Known as an 'extender', 'lens extender' or 'telephoto extender' by some manufacturers.

Telephoto lens – A lens with a focal length giving a magnification greater than the naked eye.

TIFF – A loss-less compression file format that is ideal for digital photography.

White balance – Artificial light appears in a variety of forms, with tungsten and fluorescent being two of the most widely used. Each type of lighting produces a different 'colour temperature' that our brain compensates for to make everything appear as though it's neutral light. Digital cameras and film record the colour as it really is, so in tungsten light the picture comes out orange/yellow and fluorescent goes green. These colour casts can be corrected using filters on a film-based camera, while digital cameras have a white balance setting to make the pictures look like the view that our eyes see. Some models have manual white balance control where you select the type of lighting from a list, but most take care of the colour automatically.

Wide angle lens – A lens whose focal length is substantially shorter than a standard 50mm lens. Used for landscapes and photographing in small areas.

Viewfinder – The point through which you look to help point the camera in the right direction when taking a photo. SLR cameras have accurate 'through the lens' viewing, so what you see is what the lens sees. Compact, rangefinder and digital cameras have a separate viewfinder that is often less accurate at close range.

Index

Note: Page references in *italics* refer to photographs

accreditation 276–7
adapting to the action 120–1
Adlington, Rebecca 20, 22
Admiralty Arch 226
Al Focus 56–7, 269
Al servo 250, 253
Ainslie, Ben 229, 231
Alamy 266
Alexandra, Princess 209
aperture (F stop) 246–7, 248
Aquatics Centre 39, 216, 220
Archery 96–9
archiving 262
Ashes series 24–5
Ashton, Chris 115
Aspland, Marc 136, 137
Asymmetric Bar 159, 160, 163
Athletics 50–62
autofocus (AF) set–up 250–2
autofocus sensor 269
Automatic White Balance (AWB) 142

backgrounds 42, 70–1, 163
backlight 213
backup hard drives 263
Badminton 167–71, 168–9
Badrick, J.R. 20, 22, 208–9, 208
balance 199–200
Balance Beam 159, 160
ball–and–socket tripod 214
Barry, Sir Charles 208
basic camera set up 248–50
basic kit 256–8
Basketball 176, 182
Beach Volleyball 101, 112–14
Beckham, David 20
Big Ben 208, 231
black and white photography 170–1
black spots 269
Blackfriars Underpass 54, 231
BMX 63, 64–9, 64–5, 67
Boccia 172–5
bokeh 194
Bolt, Usain 20, 21, 56–7, 231
Box Hill 231
Boxing 141, 143, 145, 146, 148
Bryant, Kobe 177

British Open Golf Championships 92–3, 257
browsing software 260
BT Tower 211
Buckingham Palace 16, 59, 71, 72, 208, 209, 231, 250
bun fights 38
Bushy Park 231

camera shake 269
cameras
 camera phones 234
 compact cameras 26, 49, 142, 206, 234–6
 Digital Single Lens Reflex (DSLR) 236–8, 244–8
 remote cameras 104
 three-dimensional (3D) cameras 238–9
Canary Wharf 84, 85, 86, 207, 211, 222, 223
Canoe Slalom 122–6, 124
captioning 262
Carling Cup 103
Cavendish, Mark 153
CCD (charge coupled device) 237
Cech, Petr 104, 107
centre weighted 249–50
CF card 259
Champions League 28
Changing of the Guard 209
Cheltenham Festival 81, 242, 270–1
children
 photographing 13, 42–5, 60–1, 81
 protection of 272, 280
Children Act 2004 280
City of London 211, 222, 223
Closing Ceremonies 32–7
Coffey, Ellie-Jean 137
Colour Labs 263–5
 online labs 263–4
colour temperature 255
Combat Sports 143–8
Continuous Autofocus mode (AI servo) 250, 253
contrast 269
control of the image 272
copyright 17, 273–4
copyright notice 262, 272
County Hall 208

Cracknell, James 38, 130
creativity 18–20, 62
cricket 24–5, 115–17, 215
Criminal Records Bureau (CRB) checks 280
cropping 61, 237, 240
Crouch, Peter 266–7
Cycling 63–79

Daley, Rob 189
Daley, Tom 20, 22, 184, 186–7, 189, 215, 216, 277
Darts 172–5
depth of field 246
Diaby, Abou 103
diffusers 214
Digital File Formats 258–60
digital photo frames 264
digital studio
 importing images 259–60
 storing and organising 261–3
direct flash 68, 69
Discus 50
distance from lens to subject 246
Diving 141, 184–7
DNG 258
Dorking Cockerell 231
drag and drop 262
Dressage 81, 82–6
dusk 31, 213
DVD 263

Earls, Keith 18–19
editing software 260
Edward VII 209
Ennis, Jessica 20
Equestrian Events 81–6
Eton Dorney 13, 221–2
Eventing 81, 82–6
exposure settings 244–8

f stop 246–7, 248
Facebook 17, 265
facial shots 40–1, 41
Fencing 143, 145, 146, 148
file naming 261–2
File Transfer Protocol (FTP) 267
fill-flash 153, 154, 213
fill-flash ratio 69
filling the frame 183
filters 243

finishing line 45, 59, 60
fireworks, photographing 36–7
fisheye lenses 209, 240–1
Flamini *100–1*
flare 86, 91, 162, 230
flash photography 33, 67–9
flashguns 243–4
Flickr 272
Flood, Toby *116*
Floor 159
Florence, David *124*
focal length 30, 246
focal point 29, 30, 149, 236, 250
focus 250–2
Football 100, 101–9
foregrounds 30, 163
Foster, Tim *38*
Fox Hill, William 00 1
freeze action 61, 188, 245
full automatic (FP) 248
full frame 116

gadget bag 244
Garcia, Sergio *248*
Geraldino *144–5*
Gherkin 211, 222
Gimelstob, Justin *94–5*
Goalball 176, 177, *180*, 181, 182
golf 87–95
Gorden, Winston *144–5*
grab shot 206–7
Greenwich Park 13, 35, 81, 84, 85, *208*, 211, *222–3*
grey card 122
grey spot 269
Grigorieva, Tatiana *52*
Guildhall 23
Gymnastics 141, 158–63

Hadid, Zaha 220
Hadleigh Farm, Essex 76
Hammer 50, 52, 59
Hampstead Heath 211
Hampton Court Palace 71, 208, 210, 231
Handball 176, 180, 181
Harry, Prince *274*
Heptathlon *58*
High Jump 52, 53, 54, 59
Hockey 101, 110–11
Holmes, Dame Kelly 16, 55
home printing 264–5
Horizontal Bar 159
Horse Guards Parade *12*, 16, 112, *113*, 208, 209, *209*, 226

horse racing *270–1*
Houses of Parliament 54, 208–9
Hoy, Chris 20, *141*
Hurdles 53
Hyde Park 119, 227–8, *227, 228*

iconic images 71, 230–1
Idowu, Phillips *50, 51*
image sensor 237
Indoor Team Sports 176–83
Indoor Water Sports 184–201
inkjet printing 264–5
insurance 280–1
International Organisation for Standardisation (ISO) 247–8
Isle of Dogs 223
Isner, John 89
iStockphoto 266

Jackson, Joanne *22*
Javelin 50, 52, 53, 59
Johnson, Liz *194*
JPEG files 258
Judo 143, 145, 146, 148

Keating, David *161*
Kingston upon Thames 231
Kusurin, Ante *46–7*

laser printing 264–5
Latham, Rachael 13, *14–15*, 20–2, 23, *195*
Law, Leslie 83
Lee Valley White Water Centre 122, 125
legal responsibilities, of photographer 272–81
lens flare 269
lens opening 246
lenses 239–43
 fisheye lenses 240–1
 normal/standard 240
 telephoto 241–3
 ultra wide-angle 240–1
 wide-angles 240
 zoom 243
Lewis, Denise *61*
Li Ning 33
Liang Huo *184–5*
light 212–14
light meter 122, 127, 135, 190
lighting, photographing under different conditions of
 back *87, 91, 195*, 203
 direct light 213
 indoor 140
 intermittent 134–5

outdoor 52
pre-dawn 213
sodium 142, 255
sunrise 213
sunset 213
tungsten 142, 255
see also mixed lighting
lines, leading 30
London Eye 54, 208, 210, *210*, 212, 226
London Marathon 10
London skyline *204–5*, 211–12
London 2012 venues *see venues and under individual names*
long blur 245
Long Jump 52, 53, 59, 61
Lord's Cricket Ground 96, 226–7

Mahut, Nicholas 89
Mall, The 16, 27, 54, 208, 209, 231
Malouda, Florent *10–11*
Manual Focus mode (MF) 253
manual mode 249
Marathon 48, 52, 231
matrix metering 250
medal presentations 38–42, *39*
megapixel 234–5
metadata 258
metering modes 249–50
Millennium Dome 211, 222
mixed lighting 33, 255
 Badminton 168
 Diving 186, 187
 Victory Ceremonies 40
 indoor Equestrian events 83
 indoor sports 142, 146, 151–2, 168, 174
 Power Sports 164
 Swimming 190
 Tennis 168
 Track Cycling 150, 151–2
 Water Polo 202
 Wheelchair Rugby 179
model release forms 272, 275–6
Modern Pentathlon 9
Modric, Luka *100–1*
monopod 244
Monument 231
Moorsel, Leontien Zijaard van 73
motion blur 269
Mountain Biking 63, 76–9, *79*
multiple exposure 146, 175
Murderball 176
Myspace 265

Nadal, Rafael 20, 87
National Maritime Museum 207
Natural History Museum 222, 231
noise (visual disturbance on photograph) 269
noise baffle 177

off-camera flash 12, 13, 23, 66, 78, 121, 200, 208, 222, 243
Old Royal Navy College 222
Olympic and Paralympic Games
Sydney 2000 16, 33, 38, 52,231
Athens 2004 16, 55, 73, 80–1, 98–9, 231
Beijing 2008 16, 22, 32–4, 35, 37, 50, 51, 53, 58, 63–5, 66, 71, 74–5, 124, 125, 127, 138–9, 143–4, 184, 191, 197, 231
see also venues (London 2012)
Olympic Park 180, 206, 215, 216, 219, 220, 221, 260
Olympic Stadium 216–20
online libraries 266
online photosharing 272
Open Golf Championships 10
open shade 213
Opening Ceremonies 32–7, 32–4, 37, 247
Outdoor Team Sports 100–17
Outdoor Water Sports 118–37
overcast light 213
overexposure 269
Oxford and Cambridge University Boat Race 46–7, 126–7, 129

pan blur 20, 61, 152, 154–5, 245
pan-and-tilt tripod 214
panning 154
panoramic technique 61–2, 211
Parallel Bars 159, 160
Paralympic events see sports (Paralympic)
Paralympic Games see Olympic and Paralympic Games
Parliament Hill 35, 211
Payne, Keri-Anne 228
PCMCICA card 259
peak of the action 10

Pearson, Lee 20
Pelham, Richard 144–5, 146
permission 272
Phelps, Michael 138–9, 196–7, 236
photo books 264
PhotoBucket 272
photographic equipment insurance 281
Photoshop 260, 262
Pidgeon, Emily 17, 22
Pinsent, Matthew 16, 38, 130, 231
Pistorius, Oscar 12
Plymouth Aquarium 189
Pole Vault 52
Pommel 159, 161
Portland 76–7, 228–9
Power Sports 164–6
Powerlifting 164–6, 165, 166
prime lens 239–40
Primrose Hill 35, 208, 211
professional indemnity insurance 281
public liability insurance 280–1
Putney Bridge 231

Racket Sports 167–71
Radcliffe, Paula 250–1
Raw files 253, 258
Reade, Shanaze 20, 22, 63, 66, 67, 69, 215
red eye 269
Redgrave, Sir Steve 16, 38, 130, 231
reflectors 214
Rhythmic 159, 160
Richmond Park 231
Rings 159, 160
Road Cycling 48, 63, 70–5, 70–1, 73, 74–5i
rollerblading 227
Rooney, Wayne 232–3
Rowing 126–30
Royal Artillery Barracks 173, 227
Royal Observatory, Greenwich Park 211
rugby 18–19, 115–17
Rugby World Cup 9, 10
Rule of Thirds 29, 98, 99, 207
rules of ticketing 272

Sailing 130–5
Scott, Giles 20, 76–7, 132–4, 230, 240–1, 268
SD card 259
seating levels 53

server space 262–3
Sharapova, Maria 91, 255
sharing images 265–7
shooting (sport) 96–9, 172–5
shooting wide open (photography technique) 72
Shot put 50, 59
Show Jumping 81, 82–6, 83
shutter lag 250
shutter speed 246, 248, 269
Shutterstock 266
silhouettes 78, 79, 182, 242, 261
Simmonds, Ellie 16, 231
Single Autofocus Shot mode (AFS) 250, 253
Six Nations (rugby) 115
sky, use of 30, 49, 78, 208
slow-sync flash 76, 245
Smith, Louis 20, 22–3, 23, 207, 222, 273
SmugMug 272
snapshot 206–7
snooker 172–5, 175
soft diffused 213
South Bank 208, 211
sports days 42–5
sports (Olympic)
Archery 96–9
Asymmetric Bar 159, 160
Athletics 50–62
Badminton 167–71, 168–9
Balance Beam 159, 160
Basketball 176, 182
Beach Volleyball 101, 112–14
BMX 63, 64–9, 64–5, 67
Boxing 68, 141, 143, 145, 146, 148, 188
Canoe Slalom 122–6, 124
Combat Sports 143–8
Cycling 63–79
Discus 50
Diving 141, 184–7
Dressage 81, 82–6
Equestrian Events 81–6
Eventing 81, 82–6
Fencing143, 145, 146, 148
Floor 159
Football 100, 101–9
Goalball 176, 177, 181, 182
Gymnastics 141, 158–63
Hammer 50, 52, 59
Handball 176, 180, 181
Heptathlon 58
High Jump 52, 53, 59
Hockey 101, 110–11
Horizontal Bar 159

Hurdles 53
Indoor Team Sports 176–83
Indoor Water Sports 184–201
Javelin 50, 52, 53, 59
Judo 143, 145, 146, 148
Jumping 81, 82–6, 83
Long Jump 52, 53, 59, 61
Marathon 48, 52, 231
Modern Pentathlon 9
Mountain Biking 63, 76–9, 79
Murderball 176
Outdoor Team Sports 100–17
Outdoor Water Sports
 118–37
Parallel Bars 159, 160
Pole Vault 52
Pommel 159, 161
Power Sports 164–6
Rhythmic 159, 160
Rings 159, 160
Road Cycling 48, 63, 70–5,
 70–1, 73, 74–5
Rowing 126–30
Sailing 130–5
Shot put 50, 59
Sprint Relays 53
Steeplechase 53
Swimming 120, 138–9, 184,
 190–7
Synchronised Swimming 184,
 198–201, 199, 200
Table Tennis 142, 167–71
Taekwondo 143, 145, 146,
 148
Target Sports 96–9, 172–5
Tennis 87–95
Track Cycling 149–57
Track Events 53, 55–9
Trampolining 158, 161
Triathlon 119–21
Triple Jump 50, 51, 53, 59
Vault 159, 161
Volleyball 176, 183
Water Polo 184, 201–3
Weightlifting 164–6
Windsurfing 135
Wrestling 143, 145, 146, 148
sports (other)
 cricket 24–5, 115–17, 215
 darts 172–5
 golf 87–95
 horse racing 270–1
 rollerblading 227
 rugby 115–17
 snooker 172–5, 175
 surfing 136–7
sports (Paralympic)

Archery 96, 227, 228
Basketball 178–9
Boccia 172–5
Cycling 155
Football 101, 105, 105
Goalball 176, 177, 180, 181,
 182
Judo 143
Powerlifting 164–6, 165, 166
Rowing 126–7
Shooting 96, 227
Swimming 220
Table Tennis 171
Wheelchair 1500m 53
Wheelchair Fencing 143
Wheelchair Rugby 176, 179,
 181
spot metering 250
Sprint Relays 53
St Paul's Cathedral 23, 54,
 208, 210, 211
Steeplechase 53
streak (long blur) 245
surfing 136–7
Swimming 120, 138–9, 184,
 190–7
swimming galas 42–5
symmetry 199–200
Synchronised Swimming 184,
 198–201, 199, 200

Table Tennis 142, 167–71
Taekwondo 143, 145, 146,
 148
Target Sports 96–9, 172–5
telephoto lens 241–3
Tennis 87–95
Terry, John 103
Thames, River 211, 223
thermal printing 264–5
third-party insurance, 272
Tiananmen Square 74–5
ticketing rules 272, 278–80
TIFF 258
Torch Relay, advice on
 photographing 27–31, 207
Tower Bridge 208, 209
Tower of London 23
Track Cycling 149–57
Track Events 53, 55–9
Trafalgar Square 54, 231
Trampolining 158, 161
transmitting photographs 267
travel photography 207
Triathlon 119–21
Triple Jump 50, 51, 53, 59
tripod 214–15

Trooping of the Colour 209
trophy presentations 38–42
troubleshooting 269
TV mode 248
Twitter 265, 266

ultra wide-angle lenses 240–1
underexposure 269

vantage point 30–1, 35, 60
Vaughan, Michael 24–5
Vault 159, 161
Velodrome 39, 149–57, 220–1
venues (London 2012) 215–29
Victory Ceremonies, advice on
 photographing 30–42, 55
Vistaprint 267
Volleyball 176, 183

Water Polo 184, 201–3
Waterloo Underpass 54
Watson, Shane 116–17
weather, working with 30
webs.com 267
website creation 267
Weightlifting 164–6
Weir, David 53
WeTransfer.com 267
Weymouth 228–9
Wheelchair events see Sports
 (Paralympic)
white balance 252–5
 presets 254
wide-angle lens 240
Wiggins, Bradley 153, 155
Wilkinson, Jonny 9, 18–19,
 29, 63
William, Prince 274
Wimbledon Tennis
 Championships 9, 10, 35,
 88, 91, 94–5, 206, 255
Windsurfing 135
Wolsey, Cardinal 210
Woods, Tiger 92–3, 256
workflow 255–6
World Athletic Championships 10
World Cup (football) 10, 232–3
World Cup (rugby) 9, 10
Wren, Sir Christopher 210
Wrestling 143, 145, 146, 148

zoom burst 114, 207, 245
zoom lenses 243

Picture Credits

The photographs in this book are copyright © Andy Hooper/
Daily Mail/Solo Syndication, photographed by Andy Hooper,
unless indicated otherwise below.

The Publishers would like to thank Panasonic for their loan
of the camera which was used to take the photographs on
pp.140, p179, p209, p210, p211 (x2), p213 (x2), p219 (x2),
p220 and p227.

Internal images: Getty Images: p27 © Leon Neal/AFP/Getty Images; p29 © David
Davies/AFP/Getty Images; p43 © Ableimages/Getty Images; p53 © China Photos/
Getty Images; p79 © Stockbyte/Getty Images; p84 © Tom Shaw/Getty Images; p97 ©
China Photos/Getty Images; p105 © Mark Kolbe/Getty Images; p111 © Peter Cade/
Getty Images; p140 © China Photos/Getty Images; p155 © Guang Niu/Getty Images;
p160 © Fuse/Getty Images; p165 © Getty Images; p166 © Chien-min Chung/Getty
Images; p171 © Jamie Mcdonald/Getty Images; p172 © Frederic J. Brown/AFP/
Getty Images; p175 © Stockbyte/Getty Images; p180 © Dave Poultney/LOCOG via
Getty Images; p181 © Natalie Behring/Getty Images; p182 © Downtown Picture
Company/Getty Images; p201 © Damien Meyer/AFP/Getty Images; p202 © Dean
Mouhtaropoulos/Getty Images; © John Wiley & Sons (photographed by Andy Hooper):
p140; p179; p213 (x2); p219 (x2); p220; © John Wiley & Sons (photographed by Philip
Hartley): p209; p210; p211 (x2); p227; © Marc Aspland: p136; p137; © Richard
Pelham: p144; p146.

Front cover images: (left) Andy Hooper © Andy Hooper/Daily Mail/Solo Syndication;
(top right) © Getty Images; (bottom right) © John Wiley & Sons (photographed
by Andy Hooper)
Back cover images: (top left) © Andersen Ross/Getty Images; (top centre)
© Gary Hershorn/Reuters/Corbis; (top right) © Getty Images.